# Where did I go?

**Reflections on So-Called Late Mothering**

Edited by Dr. Suzette Mitchell and
Dr. Olga Sanmiguel-Valderrama

DEMETER

**Where did I go?**
Reflections on So-Called Late Mothering
Edited by Dr. Suzette Mitchell and Dr. Olga Sanmiguel-Valderrama

Copyright © 2022 Demeter Press

Demeter Press
PO Box 197
Coe Hill, Ontario
Canada
K0L 1P0
Tel: 289-383-0134
Email: info@demeterpress.org
Website: www.demeterpress.org

Demeter Press logo based on the sculpture "Demeter" by Maria-Luise Bodirsky www.keramik-atelier.bodirsky.de

Printed and Bound in Canada

Cover artwork: Veronika (Ron) Rakovic, daughter of Suzette Mitchell, and Ana Patricia (AnaPatty) Sanmiguel-Valderrama, daughter of Olga Sanmiguel-Valderrama
Cover design and typesetting: Michelle Pirovich
Proof reading: Jena Woodhouse

Library and Archives Canada Cataloguing in Publication
Title: Where did I go?: reflections on so-called late mothering / edited by Suzette Mitchell and Olga Sanmiguel-Valderrama.
Names: Mitchell, Suzette, editor. | Sanmiguel-Valderrama, Olga, editor.
Description: Includes bibliographical references.
Identifiers: Canadiana 20220261652 | ISBN 9781772584073 (softcover)
Subjects: LCSH: Middle-aged mothers. | LCSH: Working mothers. | LCSH: Maternal age. | LCSH: Motherhood.
Classification: LCC HQ759.43. W44 2022 | DDC 306.874/30844—dc23

# Acknowledgments

S uzette is thankful to Tania Principe for early collaboration and assistance on this venture. She dedicates her contribution to this book to her daughter, who is the greatest love of her life and her reason for everything.

Olga Sanmiguel-Valderrama dedicates this volume with the deepest of gratitude to my loving father, Eduardo Sanmiguel-Arciniegas (RIP), and mother, Emma Valderrama de Sanmiguel (RIP). Thank you for your endless sacrifices and loving support. Thank you also to my sister and brother, both of whom have passed away, who inspired me with their good example, as well as my living sister Claudia. I also dedicate this book to my daughter, Ana Patricia Sanmiguel-Valderrama for being the inspiration to my chapter and so called late mother condition, for running along with me on trips, and for giving me endless writing time that allowed me to be part of the project. Finally, I want to thank my friend Eileen Ryan, who generously fulfilled my mothering duties while my child was younger, and I had to be away fulfilling work-related duties. Finally, I am grateful to the TAFT Research Center at the University of Cincinnati (UC) and my colleagues at the Women's Gender and Sexuality Studies Department at UC for the unconditional encouragement of my writing and research. Thank you all!

We both benefitted tremendously from the assistance of Jeanne Barker-Nunn. Her skill, good humor, and support made a tremendous difference in how the volume came together. At Demeter Press, we thank Andrea O'Reilly for her interest in the book and inviting us to submit the manuscript to the press.

# Preface

As editors of this volume and single working mothers of only children performing in exciting and challenging careers on opposite sides of the globe, we sit in our homes, which have become our workspaces under the COVID-19 pandemic. Dr. Olga Sanmiguel-Valderrama is a solo parent by choice working as an associate professor at the University of Cincinnati while remotely caring for her mother who lives in Colombia. Dr. Suzette Mitchell is juggling life as a single lesbian mother with a disability, failing to find support for her daughter with a disability under lockdown while her full-time work in violence against women has escalated and increased stress and anxiety under Stage 4 lockdown in Melbourne, Australia.

This book has been years in the making. It took four years for Dr. Mitchell to find a publisher, as all the publishing houses she contacted said the topic was "too niche" to attract readers. Not until she discovered Demeter Press did she get a response that these voices and their stories were able to be formed into this book. Dr. Mitchell invited Dr. Sanmiguel-Valderrama to join the making of this book in 2017 because of her expertise and personal interest in the subject of the volume. Given the need to juggle the coordination of this book with various delays due to all our over-stressed lives and finally the context of finishing the editing under COVID-19 conditions, both editors are extremely proud that this has finally come to press.

These pieces were painful for many of us to write, and some admitted to tears rolling down their faces as they wrote. For Suzette, this pain came from reexperiencing the trauma of dealing with her identity as a later mother. The reason she wanted to create this book is

that when her daughter was young, she had searched unsuccessfully for books that realistically talked of what it was like to be an older professional mother. She yearned to hear stories like hers and her experiences echoed by people sharing the shock and the disorientation, questioning who they were and where their professional competence had gone, and talking of the difficulties of adapting to the new. But she did not find her experiences reflected in the many books she read, whose stories did not resonate with her experience as a mother until long after her daughter was a toddler.

Dr. Sanmiguel-Valderrama's inspiration for her involvement in this volume came from a different source. First, she had been completely shocked at being labelled "geriatric" by her doctor's practice at an age when she was healthy, fertile, and ready to give her best for a child. She wanted to write and reflect on the importance of destigmatizing women's having children after the age of thirty-five, as she saw this norm as an aspect of patriarchy aimed to control and limit women's reproductive capacities under the guise of protecting women from pregnancy complications. She also saw the practice of labelling women as "geriatric" or "older" at the age of thirty-five as a form of ageism that discouraged women from achieving stability and emotional maturity before engaging in the adventure and huge responsibility of being mothers. She despised the implications of labelling her pregnancy as geriatric ad high-risk, and the overmedicalization of her pregnancy and labour, which became for her yet another instance of control over women's reproductive capacities, particularly as an immigrant woman in the United States.

Together, our experiences and those of the other contributors to this volume reflect upon the way the media, government policies, the health system, workplaces, and often even our own families, partners, colleagues, and other mothers are unaware of the implications of mothering at a later stage of a woman's life and how this affects us deeply as individuals. The implications of this are not inevitable or grounded in biological realities but social constructions developed through interactions with those institutions and individuals and a lack of models providing a realistic picture of our everyday lives. Our personal stories of how we traverse this terrain are rarely written reflecting on our internal shifting identities. This is the reason for this book. The authors in this anthology have shared deeply personal stories, and we hope

these journeys provoke further discussion. We want our realities to be seen, and our voices to be heard. We want policymakers to consider our needs as well as institutions and the media to reflect our diversity and to eliminate the stigma and negative labels placed on women who dare to contradict the age norm related to motherhood.

# Contents

Introduction

# Identity Shifts and Ageism: So-Called Late Mothering in the Twenty-First Century

Olga Sanmiguel-Valderrama and Suzette Mitchell

Although the age pattern of childbearing differs greatly by country, most babies in the world are born from mothers under the age of thirty (UN 14). Since the late twentieth century, however, Western European, Australian, New Zealander, and North American women have increasingly been having their first-born child over the age of thirty. In the United States (US) alone, where the average age of mothers bearing their first child in 2020 was 27.1 years of age (Osterman et al. 4), the rate of births by women over the age of thirty has risen almost continuously since 1985, whereas the rate among women in their teens and twenties has decreased (Martin et al. 4). This pattern is also true for the European Union, where the average age of mothers' first birth continues to increase, and in 2019 was 29.4 years of age (Eurostat 1). Furthermore, some women are also having children in their fifties and even their sixties. In the US, in 2018, women aged fifty or older successfully gave birth to 959 children, up from just 144 in 1997 (Martin 4). Causes that contribute to this trend are higher education and career involvement among women, wider availability of contraception and reproductive technologies, as well as the rise of employment instability, economic uncertainty, and lower income in young adulthood.

This book is a collection of narratives written by eighteen women, including the editors of the volume, all of whom are highly educated,

have demanding and successful professional careers, and became mothers later in life—that is, older than the average for women in the context where they live. All of them transitioned to motherhood at what has been socially constructed as a late stage by health systems, workplaces, and networks of families and friends that often do not understand or respond to their needs or perspectives. Despite the statistical trend of an increasing number of smart, successful, and working professional women undertaking unpaid mothering work later in life, this group of mothers has generally been overlooked in the literature on mothering. When they are mentioned in mainstream narratives and the media at all, they are typically viewed as a problematic occurrence that highlights their age as an obstacle to mothering or as an exception to so-called normal mothering, even though, historically, having children later in life was not exceptional, as before contraception methods were widely available, women continued bearing children until menopause. Currently, however, when women have their first born at age thirty-five or older, they are often diagnosed in medical circles as "geriatric" mothers, whereas in other social and cultural circles, they have been labelled "elderly," "elder," or "late" mothers. In other words, these women are generally viewed as socially nonconforming mothers, since they perform mothering outside the prescribed heteropatriarchal Western norm of motherhood at an earlier age. But as the experiences of women who appear in this volume attest, those labels do not accurately represent the contemporary reality of many women. Professional women face a dilemma grounded in cultural expectations. On the one hand, they are encouraged to delay motherhood and focus on their careers, financial stability, and other personal goals (even, for example, encouraging them to freeze their eggs). On the other, when they reach a point of stability and decide to start their journey towards mothering often after the age of thirty-five, they are told they are "old," "late" and "geriatric" for motherhood. The tension created by these opposing discourses creates a dissonance in the lives of women, as reflected in this volume. Although other collections have been published within the broader field of mothering in academia and work-family conflict for professional women (Evans and Grant; Mantas and Peterson), this volume focuses on the less researched topic of so-called late mothers among professional women. This volume aims to fill this gap in the literature and examine the unique challenges and joys of

combining mothering later in life with demanding careers and how it affects us as women.

In doing so, this book strives to make the lives and struggles of strong, highly educated, and accomplished women who enter motherhood later in life visible to a broad audience and to include their voices in academic discourse and cultural representations. Documenting their experiences can also help us discern and transform the social constructions of ageism, which still view highly accomplished mothers and professionals as an anomaly and derogatively label them "geriatric," "late," or "elderly" mothers. The contributors to this volume have not only broken glass ceilings and walls in their educational and career paths by entering professions traditionally inhabited by white men or individuals free of mothering responsibilities, but have broken the mothering-age glass ceiling as well. By contesting a patriarchal and Eurocentric socially constructed norm that women should have their first-born earlier in life and reproduce ideally when they are young—in their twenties—but not too young—in their teens—these mothers are pioneers: a new generation that is shifting the dialogue on so-called late motherhood. The socially constructed norm of encouraging women to reproduce in their twenties (not too early, not too late) in fact restricts and controls the actual windows in which women have the biological capacity to reproduce. The editors and authors hope this volume will provide other women, policymakers, health specialists, human resource personnel, and members of the wider community with insight into the journeys and diversity of this special group of mothers and help remove the stigma placed on women who dare to contradict the age norm. The editors hope that a better understanding of the unique experiences of these mothers will help transform the prevalent perception that undermines them to one that not only sees them but also values, respects, and nurtures them. The fact that the women in this book were more mature and established in their careers, with more seniority and flexibility, illustrates how they have effectively woven together their lives of professional work and mothering, though not without difficulties, in their workplaces and in their personal journeys of their own identity.

Although the call for papers for this anthology was amply distributed in English through Demeter Press and various international motherhood and feminist online forums, most of the women whose

stories appear in this volume are from or living in North America, New Zealand, and Australia—all places where English as a first-language predominates. That most of them are also white academic women is probably indicative of the membership of these online fora. It is also the result of white women having more opportunities to achieve high degrees than other women, academia being more hospitable of white women than some other workplaces, and academia's requirement of producing publications as a part of the job (Mantas and Peterson; Evans and Grant). The contributors do, however, represent a diversity of backgrounds and experiences, including Indigenous women, immigrant women (from Turkey, Colombia, and India), and women addressing disability issues. Although many of these mothers are in heterosexual relationships, three identify as LGBTIQA+ and several are single (never married or divorced); some are solo parents (some by choice), whereas others coparent. Some do not have extended families where they live, while others have strong support systems available from relatives or the community where they live. Although they all earned advanced degrees and most established successful and demanding careers before becoming mothers, they come from different disciplinary backgrounds and professional paths, including international development workers, government policy advisers, a psychotherapist, a counsellor, academics, and the founder of a health technology company. Most of the contributors became mothers later in life through traditional conception, but some used IVF, and a couple of women adopted children. Some experienced miscarriages, difficult births, and postpartum depression. Some have only one child; some have children with disabilities, and some have disabilities themselves. With one exception (a mother who decided to temporarily quit her job after giving birth), the contributors all juggled their transition to motherhood with the myriad demands of a challenging career.

Methodologically, these chapters are feminist autoethnographies and examples of what Carla Pascoe Leahy has termed "maternography": "women's narrations of their maternal memories within the context of their life stories" (102). Each narrative refers to lived experiences and illuminates in a unique way and voice how the author managed, and survived, the many challenges and demands of their simultaneous roles as workers, community advocates, mothers, daughters, and partners and how this has affected their changing identities and their perception

of these shifts and roles. As their stories demonstrate, these mothers share the same work-family conflicts encountered by their younger peers, if at a later but often more stable and financially secure stage in their careers, as they assume a second, unpaid mothering shift in addition to their paid labour—both of which make simultaneous demands on their time, resources, and mental, emotional, and physical energy. Together, their stories reveal how this particular and largely overlooked group of mothers met the dual demands of their highly demanding careers and their mothering; how their goals, careers, relationships, and identities changed as a result; and what challenges they encountered specific to their age, educational and job status, and other identities, such as sexual orientation, ethnicity, disability, part of the sandwich generation, and immigration status.

As these women are high achievers with vocational positions of authority and respect, the emotional and psychological shift entailed in dealing with the myriad demands of children and often mundane aspects of motherhood can be overwhelming. These women are used to managing complex and highly technical issues in the workplace, yet none of these skills prepare them for motherhood, which requires patience, a need to let go of control, and for some a staggering conflict of personal identities and roles. Coming to terms with this new identity requires a rethinking of who they are as an individual in a society that offers few role models who have been honest about the personal side of their struggle. The media does not reflect their experience or reality as a mother, and in many cases, they are demonized for wanting it all and being selfish. Society does not recognize, or to a great extent even know, about the stresses and anxiety faced by this high achieving demographic of women. A great deal of productivity is lost from the workforce from the skills and expertise of these high-achieving women who are grappling with unfair burdens, discrimination and societal judgments, and most of all their internal identity crises. This is a major issue that needs to be acknowledged and considered by policymakers, academics, employers, and mothers themselves who have little space to analyze their context and share their experience in a feminist economic and personal political framework.

## Structural Context of So-Called Late Mothering

As mentioned, causes that contribute to highly educated professional women having their firstborn later in life are higher achievement in education and career involvement, wider availability of contraception and reproductive technologies, as well as the rise of employment instability, economic uncertainty, and lower income in young adulthood. We highlight three key sociocultural aspects of the structural context that the following narratives reveal. The first of these is the conflict between their paid labour as workers and their unpaid labour as caregivers. In particular, the contributors' stories demonstrate the difficulties of performing paid employment in a neoliberal context that continues to model employment around an able-bodied male as the ideal worker, who due to persistent class and gender roles is not expected to perform unpaid care work or to do so only marginally or secondarily (Drago). Such workers are able to focus completely on their paid work because they are either childless or without aging parents or family members with special needs who require daily, ongoing care, or are able to depend on an unpaid partner or paid caregivers to bear primary responsibility for biological and social reproduction (Williams). As the contributors to this volume made the shift from being this kind of worker to assuming the second unpaid shift with the birth of their children, they all struggled to find ways to balance these discordant roles and to make their own expectations and those of their workplaces more amenable to their reproductive roles. In this way, the presence of successful professional women in the workplace who are also late mothers contribute to alter the ideal gendered worker norm to one that is more amicable to the diverse roles and responsibilities of mothering individuals.

The second sociocultural aspect demonstrated by the contributors' stories is the persistent categorization of mothers by age within the social construction of mothering, in particular with the construction of the so-called geriatric late mother. As mentioned earlier, women who conceive after thirty-five years of age are classified as "elderly gravida" (elderly pregnant) or "elderly primigravida" (elderly pregnant for the first time). The classification usually comes with a twin term "high-risk" pregnancy, regardless of their actual fitness or health, as if age itself were a chronic health condition. As a result, such pregnancies and births tend to become highly monitored and medicalized and subject to

higher levels of testing, (e.g., genetic testing, weekly or frequent ultrasounds, blood and other specimen tests for different conditions during pregnancy, inductions, as well as caesareans during birth). The narratives of the women in this volume reveal many of the challenges and indignities of this age-based cultural framework of mothering.

A third sociocultural aspect of mothering experienced by the contributors to this volume is the patriarchal and class-based cultural notion of good motherhood as intensive mothering. This notion is in tune with neoliberal ideologies of individualism that place the burden of creating, maintaining, and educating the next generation primarily on the shoulders of parents, which by normative gendered prescriptions falls mostly on mothers (Lockman). Under intensive mothering, the resulting definition of good motherhood is one in which mothers' lives are centred around children's needs and performed with methods informed by experts that increase costs and labour (Lockman). The narratives of the authors in this volume amply demonstrate the pressures that the cultural expectations of this model of intense mothering places on contemporary mothers—and perhaps especially on mothers used to excelling at meeting their professional responsibilities in their paid labour.

## Organization of Volume

The personal journeys narrated by the authors in this volume have been shaped not only by the structural contextual aspects described above but also by the particular life circumstances of the individual authors. To draw attention to the varied impact of these factors, the following chapters are grouped according to similarities among the authors' identities and conditions, which go beyond their broader shared experiences as professionals who entered mothering later in life.

The first of these groupings includes two Indigenous mothers, whose pieces reflect a different model of mothering than that in mainstream Western culture. Their cultures, those of the Anishinaabe of Canada and the Māori of New Zealand, provide models of extended family, community care, and strong cultural traditions that perceive motherhood not within the contexts of age and individualism but of ability and community. As these contributors' narratives show, these cultures eschew the colonizers' patriarchal and ageist views, enforced

stereotypes, and mainstream media portrayals of tight age-gender roles in favour of holistic family, community, and cultural bonds. In her chapter, Renee E. Mzinegiizhigo-kwe Bedard describes how her cultural learnings, maternal connections, and readings on maternal resistance by Indigenous women writers allowed her to use her identity as an Anishinaabeg woman as a maternal resistance strategy not only for survival but also for nurturing. In her chapter coauthored with Gretchen A. Good, Anita Gibbs, and Awhina Hollis English, a Māori academic and social worker, draws from the strength of Māori social workers and activists of the 1970s and 1980s, who inspired her to research, publish, and teach about the experiences of Māori within the social services.

Books on mothering rarely mention mothers with a disability or who mother children with a disability. The chapter by Gretchen A. Good, Anita Gibbs, and Awhina Hollis English offers insights into the challenges and joys of such women, including the persistence they need as advocates to traverse government systems that are not designed for them and to deal with the social stigma of disability while simultaneously dealing with their own or their children's complex needs. They poignantly describe the discrimination faced not only by older mothers but also mothers with a disability, mothers of children with disabilities, as well as adoptive mothers. They powerfully explain how they need to legitimize their motherhood and constantly advocate for their own rights and those of their children.

The next grouping includes four chapters by expatriate and immigrant mothers who have mothered their children in a country different from their place of birth, bringing yet another angle or perspective to the book's central concerns, as they engage in mothering within a new set of cultural and social norms. The chapter by Olga Sanmiguel-Valderrama tracks the author's journey with her decision to flee civil war and political violence in Colombia to becoming a Latinx immigrant first in Canada and then in the US. As she explains, these circumstances engendered several obstacles to mothering, including struggling with heteropatriarchal racism, gaining immigration status, learning a second language, dealing with cultural shocks, acquiring new skills and degrees, accessing the Canadian/US labour market, and experiencing the isolation, longing, and loneliness frequently experienced by immigrants. All of these lengthened her road to financial and social

stability, which she deemed necessary before becoming a solo mother. In her chapter, Laura Beckwith reflects on her decision to move from Canada to Cambodia to conduct her PhD research shortly after having a baby—a decision that was met with judgment and a lack of understanding, which added to her already heightened levels of stress, especially about merging her identities as a mother and a researcher. Unlike the other mothers in this volume, Simal Ozen Irmak, an immigrant from Turkey living in the US, chose to become a stay-at-home mother for eighteen months after the birth of her child. Although this was a conscious and deliberate decision on her part, she was shocked by the value-laden comments she received from members of her academic and social circles, who assumed that choosing to stay at home somehow negated her other identities. Jean D'Cunha was born in India and moved to work for the United Nations for decades in Thailand, Myanmar, and Egypt. Her chapter reflects on her own experiences and those of four of her middle-class, urban Indian colleagues as older mothers. Although D'Cunha's group of Indian friends had children earlier than the other contributors to the book, from the cultural perspective of India in the 1980s, they broke strongly entrenched family and cultural traditions through their choice of careers, husbands, and delayed motherhood.

The volume continues with chapters by three contributors who identify as LGBTIQA+. Their narratives demonstrate that although many of the strictly gender-coded roles and expectations of mothering may be less acute within same-sex relationships, others remain the same and still leave them feeling "like square pegs in a round hole." Katherine Gelber and her partner Lou Stanley had been in a lesbian relationship for thirteen years before having their son and at the time of writing had been together for twenty-six years and approaching the transition to retirement. Although Gelber acknowledges the challenges of becoming a mother at a late age, she also believes her age helped her deal with being a lesbian mother by giving her more experience in coming out to others. In the next chapter, Jill White immediately confesses to wanting to have children when she fell in love with her girlfriend. She chose to first focus on her career and complete her PhD while her partner transitioned to being a male. Because her partner forbade her from coming out as a lesbian to protect his personal and professional identity, her becoming a mother also signified a public

return back to the closet, adding yet another layer to her efforts to integrate the various elements of her identity. In the next chapter, for Suzette Mitchell, the birth of her daughter seemed to have finally completed the trifecta of having a successful career, marriage, and child—a seemingly ideal state that was soon shattered when she left her heterosexual relationship within a small expatriate community in Hanoi, Vietnam. Her chapter shares her painful simultaneous struggle dealing with the transition of motherhood with her feelings of being an inadequate mother leading to severe postnatal depression.

The next two chapters of the book are by mothers who work in the mental health sector. Counsellor Caro White's piece details her postnatal depression and describes how older motherhood could be a risk factor for postnatal depression and anxiety based on the higher incidence of birth trauma, breastfeeding difficulties, as well as professional women's perfectionist tendency to place unrealistic expectations on their mothering and to blame themselves when mothering did not seem to come naturally. Constance Morrill, a psychotherapist, reflects on her childhood and the impact of her own mother in her journey to motherhood. Morrill's identity changes in motherhood also encompassed a major professional shift from development and human rights work in postgenocide Rwanda into social work, embarking on a challenging career in psychotherapy as a way of healing trauma. Her piece deals with her own trauma in motherhood and her journey through identifying her feelings of guilt, sadness, and inadequacy, which are shared by many others in the book.

The final five chapters are by women whose stories reflect the considerable, often unanticipated, and sometimes unexpectedly painful changes that mothering made in their professional and personal lives, relationships, and sense of self, specifically in the context of academia. Karen Christopher's piece draws from her academic history in dealing with work-family conflict specifically as it refers to more educated and high-income mothers. She articulates the privilege of these mothers and calls for older mothers with more education and work experience to advocate for changes in the workplace. She is also clear in her piece on how access to more resources, combined with cultural trends, puts additional strains on these mothers to be ideal workers and intensive mothers. Elizabeth Allison reflects on entering a new career in academia as well as on changing relationships with friends at different

stages in their family lives. Allison describes how she had nothing in common with the twenty-something mothers in her prenatal yoga class, who were developing their adult identities along with their identities as mothers. She considered this peerless life the most profound identity change she had ever experienced. Maura J. Mills is an academic who describes herself as driven and focused, leading her to develop "the plan," which steered her path to a professorship at a university. Motherhood consistently challenged her identity, as she had been led to believe she could have it all. Mills' area of academic focus is work-family issues; however, after the birth of her first baby, she tried to separate the two roles of work and motherhood. It was when a colleague commented that she herself appeared to "have it all" that she experienced a tipping point, where she realized she was doing other women a disservice. Caroline J. Smith describes how the inevitable stresses of her later entry to motherhood and challenging career were magnified by postpartum depression and led to feelings of being a failed mother as her husband expanded his parenting role during this time. For Smith, as for some of the other mothers in this volume, returning to work allowed her to recover her sense of self in a space where she felt competent and qualified. In the final chapter, Lisa K. Hanasono, a fourth-generation Japanese American, discusses how her postpartum struggles against her self-imposed "tiger mom" instinct to raise a highly successful child were exacerbated by her expectation that due to her age, her son would be her only child. Her piece explores the intersection between age, professional expectations, and ethnic stereotypes.

## Common Themes and Concluding Thoughts

A number of other important themes also emerge from the stories collected in this volume, including the effects that the contributors' mothering later in life have had on their relationships with various other people in their lives, including with life partners and friends. Whereas the addition of a baby is likely to test the relationships of mothers of any age, this is especially true for professional women who have had longer careers and find themselves needing new forms and levels of support as they attempt to juggle the joint demands of mothering and careers.

Most of the mothers in this volume also report losing contact with

many of their friends, especially single friends or friends without children, after having a child, because of the lack of time to invest in these friendships. Several found that, as older mothers, most of the similarly aged mothers with whom they were friends tended to have older children who placed different demands on their time and careers, whereas as older professionals, they often did not share the same interests as the younger mothers of their children's friends. Several of the contributors found that forging supportive friendships with younger mothers in playgroups was also complicated by other factors, such as being adoptive mothers, raising children with disabilities, or being immigrants with different cultural backgrounds.

Because older mothers also have older parents, many of the contributors were unable to call upon their parents for as much help as younger mothers could. They were also more likely than younger mothers to be caring for parents while also still caring for children, making them part of the sandwich generation experiencing this double bind. Many of the high-achieving women in this book had also left the cities where their parents live, adding further complications to their responsibilities as caregivers and the kind of support they could expect from their families.

Although these chapters collectively argue against the notion that age is itself a disadvantage, a number of the contributors suggest that the shifts in identity faced by this group of mothers deserve greater recognition and social support. If we try to do it all, we invalidate our own needs. The stories in this book illustrate that women who mother at an older age must refuse to hide behind the masks of mastery and have the courage to share the truth about their lives and experiences. The chapters are vocal in articulating the difficulties inherent in our shifting identities as well as the inadequacy of the workplace and social norms in current dominant cultures, but none of this is at the risk of love of our children. Indeed, it is the opposite. The love of our children is fierce, and we have learned to advocate for their needs, but often at a personal cost to ourselves.

At the same time, most of the contributors report that the maturity and security they have gained through experience have proved invaluable in dealing with the challenges of motherhood. Many of these women not merely adjusted but reoriented their professional work to focus on what they were experiencing as mothers and to serve other women through

their research, service, volunteering, and rallying against negative stereotypes of women and mothers. The authors in this volume were aware of their own privilege and chose to consciously use it to advocate not only for their own children but also those of others and for systemic changes in current policies and practices. Through the example of their work and their bravery in exposing their personal challenges in the following pages, these women serve as powerful role models.

## Works Cited

Drago, Robert W. *Striking a Balance: Work, Family, Life.* Dollars and Sense, 2007.

European Commission, "Women in the EU are Having Their First Child Later" *Eurostat News*, 24 Feb. 2021, ec.europa.eu/eurostat/web/products-eurostat-news/-/ddn-20210224-1. Accessed 9 June 2022.

Evans, Elrena, and Grant, Caroline. *Mama, Ph.D.: Women Write About Motherhood and Academic Life.* Rutgers University Press, 2008.

Leahy, Carla Pascoe. "From the Little Wife to the Supermom? Maternographies of Feminism and Mothering in Australia since 1945." *Feminist Studies*, vol. 45, no. 1, 2019, pp. 100-28.

Lockman, Darcy. *All the Rage: Mothers, Fathers, and the Myth of Equal Partnership.* HarperCollins, 2020.

Mantas, Kathy, and Lorinda Peterson, editors. *Middle Grounds: Essays on Midlife Mothering.* Demeter Press, 2018.

Martin, Joyce A., et al. "Births: Final Data for 2018" *National Vital Statistics Reports*, vol. 68, no. 13, 27 Nov. 2019, pp. 1-47.

Osterman, Michelle, et al. "Births: Final Data for 2020." *National Vital Statistics Reports*, vol. 70, no. 17, 2021, pp. 1-50.

United Nations. Department of Economic and Social Affairs, Population Division. "World Fertility Patterns 2015," United Nations, 2015, www.un.org/en/development/desa/population/publications/pdf/fertility/world-fertility-patterns-2015.pdf. Accessed 9 June 2022.

Williams, Joan, *Reshaping the Work-Family Debate: Why Men and Class Matter.* Harvard University Press, 2012.

Chapter 1

# Working in Balance: Being Kwe and an Anishinaabe Mother in the Workplace

Renee E. Mzinegiizhigo-kwe Bedard

She is called a "late mother" (Touleman), an "older mum," an "old mom" (Krajchir), and a "geriatric mother." She is described as being of "advanced maternal age" (Delfino), as choosing "delayed motherhood," and as being "late to embrace motherhood" (Hill).

This is a collection of terms used for mothers over thirty-five in North America and the United Kingdom. Women can feel trapped and shamed within a Western dichotomous worldview, where everything is either good or bad, young or old, beautiful or ugly, fertile or infertile, etc. Women endure the Western framework of maiden, mother, and crone based on Christian and patriarchal normative culture's understandings of womanhood. This his-story continues to interfere with the lives of contemporary women. Over the years, I have shared how my road to motherhood came late in my life, just as it did for my own mother and maternal grandmother. The reasoning I give to colleagues, students, or other women is embedded in traditional cultural ways of knowing that honour the rights of both young and mature women to become mothers without prejudice, judgment, or discrimination. I carry those teachings to ground me in my decision and as a shield against Eurocentric worldviews that seek to colonize me.

Do men have their manhood, male fertility, or fatherhood labelled like this? The list above offers words and phrases that are not kind, nurturing, compassionate, uplifting, or respectful of womanhood or

motherhood. Those contemporary descriptors are commonly used by medical officials, the media, and academics to describe and identify women who choose to have children after the age of thirty-five. From an Indigenous perspective, these words are created by the colonizer to control birth culture across Turtle Island (North America). Moreover, these terms are intended to evoke shame in all North American women about their female identity, sexuality, fertility, and age. As with other colonial his-stories, Indigenous women across Ashkaakamigokwe (Mother Earth) have had their femininity, knowledge, and birth culture colonized by a legacy of heterosexism, heteronormativity, and heteropatriarchal governments. The words listed above, thus, also provide evidence of the colonization of Indigenous women and mothers.

From the earliest time of contact, Europeans have disrupted Indigenous women's birth knowledge. Through a deliberate dispossession of Indigenous lands, the fragmentation of family and community networks, and the medicalization of birth, women have lost many customs (Anderson, *Recognition of Being* 100-05; Simpson, "Birthing an Indigenous Resurgence" 27-31; Simpson, *As We Have Always Done* 39-54; Tabobondung et al. 72-73; Proverbs 179-81). Overall, the imposition of Euro-Christian patriarchal beliefs, values, and ideological frameworks upon women, mothers, and their children has deteriorated and distorted Indigenous female sovereignty over birth culture (Tabobondung et al. 72-73; Anderson, *A Recognition of Being* 102-03). Indigenous oral traditions and language specific to birth culture were almost extinguished because of the impact of the residential school system, the 1960s scoop of children out of Indigenous homes and into non-Indigenous homes, the foster care system, and the displacement of midwifery by Western medicine. Today, we must reclaim the language and customs of Indigenous birth culture to decolonize our lives from the imposition of Western colonial heteronormative beliefs of femininity, motherhood, and birth. By doing so, we can provide an example for women in other cultures to follow to reject sexist, discriminatory, and racist notions of birth.

Terms like "late mother" manipulate and fool the public with false constructions of womanhood and motherhood, especially within Indigenous contexts. Such negative terms are now so ingrained in the North American consciousness that even women have internalized these beliefs about their friends, colleagues, and themselves. This leads

people to see womanhood and motherhood through the lens of these maternal stereotypes rather than as an essential contribution to the wellbeing of family, society, and nation. There are still people who believe that motherhood is only for the young. Women who turn thirty are instructed to rush to have children or to finish having their children before it is too late in life. As the saying goes, "Your clock is ticking! Tick! Tick! Tick!" That is such a ridiculous saying because according to Statistics Canada, the average age of Canadian women becoming mothers has been going up since the 1960s and is currently thirty.

From the perspective of an Indigenous woman, being called a "late mother" perpetuates the colonization of women's birth knowledge, including traditional language, philosophies, ethics, and customs. I am an Anishinaabe-kwe[1] (a human being and a woman) who was told by the obstetrician I had to see (on the orders of my Indigenous midwives) that I needed an emergency caesarean section for my first daughter, who presented as Frank breech and could not be delivered vaginally without complications arising. Being classified as an older mother made me laugh at the time, but after the birth, I was irritated and insulted by the label. Writing this chapter brought those memories back to the forefront of my mind. It is my aim here to step outside of the Western constructions of "late mother" and instead discuss motherhood grounded in the Anishinaabe teachings of Kwe, all those individuals who identify as woman, female, or those who identify on the female gender spectrum.

Situating my discussion within Anishinaabe contexts instead of the mainstream colonial constructions of motherhood is what Indigenous scholar Taiaiake Alfred (Mohawk) refers to as "Indigenous resurgence" (197). Indigenous resurgence comes from radically regenerating the use of ancestral wisdom (i.e., Indigenous intelligence traditions) so that we can make use of the teachings of our cultures to make choices as we move through the world. Alfred calls Indigenous ancestral teachings "radical wisdom," which has the power to break us "out from under the weight of colonial oppression" (197), which seeks to extinguish our identities as Indigenous peoples (197).

# Being Kwe

In North American culture, a working mother who has children in her thirties or forties has the chance of facing some offensive questions about her identity as a mother. Did you plan to get pregnant? Was it an accident? Did you wait until your career became established? Do you worry about your age affecting your baby's health? Amelia Hill writes, "Women who leave it late to embrace motherhood are often criticized for gambling with their fertility and risking their own and their baby's health." During the two pregnancies I had during my late thirties, female and male coworkers asked me a few of these questions, which often made me uncomfortable and judged. I had witnessed other women in my life, including my own mother, face the same judgmental examination along with being exposed to negative portrayal of older moms on television and in the media.

One of my earliest exposures to the negative portrayal of older moms came from an episode from the television show *The Golden Girls,* titled "End of the Curse," which aired September 27, 1986. As a child, I used to sit in the kitchen and watch this show with my mother. In "End of the Curse," the character Blanche, who is in her fifties, thinks she is pregnant. Blanche was in fact not pregnant but instead was beginning menopause, so her hormones were erratic. After Blanche has a positive pregnancy test, she and her friends go into hysterics about her getting pregnant at such a late age in life and immediately pass negative judgments on her sexuality and sexual behaviour. Watching that exchange taught me that there is a social rule in North American society against older women getting pregnant and having babies. Furthermore, mothers who do this are made to feel and appear irresponsible, inconsiderate, and a burden on their family and society. The exact age at which motherhood becomes unacceptable is unclear. Witnessing this phenomenon has always clashed with the reality of my life at home. I was the child and grandchild of two Anishinaabe women who had their children as mature adult women. I never foresaw that I too would follow in their footsteps, but I did.

As an Anishinaabe-kwe and mother, I choose to privilege Anishinaabe intellectual knowledge, traditions, and normative understandings of motherhood. In the medical community, I am called a "geriatric mother" for having my babies after I was thirty-five. I find the whole notion of a geriatric mother ageist and disrespectful of Anishinaabe

views around the sacredness of motherhood. Instead, I choose to ground my understandings of motherhood in the teachings, stories, and ceremonies of Kwe. In this way, I honour the teachings of Mother Earth, Sky Woman, and the Gete-Anishinaabe-kwewag (women ancestors), who passed down their knowledge so that we might continue to live by the ethical protocols of the Anishinaabe-kwe miikaana mino-Bimaadiziwin (the good path of womanhood). I see Anishinaabe understandings of Kwe as the foundation for understanding how to be both a woman and mother in the twenty-first century.

It is culturally acceptable, natural, and the right of all Anishinaabe-kwewag (Anishinaabe women) to continue to have children as long as they are menstruating and capable of supporting those children. My Anishinaabe-kwe grandmother Roseanne Dokis-ban had her last child when she was forty-one, and my own Anishinaabe-kwe mother, Shirley Bédard-ban, continued to have children until she was forty-three. My grandmother had twelve children, and my mother had four children. I witnessed my mother juggle having a young child when her other children were going off to college and university, but she also went back to college and eventually became a secretary for the North Bay Catholic School Board.

In my own life, I dedicated many years to finishing my education and then establishing my career as a professor in Indigenous studies before having children. When I decided to start having children in my late thirties, I knew some people around me would make judgments regarding my age and that having children would affect my career path. However, I did not allow those worldviews to affect my path towards motherhood; instead, I looked to my maternal connections, or what Jennifer Brant (Mohawk) refers to as the "motherline" (210). I relied on the knowledge of how my grandmother and mother embodied Kwe in their lives, along with the teachings of Anishinaabeg elders on the traditions of motherhood, the language and meaning of words related to motherhood, and the aadizookaanag (sacred stories) relating to the traditions of mothering. Women who follow the traditional practice of Kwe are walking the good path of Anishinaabe womanhood. Ancestral instructions and knowledge that women handed down long ago shape my feminine-centred worldview as a Kwe mother.

## The Teachings of Kwe

I understand my identity as Kwe through the stages of Kwe's life as explained in the teachings of Sky Woman or Giizhigoo-kwe. My Anishinaabe Spirit name, Mzinegiizhigo-kwe, and the teachings I received related to my Anishinaabe name include that connection to Sky Woman; therefore, her teachings hold value to me as a Kwe. That story provides lessons on our roles and responsibilities as women and mothers. I use these instructions to survive, live, and embody Kwe. Her story honours women, not for their age but for the gifts of life they offer their world, nation, community, and family. For this reason, I do not need to find value in Western labels of aged mothers but need only look to my Anishinaabe culture for terms that are supportive, nurturing, and positive.

The aadizookaan (sacred story) of Giizhigoo-kwe includes lessons on the creative powers of women as well as the parameters of a mother's roles and responsibilities. In *Ojibway Heritage,* Anishinaabe Elder, scholar, and ethnologist Basil Johnston offers a beautiful version of the story of Giizhigoo-kwe, which draws on the teachings from many Anishinaabeg Elders from across Anishinaabe territory in Ontario, Canada, which I will briefly summarize below.

In Johnston's telling of the story, a great flood had covered the earth with water, killing everything but fish, fowl, and some animals. At that time, Giizhigoo-kwe lived alone in the Great Land in the Sky Realm above the earth, and to dispel her loneliness, Gzhe-Mnidoo (Great Spirit, the Creator) sent another Spirit Being to be her companion. She conceived, and her partner soon departed. Alone, Giizhigoo-kwe soon gave birth to two children, who fought constantly and eventually destroyed each other. After the death of her children, Giizhigoo-kwe was alone, and once again Gzhe-Mnidoo sent her a companion. She conceived a second time, and as before, her Spirit companion left her. Down below, the creatures of earth witnessed the great ordeals, loneliness, and pain Giizhigoo-kwe endured and invited the Spirit woman to come down to live among them. Gchi-mishiikenh (the Great Turtle) offered its shell for her to live on. She agreed to join the earth creatures and descended. The muskrat brought her soil from the bottom of the sea, and Giizhigoo-kwe breathed the breath of life into it. The ground expanded and formed an island. As the waters subsided, earth's creatures brought Giizhigoo-kwe the remains of the grasses, flowers,

trees, and food-bearing plants that had existed before the flood, which she revived with her life-giving breath. Through Giizhigoo-kwe, life was restored to the earth.

Additionally, as the fulfillment of the promise of new life, Giizhigoo-kwe gave birth to a son and a daughter. These new beings were humans remade by this Spirit woman. When her children were grown, she explained to them that it was time for her to travel back to the Land of Peace in the Sky Realm and that when they, too, had lived out their term of life in a good way (mino-bimaadiziwin), they would also travel to the Sky Realm to live there as Spirit beings. Then the Spirit of Giizhigoo-kwe returned to her home in the Sky Realm. Since then, the Anishinaabe people have remembered her as the First of Human Mothers, whom they call Nookomis (grandmother) and is represented by the moon (dibiki-giizis) and remembered for her role in the renewal and manifestation of life on earth. The Anishinaabeg continue to follow her Nookomis Dibaajomowinan (grandmother teachings or stories) and honour her in their prayers, songs, dances, and ceremonies as a reminder of the sacred work of Kwe as a woman, daughter, mother, and grandmother. Specifically, to honour her role as First of Human Mothers, women perform full moon ceremonies each month to remember her and their mothers and grandmothers. Teachings regarding women's and mothers' agency in the cycle of creation, destruction, and recreation are shared with young women at puberty to ensure their understanding of their powers of fertility and their gifts as women. As Anishinaabe Elder Arthur Solomon wrote in his poem, "The Woman's Part":

> Fertility was her working element. Hence "the woman's cycle" or her "moon." The power of birth was given to the women. It was given by the Creator and it is an immutable law. It was given as a sacred work and because it is a sacred work then a sacred way was given to the women. The woman stands between man and God. She takes from both and she gives back to both.... The woman is the foundation on which nations are built. She is the heart of her nation. (34-35)

Another equally powerful gift of Kwe is recreation, or resurgence. Giizhigoo-kwe brought life back to the earth through the trans-formative life-giving power of her breath. As Solomon states, a woman

can create life through her body, and if she does not, her body purges itself and starts new again. Kwe naturally embodies resurgence through her body because she can recreate and make new and necessary changes to allow life to survive and thrive. In this way, Giigzhigo-kwe models Indigenous resurgence as Gikinoowaabanda'iwewin, which means to model desirable behaviours for others to follow. Giizhigoo-kwe modelled for future women how to mother and walk that path of womanhood so that we can nurture strong identities in our daughters and in ourselves.

What mothering means in mainstream Canadian society contrasts with Anishinaabe societal and cultural norms that have existed since before the arrival of Europeans on Turtle Island. Among the Anishinaabe, the period of motherhood in a woman's life is characterized by the cycles of her female body. Womanhood and motherhood begin with a kwesen's (a girl's) first cycle of menstruation, and her Nookomis stage begins when her menstruation time comes to an end. These stages of a Kwe's life, as modeled by Giizhigoo-kwe, are not dependent upon heteronormative relationships with men or age but are defined instead by the natural cycles of her body, which are connected to the ancient feminine powers of creation: the earth, the moon, and the waters.

I carry these teachings and follow them as I seek to honour my role as Kwe, which enables me to see the meaning and context of my place as a mother in the scheme of life. Not only do I try to embody those teachings in my home or community environment, where it is culturally safe, but I also assert my right to live my cultural worldview as Kwe as a mother in the workplace. I clearly state to my colleagues that motherhood is the root of my decision making and my paradigm as both an educator and a researcher. In the work environment of the university, I prioritize the sacredness of being Kwe and dodooman (mother). Moreover, womanhood and motherhood are the foundations of my teaching pedagogy, philosophy, and my research paradigm. I carry the teachings of the grandmothers and mothers who came before me. I set forth their knowledge as I walk the Anishinaabeg stage of life known as adulthood and parenthood. I use their methods of teaching others how to come to know our women; I carry their epistemological, ontological, cosmological, and axiological ways of knowing as sacred gifts that I share cautiously with the world. I also research my way

through the facets of relearning Anishinaabeg women's ways of knowing that were stolen from my mother, and girls like her, who attended a residential school in Northern Ontario, Canada. Carrying any of this knowledge is an exercise in survival and perseverance. By prioritizing a mature woman and mother's feminine-centred Indigenous worldview in every aspect of my life and work, I push back against the colonial heteronormative ideologies and knowledge systems that seek to erase and suppress Indigenous intellectual traditions while simultaneously imposing their notions of being a mature mother in the workplace. I do not make room in my life, culture, or work environment to engage with those ideas.

## The Identity of Kwe

As Sandra Laronde mentions, women owe a debt to Sky Woman and those ancestors who followed her on the path of womanhood as mothers. Giizhigoo-kwe underwent much in her life's journey, including transformations from Spirit to human woman to lover, mother to grandmother, and finally from physical body back to Spirit being. She endured the loss of her children, abandonment by her companions, leaving her home, and the delicate work of healing both the land and her own self. Through her actions, transformations, and the healing she experienced, her life moved ever forwards on the mino-miikana bimaadiziwin (good life path) as a woman. To Anishinaabe-kwewag, the Spirit woman Giizhigoo-kwe is a role model and archetypal figure for living well as mother, daughter, grandmother, teacher, Elder, and finally grandmother. These roles represent Giizhigoo-kwe's character and quality as woman. She is the Spirit being who watches over all women and all mothers throughout their lives. Through her story, we witness her progress through stages of a woman's life; therefore, we are her, and she is us. She is our mother, grandmother, aunties, sisters, cousins, daughters, and friends.

The teachings of Sky Woman remind me of my maternal connections to those ancestors as well as to my late mother and maternal grandmother. In their Anishinaabe community, these women would never be called "late mothers," "mature mothers" or "geriatric mothers" but were instead simply called "mother" and "grandmother." In Anishinaabe culture, the capability of a woman to mother and her

actions of mothering determine how she is described as a Kwe. My mother and grandmother provided me with living examples of women fulfilling the duties of Kwe as modelled by Giizhigoo-kwe. Likely without realizing it, they lived their lives embodying the teachings of Giizhigoo-kwe as their theory of living, which together have provided my model for Kwe. In essence, these Kwewag (women) represent, in their unique ways, the teachings of Kwe as mother. Through the many stories of their lives that I received from my mother, aunts, cousins, and sisters, I see living examples of motherhood. I exist today because they were mothers and lived the teachings of their mothers and grand-mothers, all the way back to Giizhigoo-kwe. As they mothered their children, they aligned themselves with the legacy of Giizhigoo-kwe, engaging in the promise of new life embodied in Kwe. This teaches me that Anishinaabe women have to look not just to the creation stories to learn how to enact the path of womanhood, but to the women in their families, communities, and nations for living reflections of The First Mother, Giizhigoo-kwe. From them, we see the diversity of mothers of varying ages and experiences.

## Aanwetamowin (Refusal): The Legacy of Kwe

I learned a certain way of being from my mother, of what it means to be strong and independent woman, a community member, a mother: what it is to be Kanien'kehá:ka.

—Kahente Horn-Miller, Mohawk ("Distortion and Healing" 31)

Women are powerful because they birth the whole world.

—Shirley Bear, Mingwon/Maliseet (133)

As evidenced by the words of Kahente Horn-Miller and Shirley Bear, among others, Indigenous women throughout North America recognize the legacy of our maternal ancestors who worked hard to survive, thrive, and resist colonization by passing on their wisdom to their daughters and sons. I look at the Gete-Anishinaabe-kwewag (women ancestors) of my community as my personal measure of what it means to be woman, mother, daughter, grandmother, and Elder. These women valued their bodies and their gifts of creating life as their

right as women. As an Indigenous woman who works in an institutionalized university environment that is in constant conflict with my gender, cultural worldview, and traditions, I find strength in the teachings on Anishinaabeg women's sovereignty over our physical bodies and our identities as Kwe.

It is difficult sometimes for me to rationalize working in an environment of institutionalized education that privileges and prioritizes a system of knowledge that actively seeks to colonize Indigenous peoples in Canada. Despite the prolific and trendy contemporary assurances of Indigenization at universities across Canada, I am hyperaware that the university is a mechanism of colonization used to perpetuate and protect the rights of the descendants of those who stole land, culture, and language from my ancestors. The institution I work for sits on the territory of my ancestors; therefore, I am reminded daily of all that the women in my family have lost so that the institution I work for can exist. I have learned to assert my maternal worldview as Kwe as a method of radical decolonization, anticolonialism, and articulation of an authentic presence of Indigeneity in the university setting. Although it is not always popular because it disrupts the status quo, I share my position as a Kwe and demand to be heard within the context of Kwe, not within the context of Euro-Canadian worldviews. Kwe as a method of working in the university has become a vital strategy for my survival and wellbeing as an employee of an institutionalized environment that innately seeks to colonize my identity. The pressure to conform to standard Euro-Canadian worldviews of the university matrix is immense and continuously aggressive. The threat of being tokenized is real and being a prop for Canadian universities to advance the current trend of indigenization is a reality for many of us who take jobs where we are hired as a decoration to fill a gender, ethnic, or racial gap (Newhouse).

In Canada, colonialism annexed our rights as mothers and stole our sovereignty as Indigenous women (Anderson, *Recognition of Being* 100-05; Simpson, "Birthing an Indigenous Resurgence" 27-30). Through the introduction of the 1876 Indian Act, the imposition of Christian and European cultural norms, the enforcement of the residential school system, and the stealing of Indigenous children during the Sixties Scoop, and now the foster care system, Indigenous women's traditional status as life givers has been attacked and eroded.

My grandmother, my mother, and I lost and regained our First Nations status in the late 1980s. Colonial policies and laws removed maternal sovereignty and replaced it with the devaluation of Indigenous womanhood and unequal gender relations (Sunseri). I carry an emotional and psychological scar because of this process of loss, recovery, and healing. Now, however, that incident inspires me to decolonize, reclaim, and proclaim jurisdiction over my maternal identity as Kwe and to feel empowered to speak out as Kwe.

As inspiration, I draw on Kim Anderson's (Cree/Métis) theory of identity formation based on the framework of a medicine wheel with four components: resist, reclaim, construct, and act. Anderson offers these words as teachings that can be used to bring about the decolonization of womanhood and resurgence of those feminine traditions and sociology that were so effective for the survival of our maternal ancestors. As she explains, together they offer a pathway for "resisting negative definitions by reclaiming Aboriginal traditions; constructing a positive identity by translating tradition into the contemporary context; and acting on that identity in a way that nourishes the overall well-being of our communities" (*Recognition of Being* 15). Reflecting on Anderson's model, I was led back to Kwe as a path for enacting Anishinaabe women's decolonization and resurgence.

To counter this legacy of the colonization of Kwe, Leanne Simpson calls on Anishinaabe women to embody Kwe "as method" (*As We Have Always Done* 33) to go about the aanwetamowin (refusal) of colonial authority, domination, and narratives grounded in heteropatriarchal normative definitions of womanhood and motherhood that label me as a mature mother. Instead, I insist on being Kwe and being a mother only within an Anishinaabe-kwe context.

I have spent years reading the maternal resistance literature from Indigenous women writers who discuss reclaiming the radical maternal wisdom of their ancestors as a framework for modelling revitalized contemporary Indigenous motherhood practices. Inspired by these strong Indigenous women, I have rooted my radical rebellion and maternal resurgence in Anishinaabe-kwewag Inendamowin (Anishinaabe women's worldview). I share Simpson's belief: "Our grandmothers tell us that the answers lie within our own cultures, ways of knowing and being, and in our languages. When I listen to them talk about pregnancy, childbirth, and mothering, I hear revolutionary teachings

with the potential to bring about radical changes in our families, communities, and nations" ("Birthing an Indigenous Resurgence" 26).

Sylvia Terzian describes this "maternal legacy" as "the site at which all things are interconnected" (147). As mothers, we model the behaviour we want for our children to mirror back, and thus our actions resonate to and through our children. Because our children are our future leaders, our values must be reflected in our parenting and our families. As Simpson points out, the Anishinaabeg value the first seven years of a child's life as important to who they become as adults; therefore, the way we mother becomes critical because our children will model how to live as Anishinaabe people by what they observe from our actions ("Birthing an Indigenous Resurgence"). Therefore, it is our responsibility to act or model for our children the ways we want the world to see, hear, and treat us as Kwe, as Anishinaabe, and as human beings.

Thus, I take up the Nookomis gikinoo'amaagoowinan (grandmother teachings) and the e-yaa'oyaanh (identity) of Kwe to embody the Anishinaabe woman I want to embody. Thus, I do not stop being Kwe or a mother when I walk in the doors of the university; instead, I try to embody the ideal of Kwe as taught by Giizhigoo-kwe because it is the source of my power, my sovereignty, my knowledge, and my living ceremony as Mzinegiizhigo-kwe. The transformation of my identity as Kwe came progressively and led to changes in how I work within the university. Based on the teachings of Anishinaabee Elder Shirley Ida Williams, Leanne Simpson offers the concept of "Chibimoodaywin," which Williams described as a "long, slow, painful crawl!" My transformation into a woman and then a mother who asserts her rights as Kwe has been a long, slow, and often painful path of experiences. Decolonization is our path to healing, but resurgence is our right as women and inheritors of Giizhigoo-kwe's gifts of recreation. As Simpson claims, "Resurgence is our original instruction" (*Dancing on Our Turtle's Back* 66).

## Pregnancy as Kwe

Over the years, I have heard from other Indigenous women academics who were advised to temper their plans for motherhood if they intended to have a career in the academy. In university settings, signs

of femininity are discouraged, and heteropatriarchal practices of masculinity are prioritized. In her doctoral dissertation, Dawn Memee Lavell-Harvard notes that "As the ultimate expression of femininity, pregnancy significantly complicates the maintenance of the non-female persona deemed necessary for achievement in the academy" (135). As Lavell-Harvard documents, participants in her study remarked that an Indigenous woman's pregnancy is not always celebrated within the academy but "seen as betrayal; pregnancy is a betrayal of your commitment to ... academics and a betrayal of the institution" (135). Many of her research participants reported feeling that pregnancy jeopardized their success in the academy. Lavell-Harvard, therefore, characterizes the atmosphere in the academy as a "prohibition against femininity in the academy, the ultimate signifiers of womanliness, pregnancy, and motherhood are perceived to be incompatible with achievement" (136). During my own experience as a university student, there was a female Indigenous student who shared with her professor and mentor that she was planning marriage and a family while simultaneously completing her degree. The professor vigorously advised her against rushing to get married and starting a family while trying to finish her degree, explaining that doing so would likely jeopardize her future career plans. I recalled feeling shocked and offended for the student, who had been so excited about this new stage of her life. I have never witnessed a male student taken aside and lectured on how marriage or fatherhood would hurt his future career. As a result, the message to Indigenous women in the workforce is that their femininity is not welcome, and that masculinity or performance of masculinity is favoured.

The pressure on Indigenous women to not have children only increases once they are hired because of the perception that being a mother ultimately disrupts the performance of masculinity and hence jeopardizes success. As Lavell-Harvard observes: "Motherhood is perceived to be incompatible with achievement. Moreover, the incompatibility of work and family is particularly acute for women with higher levels of education" (136). Syilx Okanagan scholar Jeannette Armstrong suggests that the context of motherhood and mothering practice conveys principles of traditional Indigenous feminine sovereignty, governance, and laws as radical resistance against the colonizing Euro-Canadian culture(s) within Canada. According to Leanne

Simpson, Indigenous women value their femininity, their feminine ways of living and knowing, as a source of strength that is "critical for an Indigenous resurgence" and "our liberation work" (30) that comes from surviving colonization. Radical resistance comes when traditional maternal knowledge and culture is prioritized, utilized, and passed on to the next generation. To this argument, Irene Payne adds that within the setting of a patriarchal institution, such as the academy, a woman's pregnancy can be a significant form of radical resistance because it is an affirmation of femininity (12). Working Indigenous women, pregnant, a mother, or mothering/parenting children, thwart the dominant mainstream culture by carrying their traditional teachings in their heart, but also living, advocating for, and practicing them in the workplace for all to witness.

I became pregnant while working as a university professor cross-appointed between an Indigenous studies program and department. I was the only Indigenous professor in both areas and was physically isolated with an office in a building off campus that I referred to as the "Rez." Becoming pregnant made me feel even more isolated. I was aware that some of my colleagues might harbour negative beliefs that pregnancy is a burden or weakness for a woman's career path, and I was subjected to some uncomfortable questions about my age through the course of my pregnancy. However, I chose to ignore that kind of mindset and to instead embed myself in the cultural teachings of both Kwe and Anishinaabe motherhood. I determined that I needed to lean on the traditions of my ancestors to give me strength, direction, and clarity about this journey I was about to embark upon. I did not want my views on motherhood colonized by mainstream hetero-patriarchal knowledge about femininity and motherhood.

As a first step in that journey, I contacted the Tsi non: we Ionna-keratstha, Ona:Grahstà, the Six Nations Birthing Centre, and its Indigenous midwives as a cultural support system for a healthy pregnancy and birth steeped in Indigenous cultural traditions. The support, cultural teachings, and sacred medicines provided by my two midwives gave me the strength to get through some difficult times in the workplace. During the early stages of my pregnancy, I faced an incident of sexism and racism in the workplace. Although I was an Indigenous studies professor, I was assigned a course on topics outside of my expertise or knowledge base to fulfill my contract obligations to

the other department in which I was appointed. One course topic was broken up into cohorts. Some of the cohorts were taught by another professor who happened to be an older white gentleman who was very familiar with the course material. Within several weeks of teaching the course, I quickly found my Indigenous identity and womanhood attacked by a cohort of students because I was female, culturally different than the other professor teaching the same course, and I used Indigenous-based pedagogical practices that were new to students in that department. This experience left me feeling the weight of racism and sexism. I also felt I had been sabotaged and set up to fail. But instead of being buried by feelings of failure, humiliation, and rejection, I turned to my culture to survive that tumultuous period in my career and the early stages of my pregnancy.

The Indigenous midwives at the Tsi Non:we Ionnakeratstha Ona:grahsta' (Six Nations Birthing Centre), located on the Six Nations of the Grand River Territory, led me through the process of keeping my spirit strong and my body healthy within Indigenous contexts. They used what Janice Accose describes as "maternal energies" (17) to stimulate my survival instincts and desire to thrive. In essence, these women fostered in me a process of resurgence in which I was transforming and situating myself in culture, traditions, relationality, family, and community. I moved away from the elements seeking to colonize my career and my identity to a place where I was aligned with Kwe as Giizhigoo-kwe, and Nookomis intended their descendants to live. Through the direction of the midwives, I felt as if I were coming home to my real sense of self.

In this, I recognized the sentiments of an Elder in a study conducted by Brant, who characterized the efforts of women to decolonize and reclaim their sovereignty as coming home. My midwives brought me home to my identity as a Kwe and mother. They fed my mind, body, and spirit so that I could resist the pressures of the workplace, reclaim my traditions, construct the space I needed for my pregnancy, and follow Anishinaabe-kwe mino-miikana bimaadiziwin. In this way, I was able to enact Anderson's model of womanhood. The midwives reminded me that my higher purpose was learning to be a mother as a Kwe.

At times, those midwives acted as counsellors, cultural advisors, and guides on how best to approach those challenges in the workplace using Indigenous methods. Through discussion and reflection, I heard

and internalized their challenge to look at my career path as only one part of my journey as Kwe and to acknowledge my responsibilities to my health and wellbeing, not just ambition or financial gain. They reminded me that my career and coworkers do not define my identity, which is instead grounded in my culture, my territory, my people, and my growing family. The midwives taught me to navigate away from the distractions in my workplace, which, like birthing labor, can be painful and challenging. Instead, they directed me to focus on my transformation and recreation from a woman into a mother. They also guided me to align myself with my new role as the centre of the wheel of life and my family.

The end of that academic year of challenges coincided with the end of my pregnancy. The conclusion of both led to the birth of my daughter and the rebirth of myself as a Kwe mother. Both births were painful, wonderous, and beautiful. I value the teachings of that period. I see my survival of that period as a ceremony of birth and rebirth. As Leanne Simpson points out, "Our Mothers have always known that our rebirth, like any birth, is a powerful but painful process - a pain that fades into the background as the birthing ceremony comes to an end. Bringing the old into the new is our way forward" (148-49).

## A Mother's Way Forwards

As the conclusion of my initiation into motherhood, I left that teaching position at the end of my maternity leave. By moving away physically, spiritually, emotionally, and psychologically, I followed the teachings of the ancestors and sought the path of wellbeing. After eventually healing from the birth and my time at that university, I took on other career opportunities at universities that were better aligned with my path as Kwe. The midwives were correct that as Indigenous women, we should never let other cultures colonize our paths of womanhood and motherhood, including our choices regarding pregnancy, birth, and motherhood.

During my second pregnancy, I taught a full course load and used that time to lose myself in being a gikinoowaabanda`iwewin (role model) for the young Indigenous women, 2SLGBTQ+, and men in my courses who looked to me as a reflection of themselves. Without really realizing it at the time, I was engaging with a new pedagogy based on a

maternal epistemology, which Sharron Abbey and Andrea O'Reilly describe as coming "to know, understand or claim a particular authority and knowledge based on experiences of mother" (330). I made it a priority to share with my students and colleagues the Indigenous pregnancy traditions and beliefs that I would be following throughout my pregnancy. I openly explained to my students that I was not a young mother but in my mid-thirties and that I had strategically chosen to wait to have my children so that I could provide a good home for them. Some of the women and men in my classes were also parents, and we bonded around our shared identities as Indigenous parents and the colonizing pressures of being in an educational institution. Those who were not parents openly asked questions about Indigenous motherhood, midwifery, and the cultural traditions I was following. I also lectured on the spiritual customs, ethics, philosophical beliefs, and cultural stories of Anishinaabe people regarding parenthood, and we discussed the colonization of Indigenous birth culture and the resurgence of traditional birthing practices. Sharing my knowledge and experiences was a healing and uplifting experience that allowed me to find strength despite the challenges I was facing in the workplace. The experience was also healing for my Indigenous students on their own paths of resurgence. They saw me modelling my path and found their strength to keep on their own paths.

Anishinaabe teachings tell us that the time of pregnancy is a powerful time for women and therefore has always been highly valued at a community level (Solomon; Tabobondung). In Anishinaabe culture, as Rebeka Tabobondung (Anishinaabe) notes, pregnant women are viewed as potent medicinal women. "As well as bringing the gift of new life to the community," according to Tabobondung, a "pregnant woman also brings political and spiritual insight that she might not otherwise be tuned into which can benefit her community" (5). She cites Anishinaabe Elder Minwaabnokwe Marie Anderson's recollection that "if there was a difficult decision coming on the reserve, they'd approach this young pregnant woman and they'd ask her for her advice" and that "the advice that comes out of her, really helped those people" (5).

I witnessed the medicinal power of pregnancy work among my students and fellow faculty and staff. Their moods tended to shift from negative states to positive states just by being around my pregnant belly.

People would talk to the pregnant baby belly, reminisce about their own pregnancies or children, or ask to touch the belly. I would also often see the nurturing and protective nature of other people come out when they saw that I was pregnant and needed help carrying books, opening a door, or finding a seat.

In contrast to mainstream Eurocentric views on pregnancy, my practice of Indigenous birth culture demonstrated my Anishinabek worldview to both students and colleagues. I felt my pregnancy could hold vital teachings not just for me as the pregnant woman, but also for my unborn child and the educational community. The education of those around me was a means not only to explain my actions, needs, and means for establishing a safe working environment but to liberate my pregnancy from the mainstream rhetoric around pregnancy that I encountered. By allowing my students and colleagues to witness and be a part of my journey, I created the holistic atmosphere and spatial dynamics I needed to get through nine months of pregnancy. I refused to let others shape my pregnancy outside the parameters of the cultural worldview and customs of being Kwe.

I explained this to my students and my coworkers both to prepare them for my change into a mother and to articulate for them what it means to work with an Anishinaabe-kwe. The transformation that came with my first pregnancy had initiated my desire for liberation, self-determination, and a reclamation of eroded maternal traditions. My pregnancies, my birthing practices, and my subsequent actions of mothering my children put the politics of Indigenous liberation into practice by challenging the past colonization of the women in my family and grounding my maternal process in the traditional legacy of Kwe.

During my pregnancy, my age did not become a factor for me or my midwives. Instead, my transforming into a mother was privileged over my age. My chronological maturity was not the focus of the journey because it is not a part of Anishinaabe worldview to emphasize it unless it affects the healthy progress of the pregnancy, which in my case it did not.

## Mothering as Kwe

The action of breastfeeding is critical to my identity as an Anishinaabe mother. After my second pregnancy and the birth of my second child, I began teaching part time in an Indigenous studies program at a university in Southern Ontario. At that time, I was breastfeeding my daughter regularly at my office, where I was seen by and interacted with students, faculty, and staff. For the Indigenous students, faculty, and staff, this was a common activity for an Indigenous mother. For the non-Indigenous students, faculty, and staff, it helped normalize breastfeeding and demonstrated the importance of Indigenous mothering culture and customs. Because I was not a young mother breastfeeding her child but a mature woman self-assuredly proud of her mothering practices, I believe this act of mothering educated the people I was working with about the complexity of age ranges for Indigenous mothers. When I breastfed my child at the workplace, I strategically set the narrative of my identity as simply a mother. I specifically shared my mothering process and made my work environment a space in which I asserted my sovereignty and traditional rights as an Indigenous woman.

Confronted with mainstream cultural expectations, I looked to my Anishinaabe culture and not my age to ground my sense of motherhood. The Anishinaabe language became one of my most important teachers in how to define myself in specific Anishinaabe-centred contexts. In Anishinaabemowin (the Anishinaabe language), there are a variety of terms for mother that are highly descriptive and intimate, reflecting the complex relationship a mother has with her children. The term "doodooman" is special to me because it translates to "breastfeeder," or more specifically to a woman or mother who breastfeeds her child. If we break down its etymology, the stem "doodooshim" translates to "breast" and "doodooshaaboow" is the root stem of "doodooshaaboo," which means "breastmilk." Therefore, doodooman is used by someone when they want to honour the woman and mother who fed them breastmilk and shared that gift of life. The term "doodooman" thus demonstrates that the Anishinaabe worldview privileges motherhood as a sacred act and offers no reference to or limitations on age.

Being recognized as a mother and not just an age by those in my workplace aided in my path towards the decolonization of the legacy of the women in my family who had their traditions stripped from them

due to 1876 Indian Act policies, which displaced them from their territory, their rights, and their connections to culture. Today, I can choose to displace Western concepts of a mature mother or late motherhood by instead articulating my views as Kwe. I am not a late mother; I am a doodooman. This is what Kwe resurgence looks like.

## Closing In a Good Way

Pondering how to conclude this chapter, I decided to close in the traditional manner of the *Gete*-Anishinaabe-kwewag (Anishinaabe women ancestors) and Nookomisag who have come before me. Apane Minowaadiziwin. Bimaadiziwin isa go miinawaa Noo-jitoon agoozowin. Baanimaa miinawaa odisaabandamang giga-waabandimin. Gchi-Miigwech. Always live a good life. Live the good life as a human being and pursue balance! The spirits will decide when we will meet each other again. If we do not see each other in this world, then we will see each other in the next. Thank you.

## Endnotes

1. For this chapter, I chose this particular spelling of Anishinaabe. I learned this specific grammar from my language teacher, Anishinaabe-kwe (Ojibwe/Odawa) Elder Shirley Ida Williams, Wikwemikong Unceded First Nation. See "Anishinaabe," *The Ojibwe People's Dictionary.* Anishinaabe translates to "a person, a human." Similarly, I chose the use of "Kwe" from the stem word "Ikwe." This spelling is also how I learned to spell Kwe from Williams, along with Anishinaabe-kwe (Ojibwe/Odawa) Elder Edna Manitowabi, Wikwemikong Unceded First Nation. See, "Ikwe." *The Ojibwe People's Dictionary.* Kwe refers to a "a woman, a lady."

## Works Cited

Abbey, Sharon, and Andrea O'Reilly. *Redefining Motherhood: Changing Identities and Patterns.* Second Story Press, 1998.

Accose, Janice. *Iskwewak Kah'Ki Yaw Ni Wahko-makanak: Neither Indian Princess Nor Easy Squaws.* Women's Press, 1995.

Alfred, Taiaiake Gerald. *Wasáse: Indigenous Pathways of Action and Freedom*. University of Toronto, 2009.

Anderson, Kim. "Giving Life to the People: An Indigenous Ideology of Motherhood." *Maternal Theory: Essential Readings*, edited by Andrea O'Reilly. Demeter Press, 2007, pp. 761-81.

Anderson, Kim. *Life Stages and Native Women: Memory, Teachings, and Story Medicine*. University of Manitoba Press, 2011.

Anderson, Kim. *A Recognition of Being: Reconstructing Native Womanhood*. Sumach Press, 2000.

Armstrong, Jeannette. "Invocation: The Real Power of Aboriginal Women." *Women of the First Nations: Power, Wisdom, and Strength*, edited by Christine Miller and Patricia Chuchryk, University of Manitoba Press, 1996, pp. ix-xii.

Bear, Shirley. "Equality Among Women." Spec. Issue of *Canadian Literature*, no. 124-125, Spring/Summer 1990, pp. 133-137.

Brant, Jennifer. "Rebirth and Renewal: Finding Empowerment through Indigenous Women's Literature." *Mothers of the Nations: Indigenous Mothering as Global Resistance, Reclaiming and Recovery*, edited by D. Memee Lavell-Harvard and Kim Anderson, Demeter Press, 2014, pp. 207-230.

Brant, Jennifer, and Kim Anderson. "In the Scholarly Way: Making Generations of Inroads to Empowered Indigenous Mothering." *What do Mothers Need? Motherhood Activists and Scholars Speak out on Maternal Empowerment for the 21st Century*, edited by Andrea O'Reilly, Demeter Press, 2012, pp. 201-16.

Couchie, Carol, and Herbert Nabigon. "A Path Towards Reclaiming Nishnawbe Birth Culture: Can the Midwifery Exemption Clause for Aboriginal Midwives Make a Difference." *The New Midwifery: Reflections on Renaissance and Regulation*, edited by Farah M. Shroff, Women's Press, 1997, pp. 41-50.

Delfino, Jessica. "I Had a Baby at 40, and It Was Awesome." *Huffington Post*, 26 Jan. 2018, www.huffingtonpost.com/entry/i-had-a-baby-at-40-and-it-was-awesome_us_5a551716e4b0efe47ebdb61d. Accessed 10 June 2022.

Hill, Amelia. "Worried about Being a Late Mum? Don't, Say the Experts." *The Observer*, 28 Oct. 2007, www.theguardian.com/

society/2007/oct/28/parenthood. Accessed 10 June 2022.

Horn-Miller, Kahente. "Distortion and Healing: Finding Balance and a 'Good Mind' through the Rearticulation of Sky Woman's Journey." *Living on the Land: Indigenous Women's Understanding of Place*, edited by Nathalie Kermoal and Isabel Altamirano-Jiménez, AU Press, 2016, pp. 19-38.

Horn-Miller, Kahente. *Sky Woman's Great Granddaughters: A Narrative Inquiry into Kanienkehaka Women's Identity.* Dissertation. Concordia University, 2009.

Johnston, Basil. *Ojibwe* Heritage. McClelland and Stewart, 1976.

Krajchir, Stacie. "Fortyhood: Why You're Too Old to Have a Baby After 40." *Huffington Post*, 18 Dec. 2013, www.huffingtonpost.com/stacie-krajchir/why-youre-too-old-to-have-a-baby-after -40_b_4339322.html. Accessed 10 June 2022.

Laronde, Sandra. *Sky Woman: Indigenous Women Who Have Shaped, Moved, or Inspired Us.* Theytus Books, 2005.

Lavell-Harvard, Dawn Memee. *The Power of Silence and the Price of Success: Academic Achievement as Transformational Resistance for Aboriginal Women.* Dissertation. Western University, 2011.

Lavell-Harvard, Dawn Memee, and Kim Anderson, editors. *Mothers of the Nations: Indigenous Mothering as Global Resistance, Reclaiming and Recovery.* Toronto Press, 2014.

Lavell-Harvard, Dawn Memee, and Jeannette Corbiere Lavell, editors. *"Until Our Hearts Are on the Ground": Aboriginal Mothering, Oppression, Resistance and Rebirth.* Demeter Press, 2006.

Maracle, Lee. *I Am Woman: A Native Perspective on Sociology and Feminism.* Press Gang, 1996.

Newhouse, David. "The Meaning of Indigenization in Our Universities." *CAUT Bulletin*, 2016, bulletin-archives.caut.ca/bulletin/articles/2016/06/the-meaning-of-indigenization-in-our-universities. Accessed 10 June 2022.

"On Being an Older Mum." *Older Mum*, 3 Mar. 2015, oldermum.co.uk/category/health-and-wellbeing/. Accessed 10 2022.

Oncofertility Consortium. "Mythbusters in Oncofertility: Geriatric Pregnancy." *Oncofertility Consortium*, 17 Aug. 2010, dev.oncofertility.northwestern.edu/comment/91. Accessed 10 June 2022.

Payne, Irene. "Working Class in a Grammar School." *Learning to Lose: Sexism and Education, Schooling and Women's Work*, edited by Dale Spender and Elizabeth Sarah, Women's Press, 1980, pp. 12-19.

Proverbs, Wendy. "Motherhood, Policies and Tea." In *Mothers of the Nations: Indigenous Mothering as Global Resistance, Reclaiming and Recovery*, edited by Dawn Memee Lavell-Harvard and Kim Anderson, Demeter Press, 2014, pp. 179-81.

Rhodes, Richard. *Eastern Ojibwa-Chippewa-Ottawa Dictionary.* Mouton de Gruyter, 1993.

Sellers, Stephanie. "The Power of Ancestral Stories on Mothers & Daughters." *Mothers of the Nations: Indigenous Mothering and Global Resistance, Reclaiming and Recovery*, edited by D. Memee Lavell-Harvard and Kim Anderson, Demeter Press, 2014, pp. 195-206.

Simpson, Leanne. "Birthing an Indigenous Resurgence: Decolonizing Our Pregnancy and Birthing Ceremonies." *"Until Our Hearts Are on the Ground": Aboriginal Mothering, Oppression, Resistance and Rebirth*, edited by Dawn Memee Lavell-Harvard and Jeannette Corbiere Lavell, Demeter Press, 2006, pp. 25-33.

Simpson, Leanne. *As We Have Always Done: Indigenous Freedom Through Radical Resistance.* University of Minnesota, 2017.

Simpson, Leanne. *Dancing on Our Turtle's Back: Stories of Nishnaabeg Re-Creation, Resurgence and a New Emergence.* ARP, 2011.

Solomon, Art. *Arthur Solomon: A Nishnawbe Spiritual Teacher, Songs for the People: Teachings on the Natural Way.* North Carolina Press, 1990.

Statistics Canada. "Fertility: Fewer Children, Older Moms." *Statistics Canada*, 3 Mar. 2017, www.statcan.gc.ca/pub/11-630-x/11-630-x2014002-eng.htm. Accessed 10 June 2022.

Sunseri, Lina. "Sky Woman Lives On: Contemporary Examples of Mothering the Nation." In *First Voices: An Aboriginal Women's Reader*, edited by Patricia Monture-Angus and Patricia McGuire. Inanna, 2009, pp. 54-62.

Tabobondung, Rebeka. "Wasauksing Women Sharing Strength." *InTensions*. 2012, www.yorku.ca/intent/issue6/articles/pdfs/rebekatabobondungarticle.pdf. Accessed 10 June 2022.

Tabobondung, Rebeka, et al. "Indigenous Midwifery as an Expression of Sovereignty." *Mothers of the Nations: Indigenous Mothering as Global*

*Resistance, Reclaiming and Recovery,* edited by Dawn Memee Lavell-Harvard and Kim Anderson, Demeter Press, 2014, pp. 72-73.

Terzian, Sylvia. "Surviving My Mother's Legacy: Patriarchy, Colonialism, and Domestic Violence in Lee Maracle's Daughters Are Forever." *Journal of the Motherhood Initiative for Research and Community Involvement,* vol. 10, no. 2, 2008, pp. 146-57.

The Ojibwe People's Dictionary. "Anishinaabe." *The Ojibwe People's Dictionary,* ojibwe.lib.umn.edu/main-entry/anishinaabe-na. Accessed 10 June 2022.

*The Ojibwe People's Dictionary.* "Ikwe." *The Ojibwe People's Dictionary,* ojibwe.lib.umn.edu/main-entry/ikwe-na. Accessed 10 June 2022.

Touleman, Laurent. "Who Are the Late Mothers?" *Revue d'épidémiologie et de santé publique,* vol. 53, no. 2, 2005, pp. 13-24.

Valentine, Randy. *Nishnaabemwin Reference Grammar.* University of Toronto Press, 2001.

Chapter 2

# Older, Professional Mothers: Identity and Disability

Gretchen A. Good, Anita Gibbs, and Awhina Hollis English

W e, the authors of these reflections on older mothering and disability, maintain highly demanding professional academic careers while, as nondisabled and disabled mothers, raising disabled and nondisabled children. Examining the intersection of motherhood, disability, age, academia, culture, advocacy, and activism, this chapter explores how mothers can manage to find and retain their own identity while lurching from crisis to crisis, moving from expert to novice, navigating entirely new bureaucratic systems, experiencing prolonged or permanent exhaustion, and coping with the extended dependence of their children. These are all central realities for women who parent children with complex needs and for mothers who are older and may themselves live with chronic illness or disability.

Despite the ample research on motherhood and personal and professional growth, the literature on the motherhood experiences of older mothers, adoptive mothers, and disabled mothers is scant, and the mainstream discourse regarding disability rarely includes motherhood. Yet what little research has been conducted on mothers of disabled children has found that the new roles and identity challenges they face are more demanding, more complex, and require more permanent and far-reaching lifestyle changes than those of women who mother nondisabled children (Good et al.; Runswick-Cole and Goodley). And whereas studies of delayed motherhood and identity (e.g., Shelton and Johnson) have noted that older mothers may be less resentful of constraints of motherhood and more financially secure,

professionally stable, and psychologically prepared to parent than younger mothers, Gail Landsman's study of raising disabled children found that it is often stigmatized and viewed by others as a "diminished motherhood" (13). Furthermore, a disabled child's future independence is not guaranteed, and thus active mothering can extend well into the child's adulthood and the mother's retirement. Even less understood are the experiences of mothers who themselves have physical impairments, who are largely invisible in research and policy simply because in our society, the general thought is that disabled women "are not expected to be mothers" (Grue and Lærum 673).

To help fill that gap, this chapter employs an autoethnographic method that draws on our lived experience as older mothers and as mothers with a disability and/or caring for children with special needs or disabilities. Autoethnography—which Anita Gibbs defines as "the ethnographic and critically reflexive study of the self, as well as others with whom the researcher might have a close personal or familial connection" (149)—offers us a way to reveal the everyday reality of the challenges we face caring and advocating for our children, to argue for change and remedy injustices, and to recognize the ways that our stories are situated within wider structural, political, and cultural contexts. After sharing our individual stories, we explore the shared advantages and disadvantages of being older mothers as we raise our disabled children and try to change the world in which they will live as adults.

## Anita: Mothering and Neurodisability

I became a mum for the first time at thirty-five years old, after having struggled with fertility issues and delaying parenting to ensure my job security as a social work lecturer in New Zealand. After enjoying our beautiful daughter and realizing we wanted to have more children, we decided to adopt two children from Russia. In 2007, when I was forty-two, we made the long journey to St. Petersburg and adopted two young boys, both of whom had a range of medical issues. They also had endless energy and enjoyed their toddlerhood in New Zealand immensely. Over time, the boys' neuroimpairments, notably their challenges with executive functioning and impulsiveness, presented difficulties at school and in relationships. In 2013, they were both diagnosed with

attention deficit hyperactivity disorder (ADHD) and fetal alcohol spectrum disorder (FASD). Up to this point, my work interests and teaching had involved social work and adoption and fostering, which were fuelled by my personal experiences but also by my training as a social worker. Beginning in 2013, I also developed significant expertise in the field of neurodisability, as I found I needed to keep up with the latest research and best practices in order to offer my children the best possible environment in which to flourish. My children needed more support and supervision than children of similar ages, and one of them was getting into trouble at school, mostly because his special needs were not being accommodated. In New Zealand, FASD is not funded fully as a disability, even though those who have FASD have considerable impairments as well as strengths, and I have needed to use my identity as an academic and social worker to advocate and argue for change for not just my boys but all children with FASD in New Zealand.

Discovering that my children have neurodisabilities has not made me love them any less. In fact, I probably love them more, as each day I battle to help others see that my boys have rights and entitlements like anyone else and that they have abilities that are both special or different and also the same as any other child. My identity as a mother and as an older mother has had to shift to accept and welcome the challenges that our family experiences. My parenting skills have had to become more diverse and much more flexible. Parenting children with disabilities has also made me a much better academic and social worker. I now teach in the area of neuro-disability, and my advocacy skills have increased, which benefits my employer as well as my family. Like my children, I have become tenacious and never give up. Our children always profoundly change us.

I have had to rethink my mothering and its relationship to my profession and the lived experience of neurodisability. I think being in the social work profession has been helpful in this process, as it has allowed me not only to use my parenting experiences to teach future social workers about best practices for working with families with disabilities but also to draw on my research and practice skills to support and advocate for my own family and other families dealing with stigma and oppression in services and systems that do not accommodate neurodisabilities. When I go to conferences now, I

describe myself as a Ninja FASD Mum, which to me sums up my roles as activist, academic, and mother. I also find that being an older mum has helped me stay calm and use my years of lived experience to appreciate that all people have a right to be who they are and to reach their fullest potential with or without support. Being older also allows me to use my seniority and status to lead by example as a role model for other parents of children with neurodisabilities. At work, being an older scholar, with over twenty years of research experience, has enabled me also to focus on more specific fields of research like neurodisability rather than generic disability research. With seniority comes additional freedoms to develop highly specialized research.

## Gretchen: Merging Personal and Professional Identities

When I married at age forty-five, I was already established in my academic career related to disability. I had identified as a disabled advocate, academic, and activist for decades. I have lived with blindness and vision impairment since the age of nineteen and also live with chronic health impairments. I had only forty-eight hours to adapt to the idea of motherhood with joyous rapidity when our son, who has Down syndrome, entered our lives through adoption. Motherhood was new, and I loved it. I was settled into my career, had seniority, owned a home, and had a husband who shouldered more than his share of household and childcare responsibilities, which made me well situated to expand my research and teaching to include my personal experience of disability and of mothering disabled children. After we adopted our daughter, who, like our son, also has Down syndrome, my personal and professional work moved into adoption of disabled children,, special education, and disability advocacy as I became embroiled in working to ensure that my children were included, educated, safe, healthy, and happy. I thus have the privilege of having my work life and my personal life overlap, and I am confident this benefits not just my family but my university and my community.

Despite having the advantages of career and economic stability, being older than most mums with young children means that I constantly lose sleep over what will happen to my children when I am gone. I worry about finances and about being slowed down by my own impairments. I have to work and plan so my children can have the life

we dream for them. Being older and disabled means I must constantly walk a delicate tightrope balancing all of our family's needs, energy, time, and money. When that carefully choreographed balance is tipped by a health crisis or a child's being sent home from school for behaviours or illness, we have to quickly rearrange our work, childcare, transportation, medical appointments, and activities. As a result, we live in a constant state of crisis or near crisis.

As a disabled person, I have had to be resourceful and creative about problem solving and advocacy. Now that I have disabled children, this has amped up a thousandfold. I am constantly planning, organizing, adapting, creating, nurturing, and managing crises. And I am good at it. This is fundamental to my character as a disabled person, and it has helped me as a mother and in my career.

Being an older mother also has implications, as does being an older professional woman. I am suddenly surrounded by men and women twenty years younger than me who are my colleagues, my superiors, and administrators. Although the institutional knowledge I have after working at my university for more than twenty-five years is not necessarily valued or recognized, continuing to stay abreast and deeply involved in disability issues in education and in society is the strength I offer my students and university.

I am a dedicated professional. But my first commitment must be to my family and each individual family member's well-being. Because of this and the limitations of my own impairments, I am efficient and produce competitively, although my family responsibilities mean that I am not as physically present on campus as I once was.

Late motherhood has also affected my sense of identity in the context of relationships. As a long-time single person, my relationships were deep and reciprocal and nurturing, mostly between me and other single women. When I married, most of the time I had available to invest in those deep friendships was gone. And since having children, many of those friendships have vanished, despite my desire and effort to retain them. My friendships now tend to revolve around children, and although some of those relationships with other parents are high-quality friendships, they tend to lack the same depth, knowledge, and understanding of one another as individual adults as my earlier friendships. I am not part of either the club of mothers who have been pregnant and given birth or the club of single professional women.

Instead, I am part of intimate groups of adoptive mums and mums of disabled children, although I am much older than many others who have children my age.

My experience as an older adoptive, disabled mother of disabled children was that I was really ready for the new identity of motherhood and had little sense of refracted identity or of loss about losing contact with hobbies and activities. This may be because my professional career has been so intertwined with my personal life, both of which relate to disability and advocacy. Yet the loss of some relationships and diminishing energy despite increased demands requires thoughtful planning and reprioritizing. As an experienced disabled person, I recognize that managing my own needs is an absolute necessity, and I have been able to do this while also prioritizing the needs of my husband and children, which is perhaps an advantage that many younger new mothers do not have. I have had to learn to take care of myself so that I have enough to give to others.

## Awhina: Reflections on Being an Older Māori Mother

I am one of six Māori social workers with a PhD, a qualification I had gained by the time I turned thirty. From Māori, academic, and social work perspectives, that is pretty young and quite unusual. I was sustained by the strength of activists, academics, and Māori social workers of the 1970s and 1980s, who drove me to research, publish, and teach about the experiences of Māori within the social services.

My real learning, however, has taken place over the past ten years as I became a mother and, more significantly, a mother to a child with complex special needs. This experience has had many layers. I had three children within the space of four years. My daughter, my second child, has very high and complex needs and requires help with everything, including things I had never imagined could be problematic, all of which she deals with on a daily basis. She has profound microcephaly (her head still measures forty-five centimetres at age five), spastic quadriplegic cerebral palsy, epilepsy, and uncontrolled infantile spasms; she has endured major surgeries to help with dislocated (undeveloped) hips, gastro issues, and constant vomiting as well as needing a gastro tube for feeding. She is nonverbal and nonambulatory. Along with learning about the world of special needs, I have also learned about the

disabling nature of the world.

One of the major things I have learned is to recognize the intersection of age, culture, and ability. Although I have always felt like a spring chicken, having my kids in my thirties quickly showed me that however old you are or how many qualifications you have, parenting can be tough. From a Māori perspective, age does not determine capability. Māori consider living with and relying on grandparents for support essential for passing on knowledge and support, and this interdependence and connectedness often bring positive outcomes for Māori children. Knowing this, when I contracted CMV (cytomegalovirus) during my pregnancy with my second child and was told she could be severely affected, I knew that the only way we would be able to cope with what life had to throw at us was by returning to our wider whānau group and being surrounded by our support systems. Being Māori, our strength comes from the group, and we would need all the strength we could muster for the years to come. My priorities shifted suddenly from being an academic to being a special needs mother and advocate.

The second major thing I learned was the importance of finding one's voice. Even as a social worker and academic, I found navigating disability services and support harrowing. Some services have to be fought for relentlessly (with benefits offices and needs assessment agencies) and others are suffocating (constant therapy sessions). Finding my own voice involved being able to see the difference between services we needed long term and must fight for (and finding that strength) and then being able to say no to other services that we found overwhelming. During my daughter's first year of life, for example, we had more than 160 doctor visits, hospital stays, and therapy sessions or meetings at home. Some weeks we had four or five different appointments, sometimes two or three a day. It took me a while to figure out which services were vital and which could wait. Age, family support, and knowledge of policies and health and social services enabled me to navigate challenges and prejudices and to develop strategies to cope, and I have no doubt these aspects have made me a more resilient mother and have resulted in better outcomes for our daughter.

The biggest lesson I had to learn, especially as a social worker who has always looked outwards and felt the need to be community focused, was that I needed to do what does not come naturally to me: to look

within myself and fill my own cup so that I can be strong enough to navigate the challenges ahead. Learning to say "no" has been one of the most important lessons of my life, and I am grateful to have realized this in my thirties so that I could become a master of self-care in my forties. As an older mother, I can see how I, my own mother, and others around me can easily sacrifice our own self-care in order to put others first. Therefore, my own challenge has been to identify what builds my resilience, self-worth, and identity in my own right, separate from my academic achievement, employment, and family. My age is an asset in this and gives me the clarity and experience to know how to fill my cup and when that cup is near empty.

## Discussion

The three of us are all mothers to disabled children, academics, advocates, and activists. Each of us was considered an older mother when our children came along. We are each married to men who carry their weight in terms of childcare and household management and in family decision making. Two of us are adoptive mums, and two of us also have nondisabled children; one identifies as disabled. Two of us are immigrants to New Zealand, and one is Maori. All three of us strongly identify with our professional selves but even more so as mothers and disability advocates for our children.

As all of us have discovered, mothering disabled children means that the isolation, chaos, and loss of time, freedom, and choice that many mothers experience can last much longer than when children develop more typically, and a mother's independence can grow along with the child's. As Elizabeth Laney et al. note, all women can lose themselves "for a time while incorporating their children into their identities and reforming their identities" (126). But when disability is involved, there may be no end in sight to the child's total dependence upon the mother and intense need for care and to the mother's separation from old identities, activities, relationships, and interests.

But we have also found that one of the most important moral duties of mothers of disabled children, according to Lisa Freltag, is to be the keeper of the child's identity. For our nonverbal, intellectually impaired, or adopted children, the stories we help create are their life narrative. And perhaps this need to preserve our children's stories

and identities for them overshadows our own need to hold on to our own personal identities. This duty comes along with all of the other mothering duties and can add to the pressure to prove our competence as a mother, which may be further heightened for disabled, adoptive, and older moms.

Despite our commonalities, our differences, and our privileges, we all live with the discrimination we face as women in a male-dominated academic world. We each also face the daunting and isolating task of advocating for our children in an ableist world, in which the educational, medical, legal, and social systems are biased against our children and other disabled people. Because we face discrimination as older mothers, mothers of disabled children, and adoptive mothers, our motherhood requires ongoing legitimization and (as Leslie Baxter et al. note about adoptive mothers) forces us to bear the ongoing communicative burden of constructing our legitimacy and fighting stigma.

As older mothers, we also manage exhaustion, health concerns, and long-established habits that need to change as we concentrate on parenting, and not all of us have our own parents around to help with the children. Yet we have more life experience and financial security, more stable careers and relationships, and a great appreciation for being a parent. As mothers of disabled children, we have found an amazing cohort of like-minded mothers and comrades who understand our battles and are there to support one another and value each other's hard-won lessons in advocacy and activism. We live in an age in which social media allows us instant contact with others who share our joys and sorrows and support us on our journeys.

Under more typical circumstances, as older professional mothers, we might be concentrating on reestablishing our careers after our children have gained some independence or on battling glass ceilings placed in our workplaces by the patriarchy. We might be planning and looking forwards to our retirement and cultivating new and old hobbies and pastimes. We might be following a script in which we encourage our children's journey into higher education, celebrate becoming mothers of brides and grooms, and relish the role of grandparenthood.

But our lives are more than fully occupied with our tasks at hand. Raising our disabled children is time consuming, relentless, tiring, but also rewarding. Our worries about their future, as well as our concerns about our ability to continue meeting our responsibilities or finding

alternative support for our children, surpass the typical life course for women as they age.

We have learned that despite being warned not to lose ourselves to motherhood, we must construct our identities in relation to where we exert our time, energy, love, and our brain power—into caring for, nurturing, educating, and advocating for our children. Our professional identities have also been reshaped by what we have learned from being mothers and raising disabled children as older mothers. We do this in good company. The joys of sharing this fulfilling yet also often difficult role of older mothers of disabled children cannot be minimized. The support we have found among other mothers should not be undervalued. The encouragement, shared experience, valuable expertise, and 24/7 social media presence of this kind of support continues to help us along our journey.

## Conclusion

At the life stage at which most mothers enter a phase of introspection and reduced mothering responsibilities (Shu et al. 55), mothers of disabled children continue the work of mothering as their predominant life role. We therefore recommend further research to identify how older professional mothers of disabled children can avoid isolation, maintain a sense of self and healthy relationships, and be supported as they develop new self-identities as they continue to actively parent their disabled children. We also encourage researchers and policymakers to explore how employment policies can support or interfere with older parents' parenting practices, particularly those involving children with disabilities. For example, do workplaces welcome children and disabled children, allow for extra health- and disability-related appointments, or incorporate the lived experiences of older parents into workplace cultures?

Our experiences as older mothers with disabled children have enriched and challenged our professional and academic identities as well as led to new and unique personal identities that have enabled us to deal with losses of freedom and choice and work in partnership with others to maximize our contribution to society, our employers, and our families.

## Works Cited

Baxter, Leslie, et al. "Narrating Adoption: Resisting Adoption as 'Second Best' in Online Stories of Domestic Adoption Told by Adoptive Parents." *Journal of Family Communication,* vol. 14, no. 3, 2014, pp. 253-69.

Gibbs, Anita. "Ethical Issues When Undertaking Autoethnographic Research with Adoptive Families." *The SAGE Handbook of Qualitative Research Ethics,* edited by Martin Tolich and Ron Iphofen, Sage, 2018, pp. 148-60.

Freltag, Lisa. *Extreme Caregiving: The Moral Work of Raising Children with Special Needs.* Oxford, 2017.

Good, Gretchen, et al. "Social-Model Mothers: Disability, Advocacy and Activism." *Counterfutures,* vol. 4, 2017, pp. 107-35.

Grue, Lars, and Kristin Tafjord Lærum. "Doing Motherhood: Some Experiences of Mothers with Physical Disabilities." *Disability & Society,* vol. 17, no. 6, 2002, pp. 671-83.

Laney, Elizabeth, et al. "Becoming a Mother: The Influence of Motherhood on Women's Identity Development." *Identity,* vol. 15, no. 2, 2015, pp. 126-145.

Laney, Elizabeth, et al. "Expanding the Self: Motherhood and Identity Development in Faculty Women." *Journal of Family Issues,* vol. 35, no. 9, 2014, pp. 1227-51.

Landsman, Gail. *Reconstructing Motherhood and Disability in the Age of "Perfect" Babies.* Routledge, 2009.

Runswick-Cole, Katherine, and Dan Goodley. "The 'Disability Commons': Rethinking Mothering Through Disability." *The Palgrave Handbook of Disabled Children's Childhood Studies,* edited by Katherine Runswick-Cole, et al., Palgrave Macmillan, 2018, pp. 231-46.

Shu, Bih-Ching, et al. "Process of Self-Identity Transformation in Women with Autistic Adolescents." *Journal of Nursing Research,* vol. 14, no. 1, 2006, pp. 55-63.

Ware, Felicity, et al. "Mana Mātua: Being Young Māori Parents." *MAI Journal,* vol. 7, no. 1, 2018, pp. 18-30.

Chapter 3

# Flying Solo in the Age of Neoliberalism: A Narrative on Migration, Security, and Social Reproduction

Olga Sanmiguel-Valderrama

As a younger woman, I never imagined that I would have my first and only child at the age of forty-six, but many dynamics in the times and context in which I lived led me to become a solo mother by choice at that age. Like other women of my generation, I have experienced my diverse roles and identities within a context of neoliberalism, which has, among other effects, promoted new levels of individualism, intensified labour's output, and marketized aspects of human relations (see, e.g., Gill and Bakker). Within my current field of academia, neoliberalism has similarly meant "an intensely controlled, standardized, entrepreneurial, and arguably neoliberal masculine working context" (Huopalainen and Satama 100). This corporate model has demanded ever more increased outputs or productivity and the performance of endless tasks from professors—including increasing administrative loads, competing for research funds in a context of financial austerity, accelerating outputs in the form of publications, and serving students as customers (Berg and Seeber). Simultaneously, technology and the marketplace are increasingly mediating interactions between individuals, including aspects as intimate as biological reproduction and the paid-care industries in which individuals perform as consumers, clients, or providers of paid services. Intersectional

hierarchies and identities—such as nationality and citizenship status, race and ethnicity, gender, sexual orientation, socioeconomic status, religion, and age—mediate those processes and interactions between individuals and institutions. In my own life, these forces operated in such a way that it was not until I was forty-five years old that I finally settled in a place and had enough sense of economic security that I decided to become a mother and experienced the joy of holding my own baby in my arms.

In this chapter, I use feminist autoethnographic methodologies to present my own professional and mothering journey as well as insights gathered from my ethnographic research findings on the lives of Colombian flower workers as mothers. This chapter reveals the many intersectional identities that affect mothering, the timing of women's use of their own fertility, and the degree of hardship or easiness resulting from having to assume simultaneously demanding roles in a broad neoliberal sociopolitical context, which further marginalizes mothering work and other unpaid carework. Current work-family-conflict scholarly literature argues that socially constructed gender roles related to the practices of the ideal worker and intensive mothering as well as a lack of society's policies to support unpaid carework are the main reasons contemporary working mothers find themselves overworked and with poor work-life balance, as their multiple roles compete for their energy, time, and focus (Williams; Drago). I argue in this chapter, however, that those obstacles identified by the literature are not the only ones. Rather, new levels of individualism together with the above-mentioned intersecting identities affect how mothers experience their work-life balance. The conflicting demands and expectations between the domains of mothering, other unpaid carework (e.g. caring for sick and special needs relatives as well as aging parents), domestic work, community work, and the workplace are without doubt a major part of the challenge to achieve a balanced life, but once we consider intersecting identities and hierarchies compounded with new levels of individualism, a more complex picture is revealed. Racism, xenophobia, citizenship status, ageism, gender-based discrimination, family status (partnering/solo mothering), lack of accessibility to networks with relatives and community members ("the village" required to raise a well-adjusted kid), and geographic location are aspects of our lives that can create further barriers to mothering and achieving a balanced life.

Once those differences among mothers are taken into account, the experiences of mothering can differ widely. Those hierarchies and circumstances affect the degree of easiness or hardship experienced by mothers during the daily process of mothering, caregiving, and the myriad of other roles and identity processes that they perform as workers or as community members (e.g., in spaces such as schools, unions, environmental groups, "ethnic" community groups, immigrant rights groups, political groups, neighborhoods, amongst others).

## Migration and Settlement: Leaving behind War and Rebuilding a New Life

Like my parents, I grew up under civil war conditions in Colombia, where during my twenties my lawyering work became a threat to my life. In 1992, with the support of my parents, I managed to get an airplane ticket and a visitor's visa to Canada, where I ultimately applied for refugee status. Largely as a result of this dislocation, major milestone events in my life, including mothering, have taken place at least fifteen years later than they do for most people. As a refugee-immigrant who moved from a Spanish-speaking country to an English-speaking one with a different culture and set of social relations (including racism and a form of patriarchy different from the machismo practices from my homeland), I had to learn a new language in my late twenties. I had to adapt to a new cultural space with often unspoken social norms that still today are not always clear to me. I also had to change my profession in my late twenties from a middle-class lawyer who could practice in Colombia to someone without any credentials or even the language to do more than manual labour until I was able to acquire a whole new set of academic degrees that took about a decade to complete. I arrived without a social or professional network or any close friends or family in North America. I also left behind a partner with whom I had become pregnant four months before arriving in Canada. (He was not granted a visa.) I had a miscarriage about a month after arrival. Although, as with most miscarriages, I will never know why this one happened, I attribute it to my high levels of stress before and after the trip and my poor diet and lack of medical care due to my precarious financial situation after arriving in Toronto with less than five hundred dollars in my pocket. Losing that child would feel like one

more way in which I was losing my link to my past life and all those I had left behind.

Despite those losses, I will never forget my intense feeling of relief once the airplane took off and headed to Toronto. I was fleeing a country that had suffered more than sixty years of protracted war during which diverse regular and irregular armed groups had perpetuated all forms of abhorrent violence on vulnerable populations. When I moved in 1992, neither email nor cell phones were available, and letters took months to arrive; whether I wanted to or not, staying close to those left behind was much harder than it is nowadays. I had to start alone again in a new world.

During the close to fourteen years that I lived in Canada, I moved over thirty times, mostly at the beginning of my journey there. That is the level of instability I experienced as a refugee-immigrant. About a week after I arrived, I started working ten-hour shifts as a day worker. I was paid seventy dollars a day in cash while working in the manufacturing industry—work that was arranged through the underground market of temporary work agencies. Some months later, I started working in the morning for a Jewish solo-Mom as a nanny in exchange for board and meals, which gave me time to study English as a second language at the library repeating sentences from a tape recorder and taking free ESL classes for new immigrants. Three years later, thanks to earning a full scholarship and a recommendation of a Canadian law professor who had been my adviser during my undergraduate degree in Colombia, I successfully enrolled in a master's in laws (LLM) program in human rights at the University of Ottawa and a couple of years later in a PhD program in law at Osgoode Hall Law School at York University in Toronto. My aim during my graduate studies was to understand the war in the land I left behind and specifically the structural causes that had made me a refugee. With the generosity of many kind Canadians and my parents and sisters cheering me on from Colombia, I rebuilt my career and made friends, with whom I still keep in contact.

Family, however, is irreplaceable, and like most immigrants and refugees, I was and still am lonely. Whereas I was able to make friends in an instant in Colombia, doing so in Canada and the United States (US) takes me considerable time, energy, and dedication. I sacrificed most of my social life in order to achieve material stability, which in turn also made the possibility of finding a partner largely vanish. In

part, this was the result of the demands of graduate work; writing a thesis and dissertation as well as teaching and grading students' work in a second language absorbed the totality of my focus, energy, and time.

Nonetheless, my biological clock began to tick loudly in my late thirties when I was a graduate student. Part of my desire to become a mother flowed from what I was learning about the lives of the Colombian flower workers and Colombian community mothers who were the subjects of my research (Sanmiguel-Valderrama). These women managed somehow, albeit in precarity, to combine mothering and working long hours for low wages. Despite living under the poverty line, with precarious health insurance under insecure and risky working conditions in an export-led agribusiness, most of them were the sole head of their household and immigrants from rural areas to small towns around a major city. Like me, many were alone in their struggle to survive and make a living to create a family and sense of stability. Their lives reflected the insecurity borne by labour under neoliberal globalization, and by racialized women in particular, because of the neoliberal ideologies and restructuring policies implemented by their government in agreement with global financial institutions in a country devastated by war, social dislocation, and foreign debt (Sanmiguel-Valderrama). Although their lives were not easy, they inadvertently taught me not to wait for my dream life to happen and especially not to make that life dependent on the caprice of a partner or a steady job before deciding to reproduce.

Comparatively, my own life in Canada was privileged. As a documented immigrant (after a process of four years I was officially granted refugee status in 1996 and later received landed immigrant status and citizenship), I had good health insurance from the Canadian government and unionized labour rights, even as an isolated doctoral student and teaching assistant living on less than one thousand dollars a month. I was building a future in my thirties with prospects of becoming more economically secure as a scholar in my forties. I especially felt more physically secure. I was not living any longer in a dirty war in which powerful national and transnational economic interests were imposed by military means upon Colombia's biodiversity and its people.

Before I hit my mid-thirties and began my doctoral research,

thoughts of having children had been relegated to a distant future—a future in which I was settled, hopefully with a loving, reliable partner, and had my own steady income. My liberal feminist mother had always advised me: "Have children only if you can feed them with your own income, not that of your husband. Career first, and the rest will follow." Like many Latina feminists of her generation and some of the Colombian flower workers I interviewed, she believed that the relative powerlessness of married women was due to their lack of economic independence and lack of participation in the paid labour force, not due to having kids and mothering. She and the Colombian flower workers I interviewed taught me that having kids was a woman's right if she so chooses but that a woman should not place her fate and that of her children in the hands of a patriarch who may or not be benevolent. For her, economic independence was the key to women's autonomy. My mother and I focused on examples around us of subjugated or abused women and custody battles where children became the instruments of vengeful ex-partners. I had convinced myself that unless I could find and love a truly magnanimous and generous man whom (like my father) I could trust, I would go solo. I now know that having a paid job does not guarantee women's autonomy, although it helps. Security and autonomy, as intersectional feminists and my own research on the flower industry have pointed out, depend on many other factors within the racist, patriarchal, and capitalist economic global system in which we live, including among others, class status, geographic location, race, and citizenship.

My mom had given birth to me in her forties, so it was not difficult for me to imagine having a child after my thirty-ninth birthday when I first tried, unsuccessfully, to get pregnant by means of artificial insemination. After all, if my mom had done it, so could I. I was healthy and fit. My mom, however, did not suffer the stigma of having the label "geriatric-late" pregnancy on her. So, I grew up unaware of the stereotypes or even difficulties of pregnancy in one's forties, which are so common in North America. Labelling pregnancies "late" can leave women feeling insecure, weak, vulnerable, and disempowered, even though they do have power over their reproductive capacities and bodies and are able to conceive and manage mothering.

During my early years in Canada, I did have a few relationships with male partners, but I could not find one I could truly love who also

wished to work on an equal relationship of mutual affirmation and love. After all, under their gaze, I was the embodiment of the untrustworthy "other"—the stranger who was poor, not of the right language, race, and nationality, without a family or connections, and at the time without my Canadian citizenship. All the socially constructed "isms" of discrimination and power relations—such as age, beauty standards, sexual orientation, gender identity, class, race, ability, nationality, citizenship and immigration status, and political affiliations—influence our choice of a permanent partner, whether consciously or not, and can be deal breakers in the game of romantic love and reproduction. Questioning the traditional compulsory coupling that our era has inherited, I decided to go solo. Despite all the talk about feminisms in Canada, none of my female friends were willing to take the risk of having children on their own, and my feminist dream of replacing a patriarchal marriage with a group of good feminist friends who also were moms and would collectively support one another while mothering and working never materialized. I was solo in many ways, although I still had the love of my parents and sisters, even from afar.

## Steady Income and the Possibilities of Mothering

When I decided to go solo, I felt proud to be a woman. It was clear to me that women's reproductive capacities are powerful, as I understood procreation as a female capacity to create multigenerational family units and communities. I see women's reproductive capacities as women's power. To be clear, it is not the only source of power but a key one. It is our bodies that create a being after two cells blend. Historically, it has been women who have performed the bulk of the unpaid social reproductive labour that creates and maintains generations, whereas nonmothering individuals take a privileged position in the labour market, politics, and within the home. To me, mothering is a form of power that had been traditionally dominated and controlled under patriarchal racist capitalism. I decided that I could create my family as a Latinx immigrant—a family that had been out of my grasp for decades—even if I was going solo.

Once I graduated in 2004, I found a steady job and income when my current employer offered me a sought-after tenure-track position in academia. Its price? Leaving my second motherland, Canada, and

moving permanently to the US. I did not want to join the ranks of so many other immigrants with PhDs who never find a steady academic job or are hired at the margins in the lowest racks of academia as permanent teaching assistants or contingent faculty. In academia, as in other sectors of the economy, under neoliberalism, secure positions have become rare; in the US, according to the American Association of University Professors (AAUP), close to 75 per cent of college faculty are now off the tenure track and work in temporary adjunct positions with low pay, little security, and low rates of unionization. Since I did not want to leave Canada, I also decided to apply for tenure-track jobs back in Canada, which led to five campus interviews but no job. Feeling I could no longer wait to have a baby, I became pregnant with the sperm of an anonymous donor at the age of forty-five, the second year after I was hired in my steady, unionized job in the US. On my second try, I became pregnant using my own eggs. I am grateful that at the age of forty-five that I had no biological problem getting pregnant and was able to deliver a perfectly healthy and smart girl nine months later.

## Pregnancy and Discrimination: The Ivory Tower Does Not Understand Mothering, Not Even Theoretically

When I was three months pregnant, I started bleeding the day before I had planned to interview for a job in Ottawa, Canada, and my doctor advised me to abstain from travelling because I risked a miscarriage. I emailed the head of the hiring committee, explained my condition, and asked for the day-long interview to be rescheduled. I never heard back from him. Since he did not answer, I guessed he and the committee members were alarmed. How could I possibly have inconvenienced their search process with a complication of my pregnancy?

It sounds ridiculous that I was surprised: Most pregnant women do not get hired, no matter the level of education or the location of the workplace. Why was I expecting that in the ivory tower, it would have been different? Or that such a fundamental aspect of community survival and maintenance would not have to be hidden in the ivory tower and treated as personal? That occasion marked the first moment in which the deep-seated patriarchal structures of society, including those in the workplace, directly collided with my mothering and career aspirations. Of course, the conflict between my reality and my desire to

be a mother was not really new, as my attempt to become a mother in my late twenties had failed, and my process of biological and social reproduction was delayed for decades due to the war in my country of origin and the dislocation, displacement, resettlement, sexism, racism, and xenophobia that I encountered while reestablishing myself in a new land.

A second major collision happened when I informed my boss that I was pregnant, and she responded, "Congratulations, but you will never make it to tenure now." I could not believe what I was hearing, but those words and feelings are engraved in my heart. I am not sure if she meant that it was going to be too difficult or that my workplace was going to be sure that I did not make it, but in any event, it seemed totally inappropriate to say such a thing. As I commonly do in moments of shock, I was unable to articulate my feelings in a reply, so I remained silent and mentioned this episode to only a few people. But I feared that I would never achieve job stability, and I still feel a mixture of sadness, anger, and distrust when I recall it. I did receive support from some colleagues, mostly from graduate students who were themselves mothers and from some individual faculty members in and outside the women's studies department where I worked.

My life had appeared to be moving towards what most North American liberal feminisms portray as the obstacle that hinders the possibilities of career success for women: mothering. There I was, as an immigrant Latinx, defiantly mothering and, on top of that, doing so as a sole parent without a "village" to support the endeavour. My experience revealed to me what scholar Andrea O'Reilly has referred to as "the disappearance of motherhood in twenty-first-century academic feminism" (192). In *Matricentric Feminism*, she argues that most academic feminisms have defined "woman" and "mother" as separate identities and have failed to embrace the specific needs and concerns of mothers. Even while other aspects of women's identities, such as ethnicity and sexual orientation, have gained recognition in the theoretical discourses of academic feminisms, mothering remains invisible.

A culture hostile to mothering lies underneath academia's unspoken social rules of professionalism. Rarely do you see a child in the halls of academia. Like most mothers in the US, faculty and student mothers are forced to pump breastmilk in bathrooms, including those that are

gender neutral. Mothering is sidelined in academia, pushed into the private realm, and alienated from the world of work. An undeclared but expected workplace norm of total and complete dedication to the job is the rule in academia, and there are no nine-to-five shifts. No matter how long work-related tasks take, we must complete the endless list of endeavours that a good professor ought to perform. The ivory tower follows the same patriarchal capitalist framework of private corporations, government agencies, and international institutions (including the International Labour Organization) that view mothering and other forms of unpaid care work for relatives or community members as private and personal, which frames the unpaid work and responsibilities associated with biological and social reproduction as a matter of individual choice. Since it is a choice, which presumably means that it could have been avoided, the intense unpaid work involved with parenting is seen as solely the individual's responsibility—a view that we all know is not gender neutral, especially if a woman chooses to go through it on her own, whatever her race, sexual orientation, gender identity, class, ability, or nationality. Mainstream feminism's theoretical failure to centre mothering as part of women's identities is naïve at best, and in practice, it is complicit with the neoliberal patriarchal capitalist ethos by dehumanizing those who perform mothering roles based on the ideologies of the private sphere, choice, and gender roles. Ignoring the mothering identity of many women devalues women's powerful reproductive capacities and undermines its incredible influence in communities. As a result, these theoretical frameworks serve ideologies that subject mothers to nearly impossible conditions.

## Publish or Perish: Lack of Paid Maternity Leave and Immigration Status

After finished teaching in spring 2007, I yearned to go back home to Colombia for the remaining part of my pregnancy and to give birth in a town amid the green, cool Andean Colombian mountains. Lacking support and feeling lonely and scared, I missed my parents and sisters, had cravings for the food of my homeland, and wanted to avoid the crushing heat of a Cincinnati summer. But doing so seemed impossible, as it would not have been easy to come back with my child, who would not have a US passport or citizenship. The process of sponsoring my

newborn girl to come to the US would have been long and possibly an impossible task, given I had only a temporary work visa in the US. My loving father did come to help me the last month before I gave birth in Cincinnati, even though, as I would learn later, he was terminally ill. My mother and oldest sister refused to come because they did not want to leave their businesses behind and my other sister could not come either because she was terminally ill after battling cancer for years.

As Abby Epstein's 2008 documentary *The Business of Being Born* powerfully demonstrates, in the US, pregnancy and birthing are treated as a medical emergency rather than a natural process that women's bodies have been capable of managing on their own since time immemorial. As a result of this medicalized model, birthing become one of the most traumatic events of my life. My labour was induced, which ended up in an unplanned compulsory caesarean due to my doctors' refusal to wait for my body to start labouring, even though my body was just fine and neither I nor my baby was showing any signs of distress. At the time, the "geriatric mother" label and my loneliness weighed heavily on my shoulders, making me feel disempowered, insecure, and unable to effectively resist medical procedures and the caesarean deemed necessary by the so-called experts. Thinking back, the moments of bliss during my pregnancy were outweighed by many ridiculous and unnecessary medical interventions, such as, during doctor's visits, technicians woke up my fetus with a loud noise against my belly to make sure she was alive. I now think I could have given birth vaginally if I had only trusted my body. On top of that, my body had an allergic reaction to a solution used during the surgery, resulting in a painful inflammation that took more than a year to resolve. But I did not have the luxury of feeling sorry for myself in what felt like a physical assault to my baby and my body. I felt I had no choice but to tough it out by burying the traumatic aspects of my labouring in the back of my mind in order to be able to care for my vulnerable baby who needed me completely. Every year though, just before my child's birthday, the traumatic feelings come back, and I grieve.

At the time I had my child, my university offered no paid parental leave (although AAUP, our union, has since successfully negotiated parental leave as part of our collective contract). So as not to trouble students by having a new professor take over my courses when my child was born in the middle of the fall quarter, I was granted a paid

nonteaching leave for fall 2007. I requested and was granted a research leave term for the winter of 2008 and an unpaid leave for spring quarter of 2008. If I had remained in Canada, I would have received a full year of paid parental leave, but mothers in the US (with the exception of California) are legally assured of only up to twelve weeks of unpaid maternal leave. When I moved to the US, however, I never imagined such a retrograde policy could exist in a country that claims to be the greatest in the world. Like many academic mothers in the US, I was forced to use my work-related leaves (e.g., sabbaticals, research, and teaching leaves) to catch up on the personal matters of being a mother and a human more generally. As a result, I had to spend the months after I had my baby undergoing the mental load and stress of revising my book manuscript, continuing my ongoing ethnographic research around Bogotá, applying for funding for research, writing papers for conference presentations and syllabi to teach in fall 2008, and other associated work. Of course, I could not perform all of those tasks at the same speed and level as I had earlier, given all the life-altering experiences that I was handling. These included the joyful first-year bonding experience of mothering (oxytocin hit me hard, and I completely fell in love with my daughter), which kept me going while also painfully seeing my beloved sister and father die.

As part of my hiring contract, my university processed my residency status in the US—a multiyear process that it placed on hold when I went to Colombia five weeks after giving birth (which involved packing my apartment and leaving everything in storage and having to drive to Chicago a week or so after my caesarean surgery to get my child's first US passport). We were a sad bunch, my father, then eighty-six, in a wheelchair carrying my cat, and me still oversized and in pain due to my inflammation and recent surgery, pushing a baby in a stroller in a trip that lasted close to twenty-four hours. My hurry to go back to Bogotá to resume my research was also intensified because my beloved sister was dying of cancer. Both my dad and sister, the people I loved the most and was closest to in the world, died during the first year of my child's life—my sister three months after I arrived and my dad in the middle of the fall term of 2008, when I had returned to teaching and was in the process of being evaluated for reappointment to my position. The worst fear of every immigrant became true for me: I was not able to be there when my beloved father passed away. I could not

even go to the funeral.

Although my immigration status stabilized after I came back to teach in August 2008, and I eventually received residency and citizenship status in the US, other instances of dissonance between my multiple roles and identities followed. For one, in my first review for reappointment that year, the departmental committee recommended that I be reevaluated every year rather than the typical tenure-track review every two or three years, which added unnecessary stress to my life. Contrary to the reality of how mothering has indeed contributed to a better understanding of the different concepts of my expertise in transnational antiracist feminisms, I believe some committee members were concerned that my performance and output were going to suffer because of my solo-parenting status, even though I had published in one year two peer-reviewed articles in prestigious international academic journals (one of them was reprinted later in Spanish). I also published an additional commissioned short article in an edited volume, had positive evaluations for teaching, and was fulfilling all of my service responsibilities. I ceased to look for other jobs in Canada after having my child, in part due to the fact that it coincided with the 2008 global economic recession.

A second dissonance between my multiple roles and identities was around the usual expectation that professors regularly present their research in national and, even better, international professional forums. I used to enjoy those events immensely, which are also perfect places for networking and keeping in touch with new research and career paths. With a child, however, going to those events became a nightmare, as few conferences offer childcare, and as a solo parent, I was not able to leave a young child behind for days. Taking a child with you to conferences is not only disruptive and boring for the kid but also expensive, as travel costs for the child and childcare are the responsibility of the parent—a burden that those who have partners and other close adults nearby do not need to incur. Despite all these difficulties, I was successful in gaining tenure seven years after I was hired, although the experience was so stressful that I was not able to even think about pursuing promotion to full professorship until recently.

## A Member of the Sandwich Generation

Among the disadvantages of having children later in life is that it is more likely that you will have to simultaneously juggle caring for aging parents and young children and that those children will miss the experience of having an active grandparent in their lives. About five years after my father died, my once strong mother started to develop erratic behaviour associated with her age, including mismanaging her finances and her household and collecting dogs from the streets. In my fifties, I thus became a member of the sandwich generation and am still solely responsible emotionally and financially for my now ninety-eight-year-old mother. It is heartbreaking that my mom is alone in Colombia but bringing her to live with me seems like a daunting option, in part because she would not have health insurance and would not be able to communicate with anyone in Spanish except for my child and me. The process of sponsoring her would take years, and I do not think she would be able to tolerate the extreme weather. So, I travel back and forth between our two homes in the summer and during December breaks to take care of her. I manage her business from afar, including booking her medical appointments and acquiring her medicine. She lives in a senior home now, and I have inherited two of her unsocialized dogs, and even though they make our lives richer, they are a lot of work and costly, particularly when I need to leave them behind while I travel. Mothering later in life means juggling this role while still mothering a school-aged child and maintaining a full-time job.

## Unequal Pay, Race Wage Gap, and Concluding Thoughts

In *The Price of Motherhood: Why the Most Important Job in the World is Still the Least Valued*, Ann Crittenden distils the many costs of mothering that the racist, patriarchal, and capitalist system systematically places on those engaged in mothering compared to those who do not mother or provide any kind of carework. Despite the legal norms of equal pay, those disadvantages include financial ones. Together, my status as a mother and a Latinx in the US has contributed to earning tens of thousands of dollars less a year than the average academic in my college and other faculty in my department. Like other Latinx women in the

US, I am part of a group that on average is paid just fifty-four cents for every dollar paid to white men in similar positions. I not only live check to check, but my lower income will also affect my retirement income, especially given that my late entry into the field means I have fewer years to accumulate retirement benefits and that I was forced to stop saving money for retirement first to pay for childcare before my daughter started public school and then again to assume responsibility for my mother's care.

Nor are those the only disadvantages I face as an older than the average mother. Frequently, people at the playground, school, doctor's office, and (more ominously) immigration office wonder if I am the grandmother of my child. The high levels of stress have aged me rapidly, and my health has deteriorated due to lack of good sleep and time and energy for self-care and exercise. I do not have time to cook healthy meals and often end up buying meals from restaurants. I have been exhausted to the point that I could not make the right financial decisions and feel that problems have sometimes overwhelmed me on every front. I still do not socialize much.

Despite all of the above, I cherish my child and mothering with all my heart. In fact, leaving my baby behind in a daycare facility was one of the most painful moments in my life, so much so that I felt physically sick for days. I wish I could have had a second child, but I do not think I could have kept my job if I had. I also do not regret my choice to be a solo woman, as I do not think I could have assumed another role as wife with so many other responsibilities already on my shoulders. I do not blame my choice to become a mother for my stressful situation, but rather the patriarchal capitalist system, structural racism, and ageism that have made it so unnecessarily hard.

## Afterword

After submitting this chapter to press, during the COVID-19 pandemic, my beloved mother, Emma Valderrama de Sanmiguel passed away on May 22, 2021, at the age of ninety-nine. My kid and I flew back to Bogotá in a rush, and I was able to say goodbye hours before she passed away. We were able to organize and attend her funeral. I will always be grateful for her unconditional love, care, and teachings. May she rest in peace.

## Endnotes

1. I must clarify that I had many romantic relationships through my twenties and thirties. In fact, I cancelled two engagements to marry, one in Colombia in the late 1980s and one in Canada in the late 1990s with kind-hearted men because I was afraid of losing my autonomy, intellectual growth, and career goals.

2. These include but are not limited to teaching excellence, publishing (the more the better), serving on committees or in leadership positions at diverse levels of administrative units, crafting research projects and applying for funding (external is better), and presenting conference papers and lectures—the last of which usually implies travelling and leaving one's ordinary duties behind, finding the cheapest travel means possible, booking hotels and transportation, and, if you have a child, hiring a stranger in the visiting city to perform childcare while you present. It also means conducting your fieldwork research (often including supervising students), writing books, editing books, developing curriculum for programs and new courses, serving in professional associations, peer-reviewing manuscripts for publishers for free, replying to endless numbers of emails, and for minoritized ethnic women, representing one's people on numerous committees.

## Works Cited

American Association of University Professors. *Data Snapshot: Contingent Faculty in US Higher Ed: AAUP's Data Show Weakening Protections for Academic Freedom.* AAUP, 2018, www.aaup.org/news/data-snapshot-contingent-faculty-us-higher-ed. Accessed 11 June 2022.

Bakker, Isabella, and Stephen Gill, editors. *Power, Production and Social Reproduction: Human In/security in the Global Political Economy.* Palgrave Macmillan Limited, 2003.

Berg, Maggie, and Barbara Karolina Seeber. *The Slow Professor: Challenging The Culture of Speed in The Academy.* University of Toronto, 2016.

Bezanson, Kate, and Meg Luxton, editors. *Social Reproduction: Feminist Political Economy Challenges Neo-Liberalism.* McGill-Queen's, 2006.

Crittenden, Ann. *The Price of Motherhood: Why the Most Important Job in the World Is Still the Least Valued.* Metropolitan Books, 2001.

Evans, Elrena, and Caroline Grant, editors. *Mama, PhD: Women Write about Motherhood and Academic Life.* Rutgers, 2008.

Huopalainen, Astrid S., and Suvi T. Satama. "Mothers and Researchers in the Making: Negotiating 'New' Motherhood within the 'New' Academia." *Human Relations,* vol. 72, no. 1, 2018, pp. 98-121.

Jukelevics, Nicette "Cesarean Section and Birth Trauma." *VBAC,* www.vbac.com/cesarean-section-and-birth-trauma/#.XyyexBl7k o8. Accessed 11 June 2021.

O'Reilly, Andrea. *Matricentric Feminism: Theory, Activism, and Practice.* Demeter Press, 2016.

Sanmiguel-Valderrama, Olga. "Community Mothers and Flower Workers in Colombia: Transnationalization of Social Reproduction and Production for the Global Market." *Journal of the Motherhood Initiative for Research and Community Involvement,* vol. 2, no. 2, 2011, pp. 146-60.

Sanmiguel-Valderrama, Olga. "The Feminization and Racialization of Labor in the Colombian Fresh-cut Flower Industry." *Journal of Developing Societies,* vol. 23, nos. 1-2, 2007, pp. 71-88.

Chapter 4

# You Can't Do Fieldwork with a Baby

Laura Beckwith

I am the mother of a one-year-old. I am also a PhD student, wife, sister, daughter, Canadian, and many other things. But for the past two years, from the minute I found out I was pregnant, a new identity, mother, has become paramount in my self-conception. This is partly because of its novelty and my need to feel it out, play with the idea, and see how to make it my own and partly because it has shaped every decision I have made since—from where I live to what food I put in my mouth. But I do not resent this new identity; in fact, I enjoy it. I became a mother in my mid-thirties, at a stage in my life where I felt confident in who I was. I had long ago left behind the upheaval of my early twenties, when I felt as though I was making one life-changing decision after another. But a decade and a half later, integrating a new element into what I perceived to be a fully formed identity was not a straightforward endeavour.

This new layer to my identity has been added at an unusual time in my life. My son was born two months before I started the fieldwork component of my PhD in Phnom Penh, Cambodia. Rather than defer my research, I decided to try to juggle both simultaneously and learn to be a parent and a researcher at the same time. Good fieldwork requires researchers to be self-reflective, to take time to consider how their identity, beliefs, and experiences—their positionality—affects the way they see the world. Many factors influence the positionality of a researcher—their gender, nationality, language, political views, and religious beliefs, among other things—but positionality is not fixed and is also shaped by

relationships (Neely and Nguse). To fulfil my academic duty, therefore, I would have to be critically aware of myself and the various elements of my identity that both shape my perspective and influence how I am perceived. Knowing this was one thing, but figuring out how this new identity as a mother may have changed me was another challenge entirely.

I was thirty-five when I got pregnant, and thirty-six when my son was born. I had been living independently since leaving home for university at age twenty and moving across continents multiple times, including five years in East Africa, where I had established my career as an international development practitioner. I am independent and ambitious, and my identity as a successful professional felt firmly established. I had few role models for how to combine working and having a family, which may be part of the reason I struggled so long with the decision of whether to have children. Despite the familiar narrative that more women are waiting until later in life to have children because they are pursuing a career, life is not often that simple. Women are making decisions about having children not in isolation but as part of families, communities, and workplaces, all of which have different pressures—some in favour, some against, and some ambiguous. In my case, having children was not my decision alone, and it was one that had to be worked through with the weight of two people's individual and shared histories. On my side, I felt I had room in my life for a baby, but I also feared how it would impact my professional life and did not have a clear vision for how the two would fit together.

Despite this major question remaining unresolved, I decided to go ahead with plans to pursue a PhD at the University of Ottawa in Canada. Although I was living far from my partner, who remained in Kenya, the pressure I felt to decide whether parenthood was in our future became more intense. Being back in a university environment surrounded by much younger people made me feel my age even more acutely. Because I was older, I felt a need to move quickly through my degree in order to minimize the time I spent away from my partner and my career. It was difficult to manage these personal priorities within an academic system that expects students to be unencumbered by domestic or professional responsibilities (an assumption based on but that may also be untrue for young people). Yet that difficulty also helped me focus on what I considered most important in life, and that included

having a family.

For the research component of my degree, I was planning to move to Phnom Penh to conduct ethnographic fieldwork involving long interviews in low-income communities. That stage therefore did not feel like the ideal time to have a baby. Yet as I found myself creeping into my mid-thirties as I prepared for my fieldwork, I began to panic that time was running out. That panic may have been unjustified, but a lifetime of hearing how women's fertility plummets after the age of thirty-five seeps into your psyche no matter how much you try to resist it. Deciding to become a parent required my partner and me to lay bare all of our fears about our own inadequacies as well as the state of the world in which we would raise our child. It required a confidence and optimism that I did not always feel and an ability to live with uncertainty. Having spent years establishing myself personally and professionally, it required accepting that my life would change in ways that I could not anticipate. I had to let go of the life I had in the hope that we were embarking on something even better.

Making the leap of faith that we would find a way to balance being parents and development practitioners, we all of a sudden were both all in on our plan to have a baby and move to Cambodia at the same time. I managed a quick trip to Phnom Penh while six months pregnant to lay the groundwork for my research before returning to Canada for the birth. It was at this stage that the negative comments about my plans started to become harder to ignore. People I barely knew felt the need to question my choice to start fieldwork while my son was still an infant. Other parents told me I had no idea what I was getting into, that it was impossible to plan or be organized with a baby, and that I would have no time to devote to my research. More than one person told me that I would not want to go back to work once I had a baby. Regarding taking an infant to Southeast Asia, I received mixed reactions. While those close to me were supportive, I encountered reactions ranging from condescension to horror from both Canadians and Cambodians. On more than one occasion, I was told flat out, "You can't do fieldwork with a baby." To my knowledge, my male partner was never told anything remotely similar.

I had no way of knowing whether or not this unwelcome advice would be true. Invariably, these comments came from people who did not know me or my partner well, but that did not make them easier to

dismiss. The infantilizing was infuriating, as it would be for most grown women choosing to have a child, but particularly given my age and extensive experience. I was not uninformed about what it would be like to live overseas. But it was also true that I had no experience being a parent. We were about to become three, and we did not yet know our baby, who would be bringing his own personality and temperament to the mix. And I had no idea who I would be once I was his mother. Maybe I would, in fact, decide I did not want to finish my research, but after working for more than a decade to establish myself professionally, that did not seem likely. I would like to say that the negative commentary about my ability to manage my professional aspirations with motherhood made me feel defiant, but it did not. It made me feel outraged, but it also shook my confidence. My age was no protection against this unwanted advice.

My son was born on a Friday. My water had broken the day before, hours before my labour started. I had walked home from an appointment with my midwife, shuffling along at a snail's pace, despondent at the thought that the agony in my hips could go on for weeks. I was still two weeks away from my due date and knew that first pregnancies often went overdue. As I was stocking up on provisions at the grocery store that afternoon, my water broke in the checkout line. I shoved my credit card into my partner's hands and ran out of the store to compose myself and survey the damage. My skirt was dry, but my shoes were soaked. I was shaking as I waited for my partner, more from the fear of having appeared to have wet myself in public than from thoughts about the labour ahead. My partner appeared, laden with groceries we would now not have time to cook, and we walked the rest of the way home, my shoes squelching with every step.

Despite the comedic beginning, labour was blessedly uneventful. My son was born at a birth centre, and we were home within four hours of the delivery. Physically, I had come through it well. The problems of late pregnancy—the heartburn, pelvic pain, and inability to get comfortable—disappeared, but in its place my mind was stuffed with racing thoughts. I could not sleep. I was exhausted, but even when I had time to sleep, I just lay awake, replaying the birth over and over in my mind. It had been a beautiful experience but a dramatic upheaval, and my mind was processing it like a trauma, examining it from every angle to try and establish a coherent narrative. During my waking

hours, however, I had little time to dwell on my birthing experience or any other aspect of my new identity. In addition to a new baby to take care of, I had to get ready to leave the country in two months.

I had insomnia for weeks; the need to put on a brave face and appear in control in front of other people was too strong. After having lived independently for almost two decades, asking for help from anyone other than my partner felt awkward. Even though I had told myself repeatedly before the birth that asking for help was the right thing to do, I could not do it. My identity as a self-sufficient, fully autonomous adult was too deeply engrained to comfortably merge with the confusion and chaos of early motherhood. Perhaps it would have been a more natural transition in my twenties, when my life was already characterized by confusion. But it also was not easy to ask for the particular kind of help I needed. What I really wanted was for time to just slow down so that I could work through how my life had changed and how I felt about it. The practicalities we had covered—thanks in no small part to our years of experience with complicated logistics in the development sector.

The newborn phase was not what I had imagined. I had pictured quiet days at home, lounging in bed and staring dreamily at our beautiful new arrival like an Anne Geddes photoshoot. Instead, my partner went back to work after a week, and I had doctor appointments and other new baby bureaucracy and making sure that the grandparents got enough time with their new grandson before we whisked him off to Asia, all of which gave us precious little time together as a new family. The help I needed was not about making meals or cleaning the house (although I appreciated that, of course!) but about finding time to process my new identity as a parent, which seemed an impossibility with so many logistical matters needing immediate attention. But I was hopeful that once we arrived in Cambodia, and it was just the three of us, I would manage to find my feet.

We arrived in Phnom Penh when my son was just ten weeks old, and so my fieldwork was also my maternity leave. My plan was to work at a relaxed pace and fit in some interviews around nap time and playdates. The reality was that my entire life revolved around breastfeeding. I could not work for more than a few hours at a time without pumping or feeding, so my workdays were necessarily short. The early days were difficult, with their endless rocking and feeding and diaper

changes with nothing more than an occasional smile to show for it. Despite what sometimes felt like drudgery, I could not have gone back to work full time—not because I felt bad about leaving my son, but because I wanted to experience firsthand as much as possible of my child's incremental development. I loved seeing how he learned and changed from week to week, and I loved being at the centre of it. It was not mother's guilt that kept me at home but fear of missing out.

I can say without a doubt, however, that I was able to be more present as a parent when I took time out to reconnect with my professional self. Because I was already mid-career, the elements of my identity connected to my work were too important to who I was to be relinquished entirely. I started interviewing in earnest when my son was four months old. After I got over the anxiety of being away from my baby (which took a few weeks, if I am being honest), when I was out in the field my attention was fully consumed with my interviews, even though I could only go for a few hours at a time. When I returned home, I felt mentally refreshed, satisfied with my accomplishments but also with a bubble of excitement in my stomach, much like the early days of falling in love, knowing that my little one was waiting at home. This is where I must acknowledge the gift of having a supportive partner and the great privilege of being able to afford to pay for childcare. While doing fieldwork with a baby had its complications, living in a country where childcare is not unduly expensive made it possible.

Even so, motherhood did have a serious impact on the logistics of my fieldwork. One thing the early days of parenting taught me was that I was not the fearless advocate for breastfeeding that I wanted to be. The advocate part was no problem—despite our early difficulties, I was committed to my decision to breastfeed—but I was far from fearless. I felt inhibited about breastfeeding in public and even a bit shy about talking about it in a professional context. I hated admitting to my young male research assistant that I could not stay late to do more interviews because my breasts were engorged with milk or that I could not work an eight-hour day because there was nowhere for me to pump. A couple of times I brought my pump with me to the field but could not bring myself to actually use it. I was furious with myself for this embarrassment. I am supposed to be a feminist! How could I be uncomfortable talking about feeding my child? But I was. In part, this was because it

felt like a weakness. If I said I could not do something because I was breastfeeding, it felt as if I would be admitting that my critics were right—that I could not do fieldwork with a baby.

Beyond the logistical complications, I was also reluctant to bring up my need to adjust the research plan to my breastfeeding schedule because I was still ill at ease in my identity as a mother. I felt like an imposter, not someone who was justified in claiming the rights of a real mother. I had spent more than fifteen years of my adult life pursuing my career in international development and cultivating my independence—that was who I was. In my mind, motherhood should have been accompanied by a great shift in that identity, but I just felt like the same person, more or less, but now responsible for a small human. It was not that I thought I was failing as a mother but just that at this stage in my life, I thought my identity had already been fully formed. I had found my place as a daughter, sister, friend, partner, and professional. "Mother" was not a label I had ever worn before, and it was not easy to see how it fit in with how I thought of myself. I wanted to be a mother who would advocate for the rights and opportunities necessary for women to balance work and caregiving, but I was going to have to work to become that person.

These struggles with my identity were not tangential to my role as a researcher but an integral part of my fieldwork. If you believe, as I do, that knowledge produced through research is subjective and created through the interaction of the researcher and the research subject, then self-reflection is a critical part of the research process (Kobayashi; Haraway). As I reached the point in my fieldwork where I began reviewing my findings and reflecting on what I had learned, I started to consider how my positionality had changed since becoming a mother. I had anticipated that this would happen, of course, but it had been difficult to predict in what way. Although many elements of my positionality that could be easily perceived remained unchanged—my age, gender, ethnicity, and socioeconomic status—I expected motherhood to be a shared experience through which I could build relationships that might alter the way people responded to me. In the field, I was surprised to find that motherhood was a largely invisible part of my identity. I had no reason to mention it during most of my interviews, and no one ever asked. When I would speak to Cambodian mothers at home while they cared for their children, I wanted to tell them that I,

too, had a little boy at home, but this attempt to establish common ground just felt forced and feigned, as their experiences of motherhood seemed so different from my own.

Although I never spoke about my son in my interviews, being a mother was a new lens through which to see my fieldwork. It caused a subtle adjustment in the way I see the world, even if my respondents did not see me any differently than they might have a year before. I listened to the stories of women and the lengths to which they had gone to support their families with fresh intensity. I heard from many who had left their children behind in the countryside in the care of grandparents or sisters so that they could travel to the city to work and others who had brought them along, raising them in conditions of hardship that put my own worries about work-life balance to shame. One woman I met had lived for three years with her two children in a boat barely bigger than my kitchen table, working as a farm labourer. These stories were awe-inspiring, and it felt disingenuous to try to establish a connection on simply the basis of being a mother. Instead of building common ground, motherhood brought home the reality of my own privilege.

Doing fieldwork while young and single during my early career, I could kid myself that my nationality and socioeconomic status did not create distance between myself and my interviewees; I had lived simply, with few possessions, no money in the bank, and was often in debt. Now, having established myself personally and professionally, my privilege was undeniable. Because I have the means to work part time and hire someone to help with childcare and other domestic responsibilities, I can, in fact, easily do fieldwork with a baby. Instead of bringing me closer to my respondents, becoming a mother has made me acutely aware of the distance created by the turn of fate that made me a middle-class Canadian, with all of the advantages that status will bring for my child. Having a child later in life was a complicated transition in terms of identity, but in my case, it had given me financial resources to have choices: a luxury that is not accessible to many women.

There was not one moment of realization that allowed my identity as a mother to finally fall into place. Gradually, by simply playing that role day after day, I became that new person. I got to know my son and understand his needs—how to make him smile or help him sleep. But

the small spaces that fieldwork opened up for me to be a professional, which expanded as my child grew and the biological necessities of my role diminished, also allowed me to grow as both a mother and a researcher. Being continually reflective of my positionality helped me connect what I was learning through my research with whom I was becoming as a parent. This process was essential to letting go of the fixed ideas I had about my identity and accepting that life brings transformations at all ages.

A year ago, I was awaiting the arrival of my son with trepidation. Fearful of giving birth and of moving to Cambodia with an infant, I had internalized the negative reactions to my plans, making me doubt my ability to be a mother and a researcher. But a year on, I can see that fundamentally, I am still me. I now share my life with a little person who needs me, both physically and emotionally, in a way that is mind boggling and that has added a new layer to my identity but has not erased the rest. Who I am has been shaped through years of experiences and relationships, and becoming a mother has been a similar process of learning day after day. As I continue to age, I expect to continue to change as yet new layers are added to my identity. For me, mother is only the most recent of these.

## Works Cited

Haraway, Donna. *Simians, Cyborgs, and Women: The Reinvention of Nature.* Routledge, 1991.

Kobayashi, Audrey. "Coloring the Field: Gender, 'Race,' and the Politics of Fieldwork." *Professional Geographer*, vol. 46, no. 1, 1994, pp. 73-80.

Chapter 5

# The Line That Separates Us

Simal Ozen Irmak

Here, I am writing on identity. By "identity," I am referring to the external perception of it. During my time as a stay-at-home mom (SAHM), I discovered that too often identity is what is reflected on us as our externally perceived image and not necessarily aligned with what we feel, desire, or desperately try to transmit. It is a tag that shows where we belong and, more importantly, where we do not. Regardless of whether we agree or not, we end up internalizing it. That is why and how we—collectively as a society and particularly as fellow women—identify SAHMs needs to change, since our current perceptions alienate and isolate SAHMs and do not serve any of us any good.

To be honest, the fact that I am writing about identity feels absurd because I developed a strong dislike of that concept after I became a SAHM. Although now my so-called identity has changed, my dislike of the concept and why we use it remains. I would rather not have anything to do with identity. But not writing about it feels worse. When I saw the call for this book, something inside urged me to write this piece. I had to share my experience as a former SAHM and reflect on how our society and culture contribute to the deidentification, alienation, and isolation of SAHMs. Unfortunately, academics and scientists, and particularly female scholars, often play an integral part in how poorly SAHMs are viewed and treated. Intentionally or unintentionally, many among us are complicit in contributing to the devaluation of women who work at home providing care to their children.

## Crossing the Line

Before I got pregnant, I would probably have identified myself as a neuroscientist, researcher, academic, daughter, partner, friend, and yogi. I say probably because I do not think I ever wondered or was in a situation where I had to think twice about how I should identify myself. It did not carry that much weight: I was what I was, and that was enough. And I did not even think my identity would disappear by quitting work to take care of my baby for a year or two.

Now I realize that was such a privileged, luxurious feeling. You may call it self-esteem, but except for basic needs, nothing really is purely "self" or internally driven. We are social animals. Even the most resistant of us are prone to internalize how we are perceived; that is our nature.

Being a SAHM for a couple of years was a decision I had thought out, desired, and made months before my baby was born. I was thirty-five. I needed a break from years of accumulated stress from being an academic researcher (a long PhD and a long postdoc). I was burnt out. My commute was three hours long; my pay would barely cover full-time childcare expenses. We were waitlisted in all the daycares we had applied to with no near-time opening at sight. We had initial support from our family who came from Turkey to help us, but after they returned back to Turkey, we did not have any support. But more importantly, I really wanted to provide full-time care for my daughter for some time. I had had a complicated pregnancy and had been in constant fear of losing our baby, and all I wanted to do was to spend time with her. When I returned to work after twelve weeks (six weeks of maternity leave and six weeks of disability leave) to finish up some projects before I left, I did not feel any remorse for quitting my job. I was literally counting days until my exit. When the day came, I was nervous and a bit scared to be unemployed, but I was incredibly relieved. The only guilt I felt at the time was over how fortunate we were (thanks to my partner who worked at a tech company in Silicon Valley) to be able to afford this decision.

So the decision to become a SAHM until our daughter started daycare was heartfelt and deliberate. I had approached it the same way as I did with my prior decisions. That was why I was so shocked by how most of my colleagues and friends reacted to my decision. It was almost as if I forgot to ask for permission, which would clearly not be given. It

took me quite some time to realize where the disconnect was. I was wrong to think I had the liberty to decide on being a SAHM. Most of my colleagues, friends, acquaintances, family members, and even strangers had a different take on that decision. Apparently, that decision was not mine to make. The society had not cared when I was deciding on a postdoc between Stanford or Berkeley; then the society had assured me that as a strong female, I knew what was best for myself. But it cared dearly about an educated woman's going rogue and deciding to take a break from her highly stressful career to provide full-time care for her child. The society had been fine when I was paid fifty thousand dollars with ten years of research experience and a PhD but was suddenly indignant when I decided to stay at home. The society was more than fine when I was instructed to express milk in a basement storage room without sink or refrigerator. The society was great and supportive when other women were stepping up to take care of my child for me but would not accept that I dared to take care of my baby myself. I would soon learn the price I would pay for this rogue decision. I was soon to be ripped of all of my identities. I was about to become bare, faceless, weightless, and dimensionless. SAHM would take all the space in the box carved for me.

I did not see this coming. When I willingly and wholeheartedly opted for the job of being the full-time caregiver of my baby and adding that title to all my other identifiers, I did not imagine that this job would wipe away my other identities. I did not know that SAHM was an identifier that was mutually exclusive of all other identifiers. But I would be reminded of that in almost all interactions with professional members of the society, and the more it was pushed on me, the more it became my reality.

Looking back, that this was coming should have been obvious. Never before had I announced I was taking a new job and gotten so few congratulations and silent nods accompanied with hints of disapproval. Many colleagues were not interested in hearing more. This appeared to be a conversation that most people did not want to participate in, except for the few who posed one awkward question: "So, you will stay at home to take care of the baby?" I remember being taken back by the strong emphasis placed on the "stay at home" part. I thought, "Well, yeah, I will take care of the baby; wherever she is... at home mostly, I guess." But most of the response I received from fellow female collea-

gues and acquaintances was silence. A deafening silence full of—
something heavy, something stale, and something full of shame and
disappointment. Somehow, I had walked all over the feminist mani-
festo. I had betrayed my own kind. I could hear the silent words of my
fellow colleagues so loudly: "How could you do that? With a PhD?"
That was why there was nothing else to be discussed. It was over. I had
crossed the line. Now, I belonged to the other side.

## The Other Side

Quickly after I became a SAHM, I started to hate the gateway question
to identity: "What do you do?" As long as my answer included "I am
taking care of my baby," there was no point in conversing. From the
quickly offered "how nice" followed by odd silence, it was clear that
people did not hear anything after the "taking care of baby" part. I was
a SAHM, and it required no further conversation. I did not have any
problem with being identified as a SAHM. The problem was not only
that the majority of the people did not allow for anything else in that
identity box, and they treated the box as empty.

Imagine you are meeting some people who ask you who you are, and
you say you are a researcher. They are then likely to ask you what type
of research you do, what question you are trying to answer, etc. This
small talk holds the potential to grow into a fun, engaging conversation
and perhaps even a friendship. But next time, especially if you are in a
rush to get rid of someone, instead try starting your sentence with
something about being a stay-at-home parent. You will soon notice that
if you are a woman, this is quite an effective conversation killer. In fact,
I have not yet come across another one liner as powerful at mysteriously
sucking the energy and curiosity from other people as this one. And I
do not think this is about the raising kids part. If you tell people you are
a babysitter or childcare worker, you will see that it is a societally
accepted job, an accepted professional identity that leaves room for
other identities. It does not kill the conversation but instead creates
traction for further interaction—unless, of course, you let it slip that
the kid you babysit is your own. These day-to-day, small interactions
were like paper cuts, tiny but sharp, chipping away at who I was. The
main blows to my identity, though, came from a more familiar territory.

In my fourth month of SAHMing, I attended a prestigious, new-age

healthcare conference at my institute of many years. Wearing my professional conference attire and high heels, I was feeling pretty confident and looking forward to the whole experience. I did not yet feel out of the workforce, nor was I yet aware of what SAHM means in the scientific community's eyes. I was ecstatic to be there, trying to digest all the inspiring talks and discussions, until I started to talk with a fellow female academic on the food line. When she asked what I was doing, I told her: "I am a neuroscientist and researcher, and right now I am not working, and I am taking care of my baby." Apparently thinking she had misunderstood me, she inquired further if I was employed and on leave. When I explained to her that I had quit my job, the next thing I heard was a visceral "Oh my God, This is so horrible!" Assuming she thought I had been fired and my boss was to blame, I tried to soothe her: "No, no, it was not my boss; he is awesome; he is the best boss and mentor I've ever had. It was my planned decision." But she kept insisting: "No, no. This is so horrible. I am so sorry for you." I was stunned. Not sure if I was understanding her correctly, I asked her why she felt sorry for me, to which she answered, "It is so sad to be unemployed and at home with the baby." I did not know what to say, and she did not offer anything else. We silently made our eventual way to the serving table and then went our separate ways. Take that, confidence! Conversation with other scientists during lunch was not much different either. They were utterly stunned that I was participating in that conference. They kept asking "why?" My answer did not make any sense to them. They did not believe that I was there because I was a scientist and interested in the topics discussed. Apparently, since I was a SAHM, I could not be a scientist anymore. Was I accompanying my husband? Had I registered much earlier when I worked and could not get a refund?

Later that day, as I was pumping breastmilk in my car, their words echoed in my ears. I suddenly realized how my decision to leave my job to raise my child was perceived by most members of the scientific society I had felt I belonged to before: It was a weird, wrong, undesirable, and horrible decision. I was an outcast now. I no longer belonged to the scientific community. Science and conferences were for people with institutional affiliations. I was apparently some anomaly, something that could put horror and shock in fellow academics' eyes and words.

I often felt an outcast even among friends. I noticed I was talking less in gatherings. At first, I thought this was caused by my depression, but I soon started to notice that I was also being given less of a social platform to operate on, even with people I considered close friends. Somehow, I was mysteriously being skipped when the "so what's new with you?" question was circulating among a group of friends. It is not that they were not interested in my life; instead, it seemed to be an error of omission probably made out of politeness, perhaps to avoid embarrassing me, since they assumed nothing newsworthy might be happening in my SAHM world. Sure, I could always cut to the chase and announce what was happening with me, as I did when I had the energy, but that did not protect me from ingesting the stereotype I was being boxed into again and again. Even if I spat it out, the taste was still there.

Eventually, even I started to struggle with explaining who I was. Could I still say that I was a neuroscientist if I was not currently employed? Could I still consider myself a researcher if I was not affiliated with any institution? These questions were eating lots of my cognitive energy when I started to lead an independent research project that I was passionate about. As an unaffiliated SAHM researcher, how would I be perceived by participants, colleagues, and acquaintances? I remember being so uncomfortable about my identity.

I was also struggling to find my tribe as a SAHM. It is hard for me to initiate friendships, and I did not have any close friends or family where we were living. Although I shared the playgrounds with many other moms and caregivers, I failed to form friendships with them. Looking back, I am not sure of the main reason for this: Was it the chaotic lifestyle of taking care of an infant, which made scheduling anything almost impossible? Was it my personality, my depression, not finding the energy to talk in a non-native language, or simply failing to find ways to connect with other moms? In the past, I could go on for hours explaining how an electrophysiology experiment is run, how one could build a miniature electrode drive, how brain structures connect with one another, how to prepare a grant proposal, or how poorly and inefficiently academia is run. But whereas these were okay-to-great party topics when we had the time for leisurely conversation and a martini in our hands, they seemed too outlandish to discuss while trying to breastfeed a cranky baby or running to stop a toddler from

licking someone's shoes. And since I did not feel I had something else to offer for conversing, I did not offer anything.

For the first time in my life, I had also become aware of my age. I felt too old to be a new mom at thirty-five. Luckily, thanks to living in the Bay Area, where advanced maternal age has become the new norm, my age was not an outlier. It was not the reason holding me back from fitting in among fellow geriatric SAHMs. Nevertheless, I was overwhelmed with everything, and forming new friendships at age thirty-five with a baby in tow was just too hard. I was depleted. Meeting with, introducing myself to, and getting to know people required lots of effort that I could not put in. I let opportunities slip by for building my new tribe while aching for the one I had lost.

I was also deprived of doing some of the things that gave me the biggest pleasure—such as attending talks and workshops and engaging in scientific discussions—in part because they were logistically hard to arrange but even more so because I did not want to feel like an anomaly again. I felt incredibly isolated, which together with prolonged periods of sleep fragmentation and deprivation powered the pendulum of my postpartum depression and anxiety. The stronger that pendulum swung, the more withdrawn I became, and the more withdrawn I became, the darker my moods became. On those dark days, I felt the weight of my age more. I felt as if it was too late for me to carve a hopeful, energetic mommy life out of my isolated, immigrant, ex-academic, thirty-five-year-old, tired, and bitter being. It was not complete darkness, though. There were many heart-melting moments where I could enjoy my baby girl and bathe in her love. But those beautiful memories are tainted by days of despair, moments of rage, scary thoughts, and numbness that filled the in between.

One of the greatest ironies of my experience was that during the one-and-a-half years of my SAHM period, the one thing I did not do was stay at home. I am not sure whether it was conscious or not, but my baby and I were out and about almost all day, every day. We were fortunate to live in a vibrant city with lots of good weather and fantastic outdoor opportunities. We went to every event we could find, from story times to lessons to walks, defying all the expectations regarding staying at home. Those outings were my lifeline. I was a SAHM who would not and did not stay at home. That was, at least, something I could do.

## Do We Need the Line?

How or why do some of us choose to leave our established careers to provide full-time care for our children is an important question to ask. We need to have these conversations so that we can make sure expectant parents have access to resources, such as adequate pay, affordable childcare, flexible workhours, and mental healthcare. Parents should feel supported and empowered in making their own decisions.

An equally important question is how we can embody what we all strive for and start respecting fellow women's decisions and supporting them if that decision involves being a SAHM. Why do we value stay-at-home parenting so little? Why do we not consider this a legitimate decision that fellow women can make for themselves, especially when finding full-time childcare is logistically and financially so hard? Why do we think being supportive of such a decision is against empowering women if that is indeed the woman's decision? These are the questions that occupy me most of the time when I am reflecting on my experience of being a SAHM, and I would like to invite you to think about these questions.

We need to empower each other to make informed decisions of our own, and we need to support one another no matter how much we agree with those decisions. Our children need to learn that they can be great lawyers, cooks, violinists, babysitters, hair stylists, yoga teachers, athletes, drivers, scientists, rangers, teachers, tailors, and stay-at-home parents. They can obtain higher degrees if they want to, but they do not have to. They can have thriving lives if they choose to pursue their careers to the top. They can also have thriving lives if they choose not to go to the top. Just as there is nothing wrong with wanting to go back to work at six-weeks postpartum, there is nothing wrong with wanting to take a couple of years or decades off, as long as it is one's own decision. If we want women to go through bearing and rearing children with pride and happiness, we need to elevate every woman. Boxing SAHMs into empty identifiers, ripping them off their other identities, judging the rightness of their decision, and reducing them to faulty perceptions are not the way to go.

The next time a colleague announces they are becoming a SAHM, respond just as you would do with any other announcement. If they ask your advice, offer your point of view; if they do not, do not judge. If you

cannot succeed at not making judgments, at least keep them to yourself. Likewise, the next time you meet a stay-at-home parent, just relax. Ask them how they spend their days, what projects they are working on (because I assure you that they have busy lives full of projects, whether a school project, home renovation, learning a new skill, or starting a business) or what they like to do in their free time. Ask them what the hardest part of their jobs is or the thing they love most about their work—you know, just the usual things that you would ask any other person. Please do not ever assume that you know what their lives actually look like or that they just stay at home.

## Afterword

While this piece was in the publication process, the COVID-19 pandemic hit. The lives of parents across the United States and the globe were tremendously altered. Many families struggled with loss of loved ones, health complications, financial hardship, childcare, work challenges, distance learning, social isolation, career disruptions, and many other things. Parental mental health challenges became more obvious. The one lesson resulting from this suffering was that we all need love and support from one another. We all are in this together. This piece is dedicated to all of you parents—SAHM or not—struggling out there. You are doing a great job; keep going!

Chapter 6

# Letters to My Sons

Jean D'Cunha

*A*lthough an increasing number of urban Indian women have *deferred marriage and postponed and combined motherhood with successful professions over the past three decades, doing so was rarer in my generation. "Letters to My Sons" is a personal narrative that reflects the complexities of my own experience and that of my peers— urban middle-class Indian women of varied socio-cultural backgrounds who combined late motherhood with paid, unpaid, and volunteer work, stamped by feminist consciousness regarding women's work.*

*By underscoring the personal as political, "Letters to My Sons" seeks to encourage transformative thought and action regarding late motherhood and the totality of women's work.*

December 22, 2017

Darling Nishadh and Nilay,

I marvel at the sensitive young men you have become and savour your candidly expressed feelings, and evolving views through childhood to early adulthood. Among these were your observations on why only some mums go to work, my visible greying and ageing that provoked the troubled query - 'will you die?' - my being a restless stay-at-home mom, and my needing a better work-life balance!

You have clearly internalized much of the feminist consciousness you were raised with, further honed by later influences. But there are always swathes of subliminal grey in all of our emotions, attitudes, and practice, as we live in complex, contested realities. So, I write as a mom who had both of you late in the Indian context, at twenty-nine and

thirty-six, to share how I navigated personal-societal tensions between aspirations, agency, fulfillment, ambivalences, contradictions, and practical concerns, which were all further problematized by age and other factors. These underscored my decisions to marry, bear and raise you, and work. Those struggles and many of the conversations I had with my peers were central to an empowering redefinition of personhood and womanhood—one transcending patriarchal markers of motherhood, family, and work, framed by private-public dichotomies— that many women of my generation were shaping.

We needed stamina to negotiate patriarchal power and ideologies in families, worksites, and communities mired in gendered constructs that relegated women to undervalued domestic privacy and privileged men in public activity. Our narratives show how interfaces between varied socioeconomic identities, job types, state and work policies, feminist and broader political consciousness, and individual agency mediated our definitions of identity, work, success, our efforts to combine late motherhood with successful paid and volunteer work and the effects of those efforts. By underscoring the personal as political, our stories are meant to encourage analytical reflection and transformative action regarding late motherhood and the totality of women's work.

At twenty-six, I—a Mumbai-born, well-educated, middle-class, Indian Catholic—married Dad, a mechanical engineer from a similar background, in a simple non-traditional ceremony, followed by intimate celebrations with family and close friends. Finally! I was conflicted about marriage, as I had seen many women in abusive, irreparably ruptured relationships that I dared not risk. But I believed I could make a lifelong commitment to him, which was partly attributable to my Catholic sensibility.

Raised with Catholic values of service, I was active in the students' and women's movements and aspired to enter academia, travel into interior India to plumb social issues, and advocate for women's rights. I wanted to influence policy, contribute to impact at scale, and work with women at the grassroots level

The family protested this "down-the-drain" path. "Who will marry you, if you become overqualified and undertake such work?" they asked. "Why work and for nothing when your husband would support you?" For mine was still a time in which a bachelor's or master's degree

in arts was considered adequate for women, who were then well poised to marry a good Mangalorean Catholic engineer or doctor (preferably a US green-card holder) before turning twenty-five and risking being left on the shelf. Between traditional matchmakers and family-friend networks, we were provided a minefield of information about what made marriages click—bloodline, wealth, charming looks, no vices, a churchgoer. I found these rather superficial indicators for a long-term commitment between kindred spirits in which shared world views, aspirations and complementarities in temperaments should instead, be prioritized. "Romance dies, and love follows marriage," my family retorted. Their efforts moved from well-intentioned pushing to subtler wine-and-dine invitations that ensnared me into meeting prospective grooms that I subverted with "not ready" signals. The family gave me up as an embarrassment.

Several of my peers navigated these life decisions somewhat differently. Lakshmi for instance, who you Nishadh have known as a child, had an arranged marriage at nineteen after completing a bachelor's degree in commerce in Andhra Pradesh. Her father-in-law brought her and her then to be husband who was a family friend together. They had a simple Hindu religious ceremony and celebration, without dowry. As Telegu Brahmins prioritize learning, Lakshmi and her husband continued their master's degrees. She subsequently completed her PhD at the Indian Institute of Technology (IIT), Mumbai, spending ten years doing both degrees.

Anjali, was born Catholic, but considers herself agnostic. First married at twenty-eight, this is her second marriage, an inter-religious marriage. Her life partner is also her work partner. They shared a creative work relationship, common concerns, complementary skills for some years before marriage. This continues.

In Vibhuti's case, her family insisted that she become a doctor. She became an activist, instead, graduating with a bachelor's degree in economics, mathematics, and sociology. She was convinced that as activists they needed comrades who understood Marxist economics. At twenty-two, she married Amar, also an activist and a sensitive medical student, who was unthreatened by strong women. Born into the strongly caste-governed *Patidar* Hindu community from Gujarat, Vibhuti was severely censured for marrying a Muslim.

After completing her bachelor's degree in commerce and topping

the university, Aunty Claire Ann began a satisfying software career at twenty-one, which she pursued for fifteen-plus years, with her family's support. She resisted an arranged marriage and said she would find the right person herself. She met Sridhar at work and waited before marrying at thirty.

I was happily married moving and living in Pune. But I felt twinges of hypocrisy, having previously critiqued marriage as a patriarchal institution marked by a gendered division of labour as well as the control over women's minds, bodies, sexualities, reproduction, and labour. Was marrying reneging on my feminism?

As traditional as our marriage vows appeared, the terms of our marriage were radical, based on understanding, care, equality in private and public roles, and mutual support to realize our joint and individual aspirations. Feminism, I reasoned, was about engaging all people to transform gender and other interfacing structural relations of power and exclusion. It nurtured humaneness, diversity, equality, agency, and sustainability, making it fine to enjoy love, marriage, and children centred on those values. When Dad's new job returned us to Mumbai in 1987, I was pleased for him, though somewhat thrown off kilter. With my MPhil thesis at the University of Pune incomplete, I negotiated to work remotely with the head of the Sociology Department and my supervisor.

By then, we were a year-and-a-half into our marriage without a hint of pregnancy, which in family-centric Indian marriages led to much probing from family members—from playful queries like, "Any good news?," to a sit-down talk on reproduction and family planning. An elder wielding traditional authority asked me but not Dad why I was not having a baby. "The Church holds that procreation is essential to marriage and prohibits artificial contraception, which, if you are using, is against its teachings," she said. I was tongue tied! My belief was that families must respect privacy and joint spousal decision making, or at least discuss childbearing and family planning empathetically. I was open to dialogue, not intrusion, imposition, or woman targeting. Besides, I thought the institutional Church was frozen in time and needed to respond to people's realities—especially women's suffering. It needed to breathe life into women rather than wrench it from them.

We wanted children, but in our own time, as an act of love, a yearning to experience the marvel of creating and nurturing life—the

"blood of our blood, the bone of our bones"—and to revel in different stages of your growth, applaud your joys, and support and help you grow through your disappointments.

But when we did decide to start a family, I suddenly grew uncertain about whether I would be able to find complete fulfillment in the pure joys of domesticity and motherhood—changing diapers, cooking, feeding, bathing, soothing colicky babies, pulling all-nighters, and chasing toddlers. As the hard detail of what mothering actually entailed began to penetrate my consciousness, I found myself swirling in a misty ambivalence, feeling unprepared to manage a child, job, and other activities, including a growing desire to do my PhD. My foreboding of claustrophobia, stagnation, fatigue, and lack of confidence in my ability to nurture children was overwhelming—far from my pleasant self-indulgent reveries of cherubic infants! So, I decided to concentrate on my job, and other pursuits, while exploring a bit more about how working mothers with babies and toddlers coped. We waited to have both of you three-and-a-half and nine-and-a-half years after marriage.

When I became pregnant, an elder queried, "Will you work after childbirth? I once advised a respected professional with a high profile job to stay home, as women are hearths of homes." "I will manage both with support," I replied. Living to only meet domestic obligations was not in my character. I enjoyed the academic vibrancy of teaching at St. Xavier's College, Mumbai, which nurtured value-based education and innovative course content and learning methodologies. Living these roles of a full-time academic, a freelance journalist, women's rights activist, wife, daughter, and soon-to-be-mother demanded hard work, planning and managing competing agendas, unforeseen disruptions, and guilt. It demanded negotiating entitlements at work and requesting family support. And most of all it demanded dealing with criticism for daring to exercise agency and going against the grain.

Moreover, there were several humps and bumps, especially during my pregnancies and to some extent thereafter. Both pregnancies were difficult and were complicated by age, and potential miscarriages. I experienced acute calcium deficiency, pregnancy-related hypertension, stressed labour, transverse and breech positions, caesarian sections, tight nuchal cords, and postdelivery infections. This defied my romanticized view of pregnancy and childbirth, but no pain could ever outweigh the deeply desired miracles of life that both of you were.

From your birth Nishadh in 1988, to yours Nilay in 1994 and until we left Mumbai for Bangkok in 1996, my parenting was helped by family, especially nana Cynthia, Dad, and nanny Alice. In addition, paid childcare for you Nilay after nana passed and advantages that many other Indian professions lack—such as a full-time academic job from 9:00 a.m. to 2:00 p.m., paid maternity leave, college vacations, and a year-long PhD fellowship just before Nilay was born—helped us through.

Nana's ill health tired her easily, although she did relish grandmotherhood. Dad worked long hours and had long commutes. So my day was still long and exhausting: waking early, cleaning, preparing your meals, feeding, helping nana with you Nishadh, picking you Nilu up from daycare and looking after both of you when I returned from work, coping with nana's illness, working late to prepare my college lectures, reading for my PhD en route to work while pregnant with Nilu, writing articles between lecture breaks. Although I never actually calculated the time I spent on unpaid care and paid work in our home, I am sure my work hours—unpaid care and paid work combined— were longer than Dad's, as is usually the case with women and men everywhere. Then there were the routine and unforeseen problems— you two getting viral fevers and diarrhoea, domestic workers failing to show up for work, and suffering an accident, which fractured my ribs, meaning I could not carry you Nilu for six months.

When travelling, I was always preoccupied thinking about home and called home frequently. My guilt about leaving you and burdening the family were sharpened by emergencies such as an accident that left Nishadh bloodied, with his cheek swollen, and the times when you Nishadh swallowed a plain pin, and when you Nilay swallowed a coin and lodged a seed in your ear. Extracting the seed required a medical procedure, forced me to abandon a work-related flight and had me rushing back from the departures lounge to the hospital.

In 1996, we followed Dad to his Bangkok-based job. Nilu was hospitalized with virulent diarrhoea almost immediately, and Dad was travelling. With his regular travel, I felt disoriented as I tried to manage competing needs and problems in a new environment and to cope with initial rootlessness, a new job, and a free-spirited toddler who tested my diminishing energy. But I finally managed with reliable domestic help, recommended by friends. We were fortunate to reside on a child-

friendly campus that housed Dad's office and your school. This, together with broadly compatible work and school schedules and domestic help, facilitated quality time with you and being there at a pinch in the event of an emergency.

Although Dad was helpful when he was at home, I never figured out why he so rarely undertook household chores or even childcare without asks or reminders – including the obvious cautions to prevent you toppling as you inched towards the edge of the bed. Were those trivial matters? Perhaps, but they also reflected how gendered socialization trains women to intuit, anticipate, plan, multitask, absorb strain, and negotiate multiple tensions better than men—all skills integral to unpaid care work and collective wellbeing.

I really do believe that childbearing and unpaid care work in families and communities create and replenish the work force and human capital, generating and reproducing socioeconomic wealth. Although individuals may be paid for this work when undertaken as a contractual obligation, care work done by family women at home is seen as a natural labour of love. It is unpaid and not considered work or counted in the GDPs of countries. This obfuscates its value and lowers the value of women's paid employment, including paid care work. And this is indeed unfair.

Caring for you holistically was largely how I stayed proudly engaged with you, besides career and other social and family commitments. Dad fell a trifle short on family time, reasoning that I had a more flexible job, whereas he worked in an institution. But Dad's identity was primarily work related. And even if he did hold shared care work as a value, which he did, larger state policies and work policy and culture in his demanding male work terrain of disaster management— such as the absence of paid non-transferable parental leave, flexible working hours for men to shoulder care responsibilities, or equal recognition at the workplace of paid and unpaid care work for both men and women—also eroded his care contributions. This situation could have interrupted or derailed my career path, as it has with countless women, had I not been in the somewhat more flexible academic stream and enjoyed varied forms of support.

Focusing more or less full time on my PhD, I managed to complete it in good time. This was made possible by Dad's income, day-long domestic help, and a great deal of discipline. But finding an academic

job was difficult in Bangkok, where English-language instruction was at the time rare, so I decided to return to India with both of you, having secured a professorial job in Mumbai, but then joined the United Nations Development Fund for Women Bangkok (UNIFEM, now UN Women).

I brimmed with anticipation. I saw my commitment to support policy reform and work on issues of women's rights with the UN advantage of supporting implementation at scale, converge with fulfilling paid work. But fulfilling jobs in leadership roles have challenges, too. You Nilu in particular were uncomfortable with our heavy work-travel schedules, although Dad and I consciously made it a point not to be away from home at the same time. Although our attention to your needs was distracted by family adjustment to relocations, politically complex new duty stations that we relocated to, conflicting demands from the constituencies we served through my organization, multiple tight deadlines, poor work-life balance, and organizational change management, I tried spending more time with you, listening to your concerns, and responding to your feelings and practical needs to the best of my ability.

As I said at the beginning of my letter, I do want to share how my peers managed late motherhood and careers. Not too surprisingly, we did so somewhat similarly, although with nuanced differences. Lakshmi and her husband, Chelpa, were studying, needed economic stability, and wanted to raise their children by themselves. According to Lakshmi:

"I survived a ruptured ectopic pregnancy, needed recovery and adjustment time to my new job at the Tata Institute of Social Sciences [TISS]. Married early, I faced queries about childlessness. Unsure about conceiving after the mishap, I finally had Rishab at thirty-three. Chelpa and I adopted Manavi six years later. Rishab wanted a sister and we wanted another child and company for him. I ultimately relied for childcare on our parents, Chelpa, and domestic workers, who are often behind many successful Indian women. Our men ideate, but seldom wash teacups!

I was looking forward to making a difference in my new job. TISS's public policy remit and emerging women's studies in India provided an

opportunity to contribute nationally, visibilize women's experiences, and engender institutions. I established TISS, Hyderabad in 2012. With Manavi's growing needs and demands as a teenager and my concern about her well-being, my aging mother's needs, and an administrator's rather than leadership role that I began playing, I returned to Mumbai hoping for a more strategic role at TISS. But hierarchies within the organization disregarded this. This made me reflect very deeply on the need for all of us to care for ourselves and explore larger existential questions about prioritizing careerism holistically.

Anjali's daughter was born ten months after her marriage:

At thirty-five, my biological clock was ticking. A tenured associate professor with a body of work, I was not anxious about my career. Initially sleep deprived, I took maternity and sick leave for five months before resuming work. Living on campus in a family- and woman-friendly workplace, I availed myself of TISS's stimulating daycare program for eighteen months, which was complemented by part-time nanny help. As co-workers, my husband and I took our baby on work trips, sharing childcare until she began school. Family assisted when I travelled overseas.

Vibhuti had registered for a PhD, was a full-time women's rights activist, and her husband, Amar, was a full-time trade unionist and health activist:

We travelled a lot around India for work. We had little economic stability, and our home was open to all our activist friends. We were clear that having a child meant a more settled life. Lara was born when I was twenty-nine, after I completed my PhD. I was also at the time confident of family support, as my parents had relocated to Mumbai. Initially, I would take Lara in a carry bag to rallies, public meetings, police stations, and conferences. I was called "Ba Ba Black Sheep," as I always had three bags full—for my baby, my feminist literature, and my daily utilities. When Lara got enrolled in school, I had to make major lifestyle changes, which included acquiring a stable academic job at Shreemati Nathibai Damodar Thackersey (SNDT) university. However, when I was away on a post-doctoral fellowship at the London School of Economics through SNDT, the Babri Masjid (mosque)

demolition in India sparked widespread communal violence—a nightmare for Amar (who is Muslim) and for Lara, who were both in India at the time. Amar lost his job. I finally resigned from my job, as I was taunted for being the wife of a Muslim and was told to go back to Pakistan. Amar and I struggled economically and emotionally, but we finally secured formal jobs. By then Lara had enrolled in college.

Claire's experience was more nuanced:

Supportive work policies—such as flexible working hours, paid maternity leave, nontravelling jobs, good daycare, and full-time domestic workers—helped. I quit working after moving to Singapore. My daughter was one year old. It was difficult. I had striven to become a project manager, with prospects ahead. I convinced myself of my readiness for a break, confident of a good job later. I joined Fiserv, a technology company in Singapore, opting for a non-travelling, non-client-facing support job, without project deadlines and team responsibilities. I missed having a higher-profile project management role but learned to accept this choice. I like to think that colleagues respected me for it, as the project managers I supported were unaware I had done their roles earlier. With young daughters, I finally quit to keep my family together, following my husband to his new Hong Kong-based job. I had by this time proved myself professionally, had high self-worth, and had accumulated savings from long years of work.

But when her children were older, Claire wanted to resume earning independently and prove she was a career woman:

"Despite my husband's help and good domestic support, I was behind on the latest developments in software. Besides, the industry demands long work hours and travel. I was unsure about full-time demands on my time. With economic security, my husband's travel, and aging parents, I decided volunteer work could provide the flexible time and self-worth I needed. But volunteer work is trivialized as only a time-passing activity largely for women—unpaid and unbound contractually. However, it involves goals, skills, and commitment; it helps many

NGOs survive as well as helps to produce goods, provide services and generate wealth. Rather than discourage such efforts, society must recognize, respect, value, enable, and encourage volunteer work for all people of all ages and all genders.

There are common threads in my narrative and those of my friends —marriage, strong and successful careers, late motherhood, family planning, support from domestic workers, family members, partners with high incomes, able children, and supportive work policies. As you both can see, in India, as in other parts of Asia in which our family and Claire's have lived, care work is almost entirely a woman's responsibility shared between the unpaid care work of women in the family and the paid labour of domestic workers—our lifelines. Inequalities have produced a reserve labour supply of impoverished, low-skilled, lower-caste, and rural Indian women (and sometimes men or children) to help fulfil care demands of affluent, or middle class households with mums in professional jobs, like ours. Although Lakshmi's, Anjali's, Claire's, and our family have heavily relied on domestic workers, all of us have been conscious of treating our domestic workers with dignity and respect, paying them market wages and more, supporting them and members of their families in various ways—such as paying fees for their children's education, finding jobs for their family members, healthcare, renewing their work and stay permits (as needed in Thailand, Singapore, and Hong Kong), respecting their rest hours and weekly holidays, and communicating with them face to face if they encountered any problems. The rights of domestic workers are, however, poorly protected in India as in other parts of Asia, and the divide between employer and worker is quite evident. In fact, I would say that a culture of hierarchy, patronage, entitlement, and appropriation of low-skilled labor for care or other manual work is embedded in our national DNA, which reflects and retains the gendered division of labour and relationships in Indian families. If Indian women ask male partners to share care-work, men may acquiesce to varying degrees at best, or may turn abusive.

In upper middle income Southeast Asian countries, there is a shortage of people available to provide care because of low birth rates, an aging population, middle-class women's increasing employment, some form of social security for nationals, difficulties in finding local domestic workers and inadequate state-provided facilities. As my own

research has shown, these care-chain deficits have been increasingly filled by women from the poorer Global South, who can provide relatively low-cost domestic labour.

I do believe that when unpaid care work is not shared equally by men and women in households and communities and continues to be borne largely or solely by women, it stymies gender equality in both private and public life. Moreover, I see how important it is to engage men as equitable, nurturing caregivers, which helps ensure gender equality and wellbeing in families and communities. But from my own observations, I also think there is something special about equitable attitudes and sensitive behaviour that most men and husbands are missing out on. As Gary Barker of Promundo, a Brazil-based NGO that works globally with men and boys, points out, "It inspires humanizing life changes for men even gang members, quality relationships with spouses and children, and a vital connection with life."

On that note, I will finally close this letter to you. But before I end, I wish to say that as we raised you, I wondered whether the values we were imparting to you would survive in an alluringly consumerist and discriminatory world, but then a friend counselled me: "Teach your children by consistent example. Admit where you fall short. Dialogue with them. Your words and actions are being absorbed, despite apparent surrender to peer pressure. As confident adults, their inculcated values will show." This has proven to be true. Not only have you grown into wonderful young men, but our bearing you slightly late, when we were most ready to enjoy parenting while balancing it with a career, has been an enriching and a humanizing experience for us.

Love,
Mom

## Disclaimer

These views are the author's and do not necessarily reflect those of the United Nations.

## Acknowledgments

I wish to express my gratitude to my partner, Loy, for his unstinting support, including encouraging me to publish this personal account.

For candidly sharing their experiences and insights, I am deeply grateful to Lakshmi Lingam, professor and dean, School of Media and Cultural Studies, TISS, Mumbai, and former deputy director, TISS, Hyderabad; Anjali Monteiro, retired professor and former dean, School of Media and Cultural Studies, TISS, Mumbai; Vibhuti Patel, retired chair and professor, Advanced Center for Women's Studies, School of Development Studies, TISS, Mumbai, and retired professor and head of Department of Economics, SNDT University; and Claire Ann Rego, volunteer worker at Christina Nobel Children's Foundation, Hong Kong, and former software professional in Mumbai and Singapore. Finally, I thank Roberta Clarke, a close friend and colleague, for her generous encouragement and insight.

## Works Cited

Barker, Gary. "Why Fatherhood Is a Game Changer for Gender Equity." *YouTube Tedx*, 18 Dec. 2013, www.youtube.com/watch?v=CDNliLIQQY0. Accessed 24 June 2022.

Chapter 7

# Like a Deer in Headlights

Katharine Gelber
(with an afterword by Lou Stanley)

"Like a deer in headlights." That's how my partner described what I looked like the day we came home from hospital with our five-day-old son. It was a week before I turned forty-one, and he was my first (and sole) child. At the hospital, I had been provided with wall-to-wall advice (the importance of skin-to-skin contact, how to breastfeed, and how to bathe him) and wall-to-wall helpers (the terrific midwifery nurses, the paediatrician full of good advice on bonding, and my wonderful anaesthetist who really cared and visited me in hospital every day just to see how I was doing). As I had a caesarean, I was advised not to carry anything heavier than my baby for six weeks. So when we arrived home, I wasn't allowed to carry my baby in his capsule. So as I stood in front of my open front door, I froze. Oh, my God—what do I do now?

My wonderful partner instantly saw what was happening. She gently steered me inside and softly said, "It's okay. We just do the same stuff you did at the hospital. We feed him, change him, bathe him, play with him, and love him." So we did. And it worked.

I do not recommend having a baby over forty, although it is a decision we have never regretted, and one that has made our lives so much richer in intangible and innumerable ways. We laugh and smile more than we used to and are more grateful for what life offers.

But at our age (my partner is four years older than I am), the shocks are bigger. I think a great deal of that shock comes from having been used to being in control of your life, from mundane things, such as when you have a shower and when you drink a cup of tea, to more

important things, such as managing a schedule. That control was completely undone by parenthood. And even though this aspect of parenthood happens to everyone, the shock to your identity is probably greater when you are older.

The first problem was fatigue. Our boy was not a great sleeper for the first year and a half, and I discovered that fatigue is the great untold secret about parenting. No one had told me how tired I would be. I had heard endless horror stories about other women's birthing experiences—why is it that when you're pregnant other women feel entitled to tell you how horrendously painful and physically difficult their own births were? But no one had warned me about the tiredness. Now that our son is older and a great sleeper, I realize there is no point in telling anyone. It's not going to change anyone's mind, and all parents have just got to get through it anyway, so why complain about it? But it was a shock. During those first few years, even strangers seemed to think it was okay to enquire into the highly personal issue of whether we would have another one, and when people would ask, I used to answer, "No, I'm too tired." They would laugh, thinking it was a joke, but it wasn't. I meant it thoroughly and completely; I could no longer imagine what it felt like not to be tired.

Then there was the shock of how caring for this little creature could fill hours and hours and hours—more hours than I even used to be awake before I had him. Whole days, even weeks, just disappeared. Other mothers seemed to manage doing other things while caring for their young babies. Not me. Practically everyone told us, "Make the baby adjust to your life" and "Take him with you, and do what you would normally do." But this was not possible because he was not a good sleeper, and carting him around everywhere was only likely to make it worse. With so much different and contradictory advice coming from other parents and parenting books, we decided to trust another wonderful helper—a paediatric nurse, who told me he will sleep better if he recognizes signals to sleep, so I should put him to sleep in his cot, which he will learn means it is time for sleep. She saved my life. Even when he was still having three naps a day, he had each and every one of them in his cot. And he started to sleep for more than forty-five minutes at a time.

Of course, the price for this was that I was tied to the house. This in turn created strong feelings of isolation, which was a massive identity

change. From being a socially and work-engaged person, I became bound to the house with a tiny creature whom I had mostly to myself. The isolation was exacerbated by what I came to think of as post-pregnancy brain, which made me feel not like my usual, competent self. One day, I put an egg on the stove to boil and then inexplicably decided that it would also be a good time to take my son out for a walk in his pram. I got home an hour later to the smoke detector going haywire and a stinky, smoky house. I had to open all the windows and go out again. Another price was the criticism—both explicit and implied—from others who told me outright that I should be doing things the way that had worked for them, which certainly did not help.

The long stretches at home seemed never ending. Although lots of people told me to please ask if I needed anything, I didn't feel comfortable asking for help. Looking back, I can see that this had a lot to do with the identity shift involved in late parenting. I felt that I should be able to cope on my own, that I should be able to develop a consistent and predictable routine, and that I should be able to figure out how to get my son to sleep. The lack of control over his—and therefore my—days was shattering to my confidence as a person. The great deal of control I was used to having over my days was gone. In retrospect, I can see I had become withdrawn and lonely. I tried to meet other new mothers and made one good new friend in my mothers' group, but mostly I felt alone and unable to muster the energy to do anything about it.

As older mothers, we had less support from our parents than young-er mothers seemed to have, as our parents too were older. When my son was born, his three surviving grandparents were already in their mid-seventies, and all lived a long way away. Although our sisters provided lots of much needed advice by telephone, they did not live close enough to provide hands on or emergency help. Not only are older mums less likely to have parents who are still alive, but those who are also tend to be older and less able to be active grandparents. When I would fly to visit my mother when my son was really little, she was just wonderful, taking care of me while I took care of him. She fed me, brought me lots of cups of tea, and was wonderfully helpful and supportive. But when he got older and a friend suggested that perhaps I could send my son for a trip on his own to his grandmother's, I laughed out loud. The idea that I could or would send a toddler to be taken care of twenty-four hours a

day by my nearly eighty-year-old mother without my help was simply ridiculous, not to say unfair for my mother. She remains incredibly supportive, and my son loves her to bits, but it was my and my partner's decision for me to become a mother at forty-one, not hers.

Before the baby came along, I was used to organizing my own life. I had achieved a high level of success in a demanding academic career that I loved. Prior to having my child, I had completed a PhD, obtained a tenured academic job, been awarded competitive research grants, coordinated and delivered courses to students, written books and journal articles, and undertaken a range of administrative roles at work. I was used to being highly competent and in charge of my life. I was free to choose the projects I wanted to work on, pursue the research I was interested in, and find answers to the questions I posed in my work. In my personal life, my partner and I had bought a flat, then upgraded to a house, and were used to setting goals and reaching them.

But after I had my son, I was floored by the simplest of tasks—getting this little creature to sleep, managing to shower and get dressed before lunchtime, and drinking a cup of tea while it was still warm. Things that had once seemed seamlessly achievable had somehow and overnight moved beyond my grasp. It was intensely frustrating, and I believe those feelings of losing control over simple choices about how to organize and manage your day and get things done are stronger when you are an older mother. Maybe it was also because, as an academic, I was used to others expecting me to be able to manage and juggle many complex tasks simultaneously, which added to my self-perception that I should be able to cope.

But I simply could not master the feeling of being competent at caring for an infant. I took good care of him, and he was well loved. But I never felt I was doing it right, and my instinct was to approach caring for a baby as I did most things in my professional life—by doing research. But this time research did not help me. The advice I discovered was highly conflicting, and most of it did not work for my baby or for me. Finding that none of the highly developed organizational and research skills I had at my disposal professionally were of any use to me was quite devastating.

My professional life did have some upsides, though. Because I had good maternity leave, I took six months off full time and then returned to work full time. I managed to work from home one or two days a week

until he was old enough to go to school. I also had some wonderful and supportive friends at work. I will always especially remember and be grateful to one who babysat and gave me and my partner our first evening out together, another who took him out for a walk in the pram so I could sleep, and another who brought me freshly made pumpkin soup. But in terms of my career, my goal was to make sure that the six months I took out were not noticeable on my CV. Although things are changing now, at the time I feared that a noticeable gap in my academic career would look like I had taken my foot off the pedal and would hold me back in the long term. So I added an extra layer of organization to my career aspirations that those who did not take parental leave did not have to do while at the same time struggling with a lack of organisation and control in the other aspects of my life. I achieved this goal work wise and managed to regain my work-related identity when I returned to work.

I am also a better mother because I was able to regain that working identity. My known, reliable work identity gave me stability and a renewed sense that at least one component of my life was back under my control. The skills I had spent years developing were of use at work, where I could set myself tasks and undertake them successfully and competently. This was in contrast to the tasks associated with mother-hood, at which I felt far less competent.

The transition was made easier, though, by my partner's reassess-ment of her work life and goals. We had an additional catalyst for this. When I was seven months' pregnant, my partner had a serious health scare. It ended up being treatable and not life threatening (although for the longest five days of our lives, we did not know that), but this event, along with the baby's arrival, made it a perfect time for us to reassess our priorities. When we decided that we could not both have demanding, time-consuming jobs and be good parents, she decided to scale down her job and move back into a hands-on role instead of managing others, which necessitated moving to a new job and taking a one-third cut in salary. Serendipitously, she also discovered that she actually liked the hands-on role better, but that decision made everything else since then possible. So this change in our lives meant an identity shift for her, too. She spent years after we made that decision trying to come to terms with the fact that she was not her job, and that shifting down in terms of salary and status did not mean she was any

less a person. We collectively reprioritized what was important in our family.

I still remember, though, saying to someone shortly before my son was born, "I'm going to be a mum," and being surprised by the idea. The new identity of motherhood, coming so late in life, was bewildering. Shortly before the birth, I thought of my son already as an independent human being. I said to a good friend in late pregnancy, "He's a person, and he has rights," and she laughed and said, "Only you would say that." The change in identity, the addition of the nomenclature of "mother," is profound when you are older. You have spent many more years on this earth with a range of other identities—in my case, daughter, sister, partner, ambitious and successful academic, smart researcher, effective organizer, friend—and then suddenly you add a new one that carries so much responsibility and gravitas.

Late motherhood takes a lot of effort. It is harder on a body that is less adaptive to large physical changes. And for me, being in a same-sex relationship, conception was daunting. My partner and I discussed options, and we had several. First, we asked a friend who wanted to be an involved father, but a health problem precluded that. Then another good friend offered to donate sperm to us, but by then, we were clear on how we wanted to make our family—with the two of us as the involved, decision-making parents, and with full legal rights. Finding out all the legal ramifications of same-sex parenting was not easy. The turf was also (and still is) constantly changing. Given my age, we had to make a decision quickly, as my window of fertility was closing rapidly. So we went to a clinic and chose a donor who agreed to be contacted, since that way our child would be able to make her or his own choice about whether or not to make contact with the donor later. Making that decision was complicated and involved a lot of soul searching.

Being a lesbian mother added yet another dimension to the identity challenges of parenting. It meant that I no longer had a choice about when, or to whom, to come out. I had to come out all the time—to health professionals during the pregnancy and to absolutely everyone after he was born, such as doctors, nurses, council workers, childcare workers, new friends, other parents at school, staff at every office I ever went to, teachers, his classmates, his classmates' parents, and sports coaches. Perhaps this was easier because I was older and used to successfully navigating coming out. We had also read all the literature

on lesbian parenting, the wellbeing of children in same-sex families, and of course the legal and health issues involved in conception and birthing. Compared to younger lesbian mothers, I was probably more experienced and better informed.

I remember one earnest and well-meaning young man at the Family Assistance Office who offered to link the three of us together as a family for the purposes of the Medicare safety net in the Australian public health system before that became legally possible in 2010. I had to explain to him that what he was offering us was not legal, although I appreciated his efforts on our behalf. Throughout our parenthood journey, the law has been in a constant state of change trying to keep up with parenting practices in the community. When our son was first born, only I as the birth mother was able to be listed on his birth certificate. So we consulted a lawyer and obtained a court order recognizing my partner as a co-parent, for his protection and just in case something bad happened to me. A couple of years later, the law in our state changed, and we were able to apply retrospectively to have my partner also listed as a parent on our son's birth certificate. On top of that, the laws on donor conception are changing all the time. So maybe it wasn't surprising that I knew more than the public service employee did about the law at the time for same-sex families.

For my partner, this adventure meant embracing nongenetic parenting, a role she took to like a duck to water. Our son is closely bonded with both of us; he feels loved, treasured, and safe. He tells us he got his sense of humour from his nonbiological mother and knows that some things can be learned from parents without having a genetic connection to them. This privilege reminds us constantly that parenting is about so much more than genetics. We keep up to date with the research on the outcomes for children of same-sex parents, which demonstrates that these kids do just as well, if not better, on all indices of wellbeing as children of heterosexual couples. They are even usually more resilient, since they have to learn at a younger age how to deal with intrusive questions about their family.

Being a lesbian mother means being in a constant process of normalizing my and my family's, identity. I remember that before my son was in childcare, there was a media-driven issue about the fact that some childcare centres had a book on their shelves about a family with two mothers. Conservative commentators were saying they did not

want their children introduced to such a contentious political issue at a young age and that families (assumed to be heterosexual) should have a choice over whether their children were introduced to it. I remember saying to the childcare workers I was speaking to at the time that this was not a political issue; it was my son's life. He needed to have access to books that reaffirmed the normalcy of his family structure, just as he would inevitably be constantly exposed to countless messages about, and invisible pressures to conform to, heteronormativity.

Although I want to avoid the clichéd and cloying soppiness of Hallmark cards, being an older, lesbian mother is ultimately incredibly rewarding. The real shifts in identity faced by older mothers deserve greater recognition and social support. Whereas the mothers' groups organized by local councils in Australia put women in contact with one another based on the birth date of their child, it might be helpful for these kinds of services to pay closer attention to the mothers' needs. Older mothers have different support needs from their younger counterparts and are dealing with different shifts in, and challenges to, their established identities. But although some of the challenges I faced were unique to my age group and same-sex parenting, other elements of motherhood are shared between mothers of all ages, regardless of generational differences: the rewards of your child smiling at you, the joy of watching them express their personalities, as well as opportunities for the whole family to grow, learn, and laugh more than you thought possible.

Thankfully, I am no longer that deer in the headlights, although I was for a really long time. It took years for my partner and me to adjust fully to the new identities we had taken on, which I believe had a lot to do with our ages. We had been together for thirteen years when we had our son. Now we've been together for twenty-six. We are looking forward to the next twenty-six years and the twenty-six after that. We just might suggest to our son that, if he wants kids, he might not want to wait until after he's forty years old to make it happen.

## Afterword

### Lou Stanley

As my partner has said, as an older parent, the tiredness and the limitations on our physical abilities were unexpected hurdles to overcome, but the deep feelings of joy and connectedness we have experienced outweigh the downsides.

The health issues I had when my partner was seven months pregnant highlighted for me the importance of being around and being physically and mentally well for my family. A health scare tends not only to reprioritize your relationship to work but to also clarify your relationship to family. The decision as to which of us would downsize our career to make the family work was precipitated by the health scare, which resulted in two years of surgical procedures, and the decision was made easier by the life-changing event of becoming an older parent.

I also had an older mother who did not live near her parents, so the idea of parenting without grandparents being around to look after children did not figure in my decision making. As older parents, our life experience had made us more aware of the potential issues around same-sex parenting, so we did make a conscious decision to live in areas and use services that would be accepting of our family.

In terms of my bond with our son, I was the first human being to hold him, and I've always believed that you do not need to be biologically related to a child to love them and be willing to put them before your own needs. I completely identify as a fully involved parent; he is my child, he treats me as his mother, and I'm fiercely protective of him. It's a role I chose; it didn't happen to me accidentally. I did have to negotiate my role with my partner at one point because after spending six months at home on maternity leave, she was so used to making everyday decisions for him that it did not occur to her that this was a responsibility that needed to be shared.

Fourteen years on, we are happily discovering an unexpected benefit of being older parents. As our son enters his third year of high school, I have taken early retirement. Even though his physical independence has grown, his emotional needs and his need for us to be around and in touch with his life have remained, even possibly increased. One of the benefits of being an older parent is that I've been there and done that,

so I don't need to wait for him to grow up and leave home so that I can be free to do the things I want to do. I am happy to spend the time together that a teenager needs for stability and consistency in order to navigate his world successfully during a period of rapid change.

Chapter 8

# Does Your Husband Have a Screwdriver? One Woman's Journey through the Heteronormative Vortex

Jill White

"Wow," one of the other mothers said, "you're the only straight person in this rainbow playgroup." "I'm not straight," I said. "My partner is trans." "But you look straight," she replied. I could not disagree; even my friends would think I am straight, unless I told them. I think about our picket fence, our two small children, and our 1950s-style division of labour. You are right, I think. Damn. Even though I had been out fighting alongside other women for equality as a lesbian and as a feminist since my university days, at forty, I now found myself alone and invisible fighting for equality as a wife and mother. This chapter is about how I lost myself in that battle and discovered a deeply entrenched gender war I could not win.

These are the things that I was taught are supposed to make women like me happy: marriage, children, and now, perhaps more importantly than ever, work. We are socialized to believe that attaining these goals perfectly and simultaneously is the height of women's achievement. Successful women must also be white, English speaking, privileged, young, and, of course, thin, and I was all of those things, except heterosexual and a mother. But what if these goals are not designed to make women happy but rather to support the structures of power? This idea is not new, but it is time to take some more of the sugar coating off and

expose a truth I have recently discovered firsthand: Motherhood in the twenty-first century is still not an equal deal for women. This truth came as a shock to me when, at age thirty-five, I finally achieved the life goal of becoming a mother.

Achieving that goal had been particularly sweet because it was so difficult. At the time, I was partnered with a transgender man, which meant that we had to undergo the process of family making under an unusual set of circumstances. When I met him, I was an out lesbian, and he looked like a girl, just my type, and I fell in love at first sight. We immediately confessed to each other that we both wanted children, and although I felt in my heart that this was the person I wanted to have babies with, I also knew it would not be easy. Then he told me he was trans. I decided that our going through transition at the same time as having babies would be a bad idea so I decided to wait, finish my PhD, and focus on my career and on her becoming him. Five years later, we were more dented and tarnished by that transition than I had ever expected in my naïve, early in-love days, but I held on to the dream of having children and moved from my beloved remote Australian town to the inner city to be with him so we could do just that.

Before my move, I had been well paid, appreciated, and challenged by work in a field I felt was high value: planning health services in remote Aboriginal communities. When I arrived in the city, I experienced my first major identity crisis. I had left my work behind, which by then had become an enormous part of my sense of self-worth. I had also left my lesbian identity behind, one I had fought hard to be proud of. In contrast, my partner had moved to the city for his career and to complete his transition from female to male. He changed his name, went largely without telling people he was trans, and—just like that—I was no longer a lesbian. We had talked about it, and he said I was not allowed to call myself a lesbian anymore because it did not support his identity. I saw his point, but I also felt bereft that something so hard won and important to me seemed to have been erased so finally.

So now people saw me as a straight woman, which felt akin to going back into a very stuffy closet after over ten years of being out. When I could not just drop a "my partner, she…" into a conversation anymore in order to out myself, that part of me became invisible. At the same time, I got my first ever corporate job and found that its values profoundly conflicted with my own. I remember standing in an office

on the forty-fourth floor and seeing myself reflected in heels, tights, and a pencil skirt just a week after having sat down in the dirt in one of the most remote communities in Australia to talk with Aboriginal women elders and wondering, "Who is this woman, and what has she done with me?"

What I realize now is that the loss of self-identity that so many women speak of as part of motherhood had by then already started. My choice to move to the city to have a family with my now male partner meant that I had let go of three fundamental parts of myself all at once: my home, my work, and my lesbian identity. But I forced myself to suck it up and keep going with my plan. There were babies at stake. I was thirty-four, and time seemed to be running out, especially as I would need assisted reproductive technology to become pregnant. Nonetheless, I quit the corporate job and took a pay cut to work in LGBTIQ health as a way to reconnect with my queer identity and community (and receive fourteen weeks of paid maternity leave, which was one of the best deals in Australia at the time).

There was a catch to this plan, however. I could not say my partner was trans because he did not want to be outed in his job. This was before any widespread awareness or acceptance of trans people, so even though I hoped his fears were unfounded, I respected his wishes because I loved him. There was no argument I could mount against his fear, no evidence I could give that it would be okay and that he would not be discriminated against at work because he was trans. So there I was, an ex-lesbian in one of the queerest jobs in town, back in the closet as a partner of a trans person. The impact of the babies I had not even conceived yet was already profound. Having a family in my situation came with two identity shifts—to become a mom, I also had to go back in the closet.

Why did I do it? The clock was ticking, and I had a man who wanted to have children. Even though it meant I had to bury who I was, I felt I was out of time to make a different choice, and in truth, I was not brave enough to take the risk of missing my fertility window or of going it alone. Part of me felt I had the perfect circumstances to create a family in a world where queer families are still subject to discrimination. My substantial angst about creating donor-conceived children as queer parents was ameliorated by the fact that we looked like straight people. I hoped my children would be comparatively safe from prejudice and

discrimination compared to other gay families. I would finally have all I needed to be accepted: ostensible heterosexuality and motherhood. Secretly, however, we would be the queerest of the queer, meaning that I could still be me in private, with our friends, and in our queer community bubble. In addition, I thought I would easily retain my identity as a well-educated, staunchly feminist, older mom with a career I had worked hard for. I would not have to fight to keep all that, like most straight mothers have to do, because my partner was not socialized in male privilege. We could both have great careers and be parents without being constricted by the unequal roles modelled by previous generations. We would be queer and could make our own rules about family. Or so I thought.

What I did not expect was the effect that having a family would have on my professional identity. Although the juggle of work and family life is well known among older and educated white middle-class women, it is often described as just that—as a game or skill that can be achieved. What no one really acknowledges is that the game is rigged. Yes, do get a degree or three and work to set yourself up in a career. Find yourself a male partner who is willing to have children. But when you do have children within that partnership, you will also be expected to do all the childcare, housework, and family care that women have always done but with a professional job as well. At work, you will be expected to carry on as if you do not have children, and at home, you will be expected to fulfil your duties as a mother as if you do not work. Nothing less is considered good enough for partnered, white, and wealthy older mothers in professional careers in Australia.

Despite my best efforts, the impact of having children on my career started almost immediately. He said I could not tell anyone I was trying to get pregnant in case it affected my prospects. He said I could not tell anyone he was trans in case it affected his career. When I first became pregnant, he said I could not tell anyone in case I lost the baby, or I got put on the mommy track too early. He said I could not tell anyone I was a lesbian in case it affected his identity. I erased myself further and became more invisible to others. So when a misplaced progesterone oil injection during IVF rendered one of my thigh muscles useless for a day, I made a vague excuse for my hilarious limp. Later, when I was pregnant, I wondered how colleagues did not notice the airsickness bands around my wrists I was using to combat the debilitating nausea.

I suffered alone, silenced by the twin spectres of discrimination against my partner for being trans and against me for being a pregnant professional woman.

The most unexpected thing about being unwell while pregnant was realizing that when I got home, I was supposed to cook and clean and look after my partner as I always had. Stealthy, silent expectations crept inside my relationship like smoke through the cracks under the doors and made it feel distinctly unqueer and very unfair. Pregnancy, according to him, was my job as a woman, and complaining was frowned upon. My sister loved being pregnant, he said. One of my colleagues had worked right up until her due date and then wrote a novel during her maternity leave, he said. At my house, however, there was a me-shaped dent in the couch from all the lying down I had to do as well as screaming fights through the bathroom door and no dinner. To mask my misery, I joked with my friends that I was going for gold in the Complaining Olympics. At one point, I caught myself asking my doctor, "What do you mean, these incessant headaches are caused by 'swelling of the eyeballs during pregnancy?!'" My body was out of control. I could barely work, and I was failing at enjoying pregnancy— the first major task of motherhood. As a thirty-five-year-old, privileged, educated, and entitled white woman who was used to loudly kicking down doors to get her way (and not admitting to failing at anything), I found the experience profoundly distressing.

After the baby was born, there were more shocks and indignities. A third-degree tear, condoms filled with ice in my underpants, no milk, excruciating nipple pain, vasospasms, infections, mastitis, too much milk, and baby with reflux, screaming for hours every day. Our families handed the baby around and congratulated us while I sat there leaking from everywhere and in all kinds of pain. Why was I expected to be okay, to just put the baby on my breast and let it feed away? Why didn't my body work? Breastfeeding is not supposed to be painful, the nurses said. Bleeding nipples was painful. Mastitis was painful. One book said, "You may feel an impending sense of doom with the onset of mastitis." An impending sense of doom? No one had told me this could happen. Why was I suffering so much? Wasn't this supposed to be the most joyful time of my life? The professional skills I had relied upon throughout my adult life became useless: I could not think, read, argue, or work my way out of this one. I was completely unprepared, and

righteous anger was all I had. I jealously looked over at my partner, cradling his new baby with his intact body and intact career after having made comparatively zero effort to create this new life. I was furious. This whole having babies thing is not a good deal for women, I thought. I felt completely ripped off.

Of course, among the indignities, the shocks, the pain, and the weight of expectations, there was also the love. I had a baby, and I felt so proud of myself and of him. I had a baby! And I loved him with all of my heart. But even with the love, I wanted someone to blame for the culture of silence around how hard and often painful motherhood is. Why didn't our mothers tell us what it is like? I do remember my mother saying that when women's vaginas tear during birth in Southeast Asia, the treatment is to sit daily over a bowl of guava juice to help them heal, but without any sense of the suffering this reflected. Why are we silent about women's suffering as mothers? Would talking about suffering mean that we are ungrateful or that we do not love our children? Or is it simply that it is impossible to hear those stories and not damage the fantasy of motherhood that compels women to do it? I think that in our collective unconscious, we fear that to truly hear about this suffering would threaten our species and that women would stop having babies in droves, as if the drive to reproduce in some of us was not so strong that we not only go through all of that but then also, just like me, do it all over again.

I tried to get a promotion when I was pregnant for the second time. I did not get it. Someone else, older and male, was parachuted in over me. Was it because I was pregnant? I will never know. What I do know is that my children's father, since becoming a straight white male in his late thirties, has never ceased to be promoted. In fact, our salaries, which were equal before our children were born, are now so far apart that I would wonder where I went wrong if I did not already know the answer: I am the woman, and I had the children. After I told him that I wanted to go back to work after maternity leave, and for our relationship to be more equal, we had a fight about what we thought our family life would be like. This is a discussion I now wish we had thought to have before we had children. He thought we would both have big careers and other people would look after our children, whereas I thought we would take turns to work part time so we could both look after our children. But what actually happened was that he kept going

with his career, and I went to part-time work, and we ended up in very traditional roles, compounded by the difficulties of childcare. I was completely underprepared for the screaming, crying, and desperate clinging to my clothes every day for years, causing mummy guilt so crippling that it would be difficult for me to concentrate on work. Childcare also made them almost constantly sick. I remember vividly being in a taxi, eight months pregnant with my second child, trying to get through terrible traffic from work to the day care because an ambulance had been called (for the third time in as many months) because my first child could not breathe due to virus-related asthma. Why, I thought through gut-wrenching fear and tears, am I doing this? Because I knew that if I stayed at home to look after my children, I would lose my value in the world.

The scripts we learn from our parents are hard to break. In my relationship with my partner, our unspoken expectations of ourselves and each other were high. We both experienced internalized pressure to be the perfect family to make up for being queers. Our children had to be more loved and better adjusted than any other children because they had been donor conceived. Our standards were so high that we eventually broke under the weight of them. He expected me to continue a high-level career while cooking all the meals and taking care of the motherload of childcare-related responsibilities: paperwork, clothing and shoes (buying, folding, putting away, and organizing for size), activities, birthday parties, library books, baking, singing, reading, playing, bathing, haircuts, nails, first aid, dental and medical visits, and feeding two children under five by myself for twelve hours a day, every day. Plus, I was responsible for the grown-up tasks of our social life: date nights, making sure we spoke to each other at least every few days, my self-care, his self-care, my friends, our friends, my family, his family, gifts, bills, banking, budget and finances, filing, home maintenance, house cleaning, pest control, car cleaning, dry cleaning, mail and posting, organizing tradespeople, home improvement, project management, and making breakfast, lunch, dinner, snacks, and almost all the cups of tea. But you are not working, he would say. You have got to be joking, I would think. In turn, I expected him to always put his family first and when at home to give me the breaks I so desperately needed without having any breaks or life for himself. Oh, and to do two loads of washing, take out the rubbish, and clean up dog poo on the

weekends. It was little wonder that after five years of this setup, coupled with a lack of sleep and two frequently crying small children, we both ended up unhappy.

When I complained about this turn of events to a friend to whom I had complained long and loudly and who may have been sick of listening, she responded, "Well, why doesn't he know where the sheets are?" The sting of her comment was immediate. "Oh," I answered. "Well, I guess I just do it. It is too hard to try and force him to do things." When she replied, "Have you heard of enabling?" I felt a flicker of anger that I soon realized was anger at myself because I was playing out the script taught to me by my mother, which she had learned from her mother. Both had told me that I would be ready to get married when I could fold a double sheet by myself, which I always thought was a joke but now realized was not. My grandmother was a bluestocking, one of the first women to go to university in her cohort, who then had three children and never worked again. When she started a group for wives who wanted to talk about something other than babies and cabbages, it was considered so radical that it was reported in the local paper. Perhaps not coincidentally, my grandmother was also clinically depressed for most of her life.

When my husband reported with pride that all the women at work were jealous of the lunches I packed for him and wished they had a wife like me at home, I did not feel proud but murderous, gripping the edge of the sink until my knuckles went white. When a repairman asked whether my husband had a screwdriver, I wanted to answer, "I have a screwdriver, and where exactly would you like me to shove it?" I realized I was home alone fighting the patriarchy with a screwdriver, one repairman at a time, and it was a losing battle. Meanwhile, my partner was spending his days at work, taking a very different trajectory in which he was finally growing into the man he always wanted to be. For him, the privileges kept coming thick and fast: money, decision-making power, promotions, cars, and longed-for social acceptance. When he started to say things like "most blokes wouldn't do that" when I would ask for more equality at home, I would think, but I never wanted to be with most blokes.

I started to feel as if I were drowning under a thick ice sheet of what was expected of me (and what I expected of myself) as a mother, wife, and worker. I felt as if I was screaming and banging desperately on the

slick, cold surface above my head, but my mouth was filling with water while he stood on the ice, looking forwards, not seeing or hearing me. I called it the heteronormative vortex—the inexorable pull towards the norms of marriage, motherhood, and wifedom that seemed impossible to fight against. When I looked around at other couples I knew, I wondered whether their relationships were as unequal as mine felt. Did they just not complain? Did they just not notice? Did their partners stand beside them on a daily basis, noticing structural inequalities? Did they stand together back to back, vigilant and with screwdrivers drawn, ready to fight off gender-normative expectations every time they reared their ugly heads?

My life seemed so different from what I heard from the queer couples I knew with children. "My partner has been at home for a year, so now it's my turn to go part time while she gets back to work," one would say. "We each have an afternoon off to do our own thing," another reported. "The problem in my relationship," one told me, "is that we're both fighting over who gets to spend more time with the kids!" These conversations left me feeling sick and as if I had made the wrong decision. My husband said he was a feminist, but he was not. He never thought of himself as queer, which I should have noticed rather than ignored. Why had I not seen earlier that he was a straight white man in a woman's body just waiting to become himself? Why had I thought we would be able to do things differently together? That had been my fantasy, I realized, not my reality. Although the speed at which he had taken to the traditional patriarchal male role had shocked me, I also knew he would never choose to be anything else.

If I had been younger and had not already had the privilege of a career and an education, with the associated entitlement of expecting to have it all, perhaps I would have been able to fit into my prescribed role less noisily. I think being a lesbian did not help. Certainly being a feminist did not help. Neither did being an overachiever, constantly trying to prove my worth despite being queer. Having spent the majority of my life achieving educational and career goals, I still wanted to work. But the load at home was so great that I could not do both. I had tried doing so between the babies, but there was fighting in the street and again no dinner. And so I found myself trapped in a no-win situation: I could either have someone else look after my kids (i.e., they would suffer) or not work (i.e., I would suffer, which in turn would

make them suffer).

Inspired in part by memories of the feeling of absolute freedom I had experienced as a proud, wild-woman lesbian separatist at twenty-one, running through the bush in nothing but Blundstone boots and body paint, I eventually chose to separate from my partner. Freedom now is a prize I have won. Although I hope to feel visible again now that I can be myself in the world, authentic and proud, a lesbian, a mother, and a career professional, right now I feel only the losses. Marriage often brings money, privilege, and power by proxy. In mine, as for so many women, that was not my money, my privilege, or my power. I see now that all my life I have attached myself to other people's money and power in the misguided assumption that it will somehow become mine. But it does not. Being next to power is not the same as having it. (Just ask Hillary Clinton.) Spending someone else's money is not the same as making it. By initiating a separation, I am pushing back on patriarchal power, knowing that I am going to have to pay a price for doing so. I see it all around me: Women have less retirement savings. Women end up worse off after a divorce. Women have less income-earning capacity after having children. Increasing numbers of single women over fifty are living in their cars. At three in the morning, all I can see is a future of living with beige water-damaged walls and hungry cats.

I am now forty and have two children under school age. I run my own consultancy business, do 75 per cent of the childcare, and run the house by myself (which is the same except for taking out the rubbish and two loads of washing—I had to give the dog away). But more importantly, I am not forced to perform as straight or as a wife. I am finally free to be me again. Although I am frequently exhausted, I am doing about 25 per cent less childcare than I used to, and there are no constant battles about it, so at least I am finally getting closer to what I wanted. The sadness I feel is because I had to separate to get it. I did everything I could, but there was nothing I could do to change him. Turns out you cannot fight the patriarchy, screwdriver or not, when the patriarchy is your partner.

So what is the freedom I seek in queerness? How does loving another person outside the norm create space to be oneself? For me, it is about the possibility of freedom from heteronormativity: those subconscious rules of patriarchal relationships that we have all learned from our families of origin. The power dynamics between men and

women continue to be structural, unspoken, unquestioned, and strong in our culture. In queer relationships (which I would argue can be gay, straight, or nonsexual), those rules are not so indelibly written. Sometimes you can make them up a bit more, see them a little more clearly when they rear up, and work to fit the roles to the people rather than to their genders. As a reluctantly heterosexual wife and mother of two, I found that those freedoms did not apply. We had turned the cultural scripts of wife, mother, and woman into a prison of expectations that fit few older, professional, highly educated women like me, or indeed most women today.

Right now, however, I am free-falling. The family dream that I had worked so hard to achieve is gone. Should I always have known I would not be able to do it? The girl in the Blundstone boots would have been skeptical. My plan to be queer behind closed doors but to have access to all the privileges of middle-class heterosexual nuclear families like the one I had grown up in had backfired. We could not stop the permeation of those patriarchal values into every part of our lives, and they suffocated us. I thought I would have it all, but I lost myself in the trying, and because of that, I lost my family dream. I look to the future now and wonder what my children will think of my choices. As boys, will they see why I could not stay? Now they see their father cook and see me working, and they will probably also see new partners and maybe new stepsiblings, two houses, separated parents. That is a far different life than we experienced growing up, which I am starting to think is a good thing. I hope their future partners will benefit from their being whole men who know that men can clean toilets and make beds. I hope they will have grown up with two whole and happy parents instead of two unhappy halves squeezing each other into outdated roles that fit neither of them. But whether they ever fully understand why I chose to leave, I know that I did it not just for me but for them, for all of us.

Chapter 9

# Planet Motherhood

## Suzette Mitchell

My journey through motherhood was and is still bewildering. From the moment my child was born I kept a diary chronicling my feelings and thoughts. I knew I could not be the only mother who felt like an alien within my motherhood skin. I wanted to talk with others who felt like me, and I yearned more than anything to read the stories of women whose experiences echoed mine. That is how this book was born, and this is my story. According to Sheila Kitzinger,

> When she becomes a mother, it is as if a woman must go deep into the bowels of the earth, back to the elemental emotions and the power which makes life possible, losing herself in the darkness. She is like Eurydice of the Underworld. She is pulled away from a world of choices, plans and schedules, where time is kept, spaces cleared, commitments made, and goals obtained, to the warm chaos of love, confusion, longing, anger, self-surrender and intensity that motherhood entails. (2)

I struggled to surrender within my underworld of motherhood. I felt transported to another planet. Although I recognized key elements of this planet, I felt like a foreigner in need of skills I had not developed in my previous forty-two years on planet Earth. Even though I am a seasoned traveller and had managed the culture shock of moving from Australia to Vietnam with ease, my transition to planet motherhood was another story.

I offer this account of my travel into planet motherhood in the form of a *Lonely Planet* travel review of the location, history, population, food,

geography, politics, health, economy, and culture. As you might expect from such a review, it contains many complaints, but my primary intention is to map and document a space that does not often receive critical views. It is certainly not a planet all women will travel to after they give birth. But as a white, middle-class, lesbian, and feminist full-time worker, who is also an older single mom, this is my reflection on my experiences as an explorer, who despite constantly checking my compass still cannot find true north. It is an unapologetically personal testimony; an example of what Carla Pascoe Leahy refers to as maternography: "women's narrations of their maternal memories within the context of their life stories" (102). Perhaps the first work in this genre was Adrienne Rich's revelatory *Of Woman Born*, in which, according to Fiona Joy Green, Rich aims "to shatter the previous taboo of not honouring women's honest descriptions of the emotional complexity of mothering and encouraged others to explore their genuine experiences of mothering" (29). I offer the maternography that follows in the hope that my journey resonates with those of other explorers who find themselves lost at sea.

## Location

The story of my journey on planet motherhood took place, as it does for all of us, on the terrain of my identity politics. Mine began as a white middle-class Australian woman with the birth of my child, Veronika (referred to here by her Vietnamese name, Vy), in a hospital in Vietnam, where I had moved for work when I was three months pregnant. As head of a United Nations agency, I was provided three months of maternity leave but decided to go back to work early to a place I knew, and where my skin felt comfortable. I continued in the job for a further five years. The ensuing identity crisis, postnatal depression, and consistent clashes with my husband regarding parenting (as well as almost every other issue by this stage) led to the breakdown of my marriage. I fell in love with a woman and began the first lesbian relationship of my life. I craved feeling love for me. I had none for myself after giving it all to my daughter. Being in a different country from my new partner meant my daughter saw little of us together. I thought the right time to tell her of my newfound sexuality would occur naturally, which it did, but not for another seven years. I

know this delay was tied to my fear of disappointing her, but it was also connected to living in a microcosmic expatriate community where I dared not speak the name of my new identity, which was another layer of transition that I felt I needed to protect from public eyes.

I am now a single mother and have returned to suburban Melbourne in Australia. After I left the UN, I resumed consulting in the field of gender and women's rights in international development. Two years ago, my ex-husband, with whom I had shared joint custody, returned to Vietnam, rendering me a full-time single mother.

As I write this chapter and recount my journey, tears roll down my face. I wonder both why I could not have developed more control at the time and how I traversed it at all. Each day was a new trek. The best advice that echoed in my head was that it was enough just to get through each day. If we (my baby, my husband, and I) were all still alive at the end of the day, I considered it a success. But this did not feel like real success. I was used to recognizable success in my work—measuring results and delivering outputs. Surviving a day with a baby had so few verifiable indicators, no way of knowing if I was on the right track and uncertainty about whether I had the skills and ability necessary to make it across this new planet. My daughter is now twelve, and I remain locked on planet motherhood on a daily basis—a world I continue to explore in my head each day, one I still believe I cannot master.

## Population

There are two of us on planet motherhood, but as with most first-time mothers, it felt as if I had been eliminated as a separate entity with my life focused in the orbit of my child. Days and nights would pass without a shower or proper meals. Diaries and watches were no longer needed. This life was a continuum. All that existed was my baby. I was unable to identify myself as separate or having my own needs. Susan Maushart describes this doubling population of oneself as "trying to fit two people into a space formerly served for one" (113). Maushart became my travel guide and my touchstone. With her book, *The Mask of Motherhood: How Mothering Changes Everything and We Pretend It Doesn't*, she confirms that I may not be the only person on planet motherhood and not the only mother to feel such a seismic shift that I lost myself.

Being responsible for the life of another living being was exhausting and constant. I worried that she was not sleeping; then as soon as she fell asleep, I would worry that she would wake. I checked her breathing constantly, panicked over whether I had done enough, and feared that I was not enough. My life was no longer my own; I was my daughter's mother. I aimed every day to keep her alive. I worked for pay to feed and house her, to clothe her, and to provide toys and games to amuse and educate her. All my decisions came back to her. My own needs were shut down, deferred to another time. This, of course, was not her doing; I had made all the decisions that got me here. I called the shots. I owned my accountability but had no power.

In my head, she was all there was, and my purpose was to fulfill all her needs. I did not reach out for help for fear of breaking down and coming undone. I was experiencing what Phyllis Chesler has called the "savage ... alone" (qtd. in Maushart 31). Moreover, in Hanoi, where I was living at the time, there were no English-speaking women's health centres, baby clinics, or even follow-ups after birth. I was living in a small expatriate community in a foreign country. I had lost any emotional connection with my husband. Mostly, I felt I needed to be stoic, and it never occurred to me to ask for help.

The transition from being a couple to having a baby and becoming a family is difficult for most couples and extremely difficult for many older high-achieving and tertiary-educated women. According to Maushart, middle-class professional people who have children later in life experience a "significantly deeper decline in marital satisfaction than their younger counterparts" (220-21). She refers to research by Mary Boulton that found "Better educated, better salaried sisters of the middle class tended to find motherhood less satisfying, and felt more alienated and conflicted in their roles" (128). This was certainly true for me. My marriage broke down soon after bringing my baby home from the hospital. Vy and I existed on our own planet. Alone and terrified, I refused to let anyone else in.

## History

The mothering I had received myself came into full view only after the birth of my daughter. I had thought about it, of course, but I had never analyzed it with a view to how I would have liked to have been mo-

thered and how I wanted to mother my child. My mother was from another era, when societal expectations were different. She had left school at the age of fourteen to care for her mother, who died of cancer.

After my four sisters and I were in school, my mother laboured on the factory floor for thirty years before becoming an executive assistant to the manager. She enjoyed her identity, friends, and money outside of the house and children. But her approach to mothering was planets away from mine. She had been a young mother of five daughters, and I am a late mother to one daughter. I give dedicated thought to my approach to mothering through a critical reflection of theories and practices, whereas my mother's approach was much like that of other women of that era in middle-class Australia—free range and free from the hundreds of mothering texts we now have.

A major issue for older mothers is that our mothers are also older. My mother lives in another state, and like my daughter, I lived in a different city than my grandmother and missed not having the kind of tender and safe relationship that I see many others have. As a mother now, I am so envious of peers who have younger mothers living in the same city who can help with care. I also feel deep sorrow that I may not be around long enough to be a grandmother or be well enough to provide the care I would like to if my daughter has children. This sits with me often.

## Culture

Planet motherhood has its own culture and accessories. I swapped my fabulous handbags for nappy bags and my incredible shoes for comfort shoes; my unused lipstick melted under the weight of bottles and toys. Rachel Cusk's story of her postbaby shopping trip in London encapsulates how my attitude to clothes shopping changed once I entered this new culture:

> Everything seemed weirdly futuristic, as if I had been deposited there by a time machine. I want to buy clothes, to make up for two years in which I have been as far from fashion as an anthropologist on a long field trip; but the racks of things look incomprehensible and unrelated to me, like costumes for a drama in which I no longer have a part. I lack the desire for myself that

would teach me what to choose; I lack the sense of stardom in my own life that would urge me to adorn myself. I am backstage, attendant. I have the curious feeling that I no longer exist in synchronicity with time, but at a certain delay, like someone on the end of a transatlantic phone call. This, I think, is what it is to be a mother. (210-11)

I went from pride and focus on my appearance to not caring at all— at times reveling in how far I could push the noncare, how many days I could wear the same jeans and t-shirt. I did care about what my daughter wore; her wardrobe was a reflection of me. It is still a great delight to curate. I have boxed away my prechild clothes as vintage clothes for Vy, as the extra twenty-five kilos I have gained since her presence on the planet render these useless to my body.

Mothers' groups can form a cultural clique (both real and virtual), as they define cultural codes for dressing and accessorizing babies and mothers. They may provide much needed support to many on what to buy, where to buy it, book reviews, recipes, and a great deal of practical, if sometimes unsolicited, advice. The mothers' group I joined in Hanoi was comprised mostly of expatriate women. Little can be said to one person in an expatriate community without it quickly becoming common knowledge. Anonymity and confidentiality did not exist. By far the oldest in the small group of mothers in this community, I struggled and felt anxious, and my baby responded to my anxiety. My fellow moms looked confident and self-assured with their babies. I envied the joy in their eyes.

Being the eldest, but least competent mother in the group was new terrain for me. In my professional life, I felt competent and was often the youngest of my peers; this new context sat uncomfortably with my identity.

The mothers' group filled me with a deeply wedged sickness in the pit of my stomach, an anxiety that gripped me before returning to work and beyond. I would sit there on the verge of tears as the other mothers laughed and ate homemade cookies and cake. I felt as if I had failed in the competitive mothering race. How were they able to pull this off with such aplomb and seeming joy? I wanted to scream. Did they really think this was fun? Where was the crack in their armour? Maushart captures my own sense of bewilderment perfectly:

The transition to motherhood is like some arcane initiation rite to a secret society to which the price of admission is (as with the birthing process that preceded it) an oath of silence. Only in this case the silence is maintained not only outside the group, but to a large extent within it as well, where communication, to the extent that it can be detected at all, proceeds obliquely in a kind of assumptive code only really decipherable in full. Motherhood in our society is, in short, a club so clubby that even its own members remain significantly estranged and ever anxious about their status, their entitlement to "belong." (107)

Although being in another country affected my context, I have spoken to many older mothers who agree they missed a connection in their mother's groups and did not feel comfortable raising their own issues within the clique.

## Food

I was the food on this planet, and the customer would not leave the café. My baby and my breastfeeding cushion were attached to me for four hours at a time. Vy was not really sucking, but she still held her mouth over my breast and her little hands held onto my nipples as we co-slept. As Maushart notes, breastfeeding puts women in a "reactive, essentially subservient position in relation to their babies" (167). Vy was the one in control of this situation, as her gums were positioned around my nipples to remind me not to make any false moves. In this context I recognized I needed help.

As there was no such thing as a breastfeeding clinic in Hanoi at the time, no expertise was close at hand. When I told my story of breast attachment through tears to a friend from UNICEF, she soon visited our home and pushed a pacifier into Vy's mouth, which was met with resounding screams. My daughter's cries were so unbearable that I left the house and walked around the neighbourhood wailing. I desperately needed to manage this, but to admit defeat felt like annihilation. I had never experienced something so important to me that I could not master, and I felt despair and failure. When I returned, my baby had happily attached to something other than my nipple. Feedings were now less than thirty minutes, and she happily self-soothed on her piece

of plastic. I gave her another two pacifiers for her little fingers to hold each night, and the cow was released!

## Health

My physical health had never been an issue before having a baby. At forty-two, however, I was informed I was having a geriatric pregnancy. In Vietnam, with little specialist paediatric support available, I was advised to have a caesarean. The process was fairly straightforward, and apart from several issues with mastitis, I returned home with child and husband after a couple of days. Two days later, I presented with rotavirus and almost lost my baby. Although my physical health returned, my mental health deteriorated. Already prone to depression, I knew my chances of experiencing postnatal depression were high. I understand depression; it has been my shadow since adolescence. But I recognized that this was different when one day I found myself lying naked on the floor crying and hitting my head on the floor tiles. I felt I just could not take it anymore; I could not stay still long enough to finish a hot coffee or a full sentence. I had lost all control. I fluctuated between thoughts of harming the baby and thoughts of self-harm; in my ultimate fantasy, we would both die simultaneously. My husband rightly pointed out that I needed to address my depression.

I have since accepted that suicide is no longer an option for me, as I am responsible for my daughter; but if anything were ever to happen to her, I would fantasize about how to source heroin so as to lie next to her in death. These ideations may seem extreme, but many of them are not unique to me and are cited as more common in older white mothers. They were, in fact, identified in a study of the US National Violent Death Reporting System (NVDRS), which assessed the estimated rates of pregnancy-associated violent deaths as deaths due to homicide or suicide during pregnancy or within the first year postpartum. The study found: "Older mothers were at greatest risk of pregnancy-associated suicide. Women 40 and above represented 17.0% of pregnancy-associated suicides but account for just 2.8% of live births in the NVDRS states. In addition, victims of suicide were significantly more likely to be White" (Palladino et al).

There was no English-speaking psychiatrist in Hanoi, although drugs were readily available across the counter without a prescription.

So I contacted my doctor in Australia via email, who helped me decide on Zoloft, an antidepressant not transferred through breastmilk. Zoloft helped balance my moods and mask my depression, but it did not touch my deep-seated unhappiness. I sought treatment from a private expatriate psychologist, basically paying to talk to someone who was bound by oath not to spread my stories within the claustrophobic expatriate community. I was paranoid that my façade of coping as a mum would taint my professional career and that my fragility would appear through the cracks in my nipples. As time progressed, my depression remained, and at the age of forty-five I added an additional layer onto the dilemma of my identity—I became a lesbian. I knew my husband had been telling others that I had left him for a woman and had destroyed his life, but I had remained silent on these issues to all but a few. I have spent many hours pondering why I did not act on my sexuality when I was younger and can only identify social expectations—the same expectation I feared as a mother—as the barrier. For many decades, my work had been my identity, but I yearned to have it all in the traditional social context: the husband, the house, the child. With this I believed, my life would then be complete, and I would be a success as a person beyond my work. Ironically, when I finally achieved all this at forty-two, my life fell apart. Instead of it being everything I wanted, I felt I was suffocating alone. Believing I was a bad wife and a bad mother, I buried myself in my work. It was not until I met my girlfriend that I realized there were other options.

My work identity was my only stability, as I could not form an identity as a competent mother. I still struggle and see myself as a failure. I have spoken to many mothers who recall recognizing that they needed to say goodbye to the person they were before they had their baby and embrace their new identity. I have never been able to do this. I kept wanting to be the woman I had once been, the woman who was competent, more in control of her life, more independent—not the scatty, insecure, double-doubting, and angst-ridden mother I had become. I felt like my old life was still waiting around the corner and I could not wait till the door opened. Just like Alice in Wonderland, I thought I would awake from this nightmare, that this surrealist adventure on planet motherhood was nothing but a Dali-esque joke warning me to be careful what I wished for. Penelope Leach recognizes the futility of this state of yearning to get back to the "real" and

"normal" self that is experienced by many mothers: "In truth they cannot get back to normal at all, because birth shakes up lives as children shake kaleidoscopes, leaving the patterns of the past in pieces" (54)

## Geography

I had traversed planet Earth as a global and itinerant traveler, flitting from country to country and from bar to party to café. But planet motherhood was limited to my house, where, if at all possible, I lay curled on my bed with the cat and my darkest thoughts. I had resigned myself to the feeling that I was no good at mothering, and I wanted to get off the bus at the next stop. I went into hiding. I could not communicate what was in my head. I felt I would be pitied, derided, and judged if people knew that I could not cope with being a mother. At my age and with my position at work, I could not bear the thought of abject failure, so I donned my mask.

Maushart encapsulates this feeling of donning the mask:

> The mask of motherhood is what mutes our rage into murmurs and what softens our sorrow into resignation. The mask of motherhood is the semblance of serenity and control that enables women's work to pass unnoticed in the larger drama of human life. Above all the mask keeps us quiet about what we know, to the point that we forget that we know anything at all ... or anything worth telling. (5)

My only competent self lived at work. I felt I had nothing to say on a personal level. Everything in my head was about Vy, which was not an enthralling topic of conversation, and I could not focus on the conversations of others. I went from being a social extrovert to an introverted hermit. I went from hosting social events and attending every work and social function, eager to frock up and feel good, to not leaving the house other than to drop my daughter to school and go to work. After I left the UN and began consulting, I no longer even needed to go to the office. Vy was no longer a toddler, and when she was with her dad, I would stay in the house for days without showering, barely eating, just drinking coffee and smoking cigarettes, pondering how this had transpired.

My early forays to local cafes resulted in heavy stares, mumbled whispers, and people actually pointing at me and talking to others at their table. Gossip filled the air; people knew intimate secrets of my life from my former husband, who informed everyone I had left him for a woman, resulting in a stone cold silence from the expatriate community. No one outside of my tiny circle of trusted friends even acknowledged me. My social life in Hanoi ended there and then; judging myself was debilitating, but watching others judging me was too much to deal with, so I went inwards in a desperate act to keep myself safe, and home was my haven.

## Religion

Many moms become avid supporters of what we might think of as different baby-care sects. The major churches of thought in Australia are associated with Gina Ford and Penelope Leach. Like in religion, Gina Ford is considered a guru. Her *Contented Baby* mom fans swear by her fervent practice of routines, to the extent that they will wake a baby in any circumstance if it is the set time in their fixed schedule or put the baby to bed at the scheduled time with no eye contact or cuddles to soothe their cries. Ford's routine and predictable outcomes were a fervent desire of mine, but my child was not a willing convert. Her cries stabbed my heart, and Ford was not to be my religious leader. My child would not tolerate a routine, and just like her I still challenge routine on a daily basis.

Penelope Leach, at the other end of the spectrum, advocates that parents listen to the needs of their child and assures them that intuition is all they need to soothe the child. One reviewer referred to her *Baby and Child* as "the child-rearers' bible" (Morrison). But this approach also did not work for me and made me feel more guilty as a mom for not having this supposedly natural intuition. Although I continued to read many other books with various approaches, none provided solace or support. I, like Rich before me, found "that calm, sure, ambivalent woman who moved through the pages of the manuals I read seemed as unlike me as an astronaut" (35).

During a work trip to UN headquarters in New York, I stood in Barnes and Noble in front of the section titled "Motherhood" looking for Naomi Wolf's *Misconceptions*. I scanned the shelves several times

before asking the information desk if they had the book. Even though Wolf's subtitle, *Truth, Lies, and the Unexpected on the Journey to Motherhood,* includes the word "motherhood," it was shelved in the "feminism" section instead. Why would a book that provides a critical analysis of some of the difficulties and the dark side of mothering be excluded from the motherhood section? This was no mistake. The store assumed that readers visiting the motherhood section were only interested in the pink and blue covers offered there.

Yet the books on those shelves were of little use to me, even though I skimmed many of them and read others, diligently following their approaches until the next book offered an opposing methodology. I could not find the authoritative, fact-checked source that was destined to be my compass from the main texts on motherhood. Later, when my daughter was a toddler, I discovered Maushart's *The Mask of Motherhood,* which was, and remains, my touchstone for traversing the depths of the demands, challenges, and joys of mothering. All the other tour guides I consulted were confusing or conflictual.

## Education

Before and during pregnancy, my reading about motherhood had focused on pregnancy and getting the baby's room prepared. It had not occurred to me that I needed to read up on caring for the baby. I had assumed that mothering came naturally and believed I would be able to wing it. I was excellent at winging it. I had a PhD—how hard could this be? For a decade, I had longed for a daughter. This was my dream. But somehow the intuition never arrived; instead, performance anxiety stood in its place. Panicked, I bought every book on babies and baby care that I could find. My thirst to fix this problem led me into the mire of the baby-care books as discussed above. My education was not to come from books or from myself.

I was clueless. In Hanoi, there were no English speaking maternal or paediatric nurses, maternal healthcare centres or helplines where I could ask stupid questions and seek basic advice. I did have a nanny, Khanh, a beautiful woman I watched as she cared for my baby. She was with Vy from the ages of three months to eight years. She was with her from the time I went to work until I came home, thus spending more waking time with my baby than I did. For this, I was thankful. At least

Vy would feel the confident hands of a skilled, protective maternal figure. Although I was jealous of what I could not do for my own child, I embraced Khanh as a part of our family.

I have since admitted to Khanh that I spied on her through the crevices of the doors but not like expatriates who spy on the hired help to ensure they are working well. I did so to learn from her. Watching her was my education. She was the expert—the person in my insular world who had the skills I yearned to have. Yet I never asked her to teach me because I was too embarrassed that motherhood did not come naturally to me. I am embarrassed to say I never bathed my baby because I was afraid that I would break her. I delegated that responsibility in the same way I did at work. Assessing the situation, I realized I was not the expert and needed the skills of another. Was this a sign of good judgment? My daughter got the care she needed. Was I strategic in returning to a place that valued and remunerated my skills, or was I just outsourcing being a mother? These were the thoughts that swam in the ocean of my mind while I curled into the tiniest space I could occupy at night in bed, hoping no one would see me.

## Economy

As an older professional single mother, I found the economic reality of being a mother claustrophobic. Suddenly, supporting a house and a baby, I was no longer a free agent, free to make my own decisions. The needs of my child, and secondarily of my ex-husband, became inextricably linked to my decision making, and I found it stifling. When we had moved to Vietnam, my husband had technically become my dependent, according to UN personnel forms. I received a financial allowance for both him and my child to be with me in my overseas posting. Dependents—and my forte had been independence.

I had given up my economic autonomy. As my husband was the at-home member of our family in the early years, he had paid the bills from our joint account and managed the household repayments. When I left our shared home in Hanoi, I continued to support him out of guilt, paying for his rent and funded him to establish a business. The feminist in me hated myself: I had lost autonomy over my finances, and each tiny decision became a battleground. Because of our highly acrimonious divorce, I could not take another posting, as my ex-husband would not

relocate to another country, and I could not take my daughter without his permission. He held her passport.

I am now in a position where, at the age of fifty-four, I doubt I will ever be able to afford to buy my way back into the housing market in my homeland. My five-year marriage cost me the deposit on our house and half of my pension. After thirty-five years in the workforce at a senior level, I have no economic security. Given that I have to support Vy for many more years, the stress and pressure often feels insurmountable. Most friends my age have their children leaving home and their houses paid off and are getting ready for retirement. My daughter, in contrast, is in primary school, and I fear I will never be able to retire. I am jealous. I am angry. I am scared. I have regrets. I made mistakes. I lost control. This is all because I had an unsuccessful relationship and a child. Economic stability is critical in raising a child.

## Employment

In the workplace, being the boss was something I had grown used to and enjoyed. And as Maushart observes, "it is those women who are accustomed to being 'the boss,' to 'having control'—and who mistakenly carry those expectations over into their new role—who tend to be the hardest hit" (124) by the reality of motherhood (most common for women who mother at an older age). The reason for this, she argues, is that "most new mothers have been schooled to believe that an infant's behaviour is primarily a reflection of the quality of mothering it receives—again our obsession with control, rearing its ugly and altogether inappropriate head" (124). As a self-confessed control freak and an overachiever, I felt these words hit the mark: My maternal performance anxiety was tied to my conditioning that if I tried hard enough, I could be the best mum ever.

The subhead to Anne-Marie Slaughter's *Atlantic* piece "Why Women Still Can't Have it All" states that "the women who have managed to be both mothers and top professionals are superhuman, rich, or self-employed." I had meticulously planned that I would have it all, and I was shattered to find that I could not. Again Maushart elucidates this point: "No Virginia, there is no such thing as Supermom. Lots of women may appear to have their cake (as mothers) and eat it too (as paid workers), yet the net result feels suspiciously like emotional bulimia" (179).

I was emotionally bulimic, bingeing into different facets of my life, with no balance in the foreseeable future. Australian journalist Annabel Crabb has aptly described this conundrum: "The obligation for working mothers is a very precise one: the feeling that one ought to work as if one did not have children, while raising one's children as if one did not have a job" (11). Although the media and society portray this as possible, it clearly is not. Many of us mothers still swallow this expectation even though we know intellectually it is nonsense.

My daughter, ex-husband, and I returned to Australia five years ago, and two years ago my ex-husband returned to Vietnam and rendered me a single mother with full custody. I found myself in a position that required more juggling, as the consulting in my sector involves international travel. A colleague recently said to me, "International aid is not for women," but what she meant was "International travel is not for moms." Managing overseas travel without a coparent or paid help was insurmountable, so there I was, changing identities once again because I am a mother.

I decided I needed to acquire an office-based job in Melbourne, Australia. Converting my thirty years of work in international development and women's empowerment, along with my PhD, into a local job based in Melbourne was neither immediate nor easy. At the age of fifty-two, it took me eleven interviews and two years to find a job. Although the most common feedback I was given was that I did not have the local experience of other candidates, I also believe ageism was at play. It was debilitating and embarrassing for me at this age, with my experience and qualifications, to think that I could not financially support the needs of my daughter. I had already hidden my age on CV and was about to delete my PhD, as many people also considered me over-qualified. My age and qualifications were a burden, not an asset.

## Politics

I once heard my husband tell someone, "Suzette does not have the patience for breastfeeding." This was a red rag to a bull, and the cow grew horns. My commitment to breastfeeding became a priority for me. The personal had become political.

As a feminist, I have always been cognizant of my body as a site of politics, from the size of my breasts to my fluctuating weight, from wolf

whistles to fat shaming. I was not a stranger to public sexism in its covert and overt forms. Still I was not prepared for the onslaught of people who felt free to comment on my image, decisions, and productivity in breastfeeding. In the most affronting example, two elderly white male heads of UN agencies publicly asked me if I was breastfeeding exclusively. Upon hearing that I was, one of them commented (in front of my staff, no less), "I am surprised you can still get enough breastmilk at your age."

Breastfeeding, the most natural process for sustaining life, has become political due to the commodification and sexualization of women's bodies. The media coverage of the forty-year-old Green senator in Australia, Larissa Waters, moving a motion while feeding her baby in 2017, which made her the first child to be breastfed in Australian parliament, sparked outcry. Sheryl Sandberg's Facebook message, "Go Larissa Waters—leading by example!" was contrasted by the thousands of Facebook trolls who condemned Waters as conducting a political stunt. The personal is political, and Parliament is a fine place for setting standards. Having New Zealand's Prime Minister Jacinda Ardern, a thirty-seven-year-old unmarried mother, take maternity leave and then be the first person to take her baby into the General Assembly also sets a standard that I wish I had seen as a young woman. For my daughter, I want this to be commonplace.

A decade ago in Hanoi, breastfeeding and expressing milk were curiosities. That it was not common practice at that time became apparent before my return to work. While on maternity leave, I was asked to conduct an interview for International Women's Day and was offered to be interviewed at home. When the television crew arrived, I was breastfeeding. In stark contrast to Vietnamese norms at this time, they asked to film me breastfeeding. In a country where both modesty and the status of infant formulae was high, I chose to subtly advocate through action.

Prior to my pregnancy, the main building at the United Nations in Hanoi had no breastfeeding room. It took some convincing to get such a room and then make it operational with a fridge and couch. Then came the challenge of convincing colleagues not to store their lunches in said fridge, which was resolved after a male colleague walked in while I was expressing. Another time, a senior colleague from the Asian Development Bank and I both needed to express milk during a

government meeting held at a major hotel. When I inquired of the hotel staff where we could go to do that, I was advised to use the toilets. I asked this gentleman if he, too, fed his child in the toilet and politely suggested that my colleague, and I would be more comfortable in the lounge in the reception area. Soon thereafter, we were provided a nice room close to our meeting hall for use whenever required. The end result was due in part to my white privilege and senior professional status. Although I was uncomfortable asserting my own needs, I was aware of the importance of setting a new precedent and recognized the need to use my privilege politically. My breastfeeding activism became the way in which I inserted the role of mothering into my approach of intersectional feminism.

Before then, my analysis of power and privilege was already conscious of the intersections of sex, age, race, ethnicity, sexuality, class, wealth, disability, education, religion, and other forms of identity. I had always identified myself as a white middle-class feminist. I was also a university-educated professional and now a lesbian, but it had not previously occurred to me that being a mother was an intrinsic part of my politics. None of the feminist and gender literature I had read had brought motherhood into an intersectional analysis.

But I now find as a middle-class, white, lesbian professional with a high level of education, nothing influences my identity more than being a single mother.

My work thus reflects Andrea O'Reilly's argument that "Mothering from a feminist perspective and practice redefines motherwork as a social and political act" (147). When I heard O'Reilly speak about matricentric feminism at an Australian Motherhood Initiative for Research and Community Involvement (AMIRCI) conference, everything fell into place for me. Her articulation aligned with my own analysis of my role as a mother and my practice of mothering my daughter. O'Reilly coined the term "matricentric feminism" to broaden feminist discourse to include motherhood as a site for feminist inquiry. Respecting mothering as valuable and essential, matricentric feminism "contests, challenges, and counters the patriarchal oppressive institution of motherhood and seeks to imagine and implement a maternal identity and practice that is empowering to mothers" (7). This social and transformative move for understanding motherhood shifts from a child-centred approach to one focused on the empowerment and agency of women as mothers.

## The Journey Continues

Embracing matricentric feminist mothering is still messy and anxiety-provoking for me. As Fiona Joy Green says in *Practicing Feminist Motherhood*:

> Since feminist mothers constantly interrogate the power dynamics of interpersonal relations (including their own) and larger social systems and structures to understand how gender inequality is produced, maintained, and perpetuated through the ideology and institution of motherhood, they are constantly engaged in the messy, tension filled, and sometimes conflicting work of uniting their feminism and their parenting. (51).

So here I still am, messy, vexed, and again reflecting on identity. I am clear that the Suzette I previously knew, whose skin I understood, is never coming back. She is galaxies away. My planets still need to merge with my future as a feminist single mom, but it cannot be as it was. This is not a fairy-tale ending, but it is where I am nonetheless, and I will continue to be here, no longer for my work but for my daughter and for our future.

My daughter is still my world. My love for her still overwhelms me every day and as her needs get greater so does the questioning of my mothering. I clearly do not have all the answers, but I am asking more questions. Telling this story has been a means to interrogate so many of my unchecked and devastating assumptions around professionalism, age, motherhood, and feminism. I do not believe that my experience as an older professional mom is unique. My precise coordinates may be different, but the history, culture, geography, economy, and politics of my planet may resemble those of others. As Maushart points out, "The lack of fit between expectations and realities of mothering may be experienced as a personal crisis, but it is ultimately a social tragedy" (118). This maternography of my personal crisis not only reflects how the societies in which we live do not fit our reality but also reinforces my commitment to ensuring that my matricentric feminist values shift those realities into a world that will be different in shape and form from the past.

## Works Cited

Crabb, Annabel. *The Wife Drought: Why Women Need Lives, and Men Need Lives*. Penguin, 2014.

Cusk, Rachel. *A Life's Work: In Becoming a Mother*. Picador, 2001.

Ford, Gina. *The Contented Little Baby Book*. Random House, 1999.

Green, Fiona Joy. *Practicing Feminist Mothering*. Arbeiter Ring, 2011.

Kitzinger, Sheila. *Ourselves as Mothers: The Universal Experience of Motherhood*. Addison-Wesley, 1995.

Leach, Penelope. *Children First: What Society Must Do—and Is Not Doing—for Children Today*. Vintage, 1995.

Leahy, Carla Pascoe. "From the Little Wife to the Supermom? Maternographies of Feminism and Mothering in Australia since 1945, " *Feminist Studies*, 45, no. 1, 2019, pp. 100-28.

Maushart, Susan. *The Mask of Motherhood: How Becoming a Mother Changes Everything and Why We Pretend It Doesn't*. Pandora, 1999.

Morrison, Blake "She Who Must Be Obeyed: Penelope Leach, Scourge of the Guilty Middle-Class Parent, Has Produced Another Book. Baby and Child became the Child-Rearers' Bible. Children First is a Manifesto for Children's Rights." *The Independent*, 17 Apr. 1994, www.independent.co.uk/arts-entertainment/she-who-must-be-obeyed-penelope-leach-scourge-of-the-guilty-middleclass-parent-has-produced-another-book-baby-and-child-became-the-child rearers-bible-children-first-is-a-manifesto-for-children-s-rights -1370667.html. Accessed 15 June 2022.

O'Reilly, Andrea. *Matricentric Feminism: Theory, Activism and Practice*. Demeter, 2016.

Rich, Adrienne. *Of Women Born: Motherhood as Experience and Institution*. Norton, 1986.

Slaughter, Anne-Marie. "Why Women Still Can't Have It All." *The Atlantic*, www.theatlantic.com/magazine/archive/2012/07/why-women-still-cant-have-it-all/309020/. Accessed 15 June 2022.

Wolf, Noami. *Misconceptions: Truth, Lies, and the Unexpected on the Journey to Motherhood*. Doubleday, 2001.

Chapter 10

# Shock of the New: Birth Trauma, Postnatal Depression, and Being Older

Caro White

We are still afraid to speak too loudly or too clearly on the subject of our own experience as mothers; still at pains to prove a point that should have been obvious long ago: that in the constellation of most women's experience, our children are no mere satellites; they are the very sun around which life revolves. And that this fact, however inconvenient, bespeaks no character flaw of gender, but rather the very greatest of human gifts. And also, as it happens, the very greatest of human challenges.

—Susan Maushart

Children are an absolute blessing, no question about it. I am in love with being a mum; nearly every day, I am grateful and uplifted by the unequivocal, unencumbered love that explodes in my heart during the moments that we share together. I have grown as a woman, adult, citizen, partner, friend, daughter, and counsellor. All the ways that I identify myself have changed for the better or at least have become more authentic. But to continue talking about all the good stuff only reinforces the advertising they show about the joys of parenting—and the advertising lies. There are thorns in the roses, my friends—thorns!

My daughter had a tough entry into the world, and I had an equally tough entry into parenthood. My relationship with my partner went through the fires of hell and burnt to a cinder our easy-going history. The good news is that like the Australian bush after a fire, we regenerated, but it was a process. The following piece is a reflection on the unexpected lows I came across and how I now hold them. I had little idea about postnatal depression and anxiety (PND/A) or birth trauma when I became a mother. My hope is to raise awareness about the condition through sharing my story.

I became pregnant at thirty-seven after many years of conceptualizing conception. It took a while to decide I really wanted to become a mum. At the time, my partner was forty-nine and already the father of two teenage children. He and they were nearing an increased personal independence and a spreading of their wings. I was completing my master's in counselling and feeling confident about my direction in life.

That confidence was rocked as I became a mother.

Like many women, I did not have an easy transition in to motherhood, which was complicated by a premature baby and the challenge of a blended family. I was naïve and completely unprepared, if I am honest. My partner and I struggled with feeling stressed and inadequate, and this was compounded by significant financial stress, resulting in an acute deterioration of our relationship. All of these things led me down the dark and well-trodden path of postnatal depression.

I approached motherhood with a healthy mix of arrogance and inexperience. I had little idea of what to expect and was too busy at university to concern myself with that—surely becoming a mum would be fairly straightforward? Most of my friends had become parents years ago, and they seemed to just roll with it. I figured that the pressure of postgraduate study would finish soon and my new role as mother would allow me to take a nice break from professional life. I was, in fact, looking forward to having some extra time on my hands when the baby came. I foresaw catching up with friends, taking some short courses, and generally enjoying the leisurely lifestyle that I had assumed was motherhood. Compared to work and study, I anticipated that mothering would be easy and natural.

Throughout my pregnancy, I was working as a counsellor while

studying my master's degree. I was living in a rural area outside Melbourne, Australia, and commuting to the city daily. Our household was made up of myself, my partner, and his children, aged fourteen and sixteen, who stayed with us every other week. My partner, Scott, regularly worked overseas for weeks at a time in a high-pressured role and as a result was not always around. I had arranged to finish work a month before I was due to give birth to allow myself time to buy baby clothes, transform the spare room, take the birth course, and read some books about parenting. But no such luck.

I went into labour at just thirty weeks and was rushed from our regional hospital to the city. It was horrendous; I was physically unwell, and there was grave concern for the health and life of my baby among the medical staff in attendance. I was wildly unprepared for a traditional birth, let alone this.

After an initially terrifying ten days of early labour, our daughter Scout was born at thirty-two weeks. She was whisked away after the short hug they afforded me, taken by a swarm of paediatricians to care for her unformed lungs and precious brain. I was left alone with my empty body and empty arms. That was that; I had given birth, apparently. It seemed impossible that the world kept on going about its business. How could everyone appear so normal around me when so much had just happened?

Scout was taken to the neonatal intensive care unit and hooked up to the machines that would keep her alive for the next five weeks. As much as the nurses tried to warn me, nothing can really prepare you to see tubes going in and out of your baby. It was hard to say "hello" to her at first; my private moments were all so public.

She was so very little. I was not allowed to hold her or stroke her skin, as she was too fragile, so I just touched her hand softly and tried to believe that I really was her mother. That was followed by a routine of breast pumping, filling her feeding tube, sitting next to the incubator, having short magical holds of her, and adjusting our lives around this new paradigm of having a premature baby.

I will never forget the dread I felt going home without her, the ball of fear in my stomach and the tears streaming down my face. It felt like returning home after someone had died, not after giving birth. It was all so upside down.

Scout came home at thirty-seven weeks, and although she was home

and safe, I just wanted to curl up and cry for all that had happened. Yet because I did not want to scare the older children or have them judge me, I chose to cry alone by our dam on our property or in my room, isolating myself in my grief. I was desperate for their acceptance of Scout and me and so conscious of how weird this must have been for them too.

During this period, numerous people (with the best of intentions no doubt) told me how happy I must be to be a mother and how well everything had worked out despite the rough start. "You must be loving life now that your baby is born and healthy?" they would say. I felt myself shrink each time someone said it. I felt I was meant to say that becoming a mother was the greatest thing that had ever happened to me. Despite their warmth and kindness, I felt distant from them and locked in a neuroticism about life, people, and the world. In response, I would say something like "Yes, things are great" in a high-pitched tone that betrayed what I really wanted to say, which was more complex :"Things do not feel okay. I love her endlessly and enormously, but I am exhausted and emotionally destroyed. Beyond exhausted. I am fighting with my partner; my body is so tense I am having panic attacks, and my baby will not sleep. It is not that I do not love my baby; it is simply so much more than I expected, and I am still really shaken up. Please, can you hold me?" The tell-tale signs of trauma.

Looking back, I suspect that if I had taken the risk to be more honest with people, they might have held and supported me as I needed, but the trauma had dropped me right into earlier patterns of insecurity about fitting in and belonging, fear of being rejected, and fear of not being good enough. And as I have since learned, this falling back into old attachment patterns is common during the transition to parenthood. It is because the stress is so great and the ground beneath our feet so uncertain, we tend to reach for the familiar inside ourselves and grab on for our lives. I experienced this return to old patterns myself, and I have seen it with countless others. The problem arises when these patterns of coping reinforce disconnection and shame, which they so often do.

Research has shown that unrealistic expectations are a key part of the formation of postnatal depression, postnatal anxiety, and post-traumatic stress. These unrealistic expectations are held by not only mothers but also by partners. How we handle our failure to meet these

unrealistic expectations informs the depression and anxiety. The fear or discomfort of failure can feed a self-criticism that gnaws at one's confidence to manage the unpredictable nature of babies and becoming a parent.

Despite some evidence that PND/A is less prevalent in older mothers in the early months following birth, most research suggests that older motherhood is in fact a risk factor for PND/A. This is based on the older mothers' tendency towards more rigid expectations, greater difficulty with breastfeeding, and higher potential for birth complications. Older mothers are often more used to having control over their lives and a well-established self-identity. Becoming a mum intimately challenges these things.

Birth trauma is a recognized risk factor for developing both PND/A and PTSD, and one in three women report their birth as traumatic. This does not mean that all of those births would be considered medically traumatic but that the women experiencing them felt they had faced a deeply disturbing and distressing shock to their nervous system that they could not down regulate from. In turn, partners can suffer from seeing their loved one bleeding, in pain, or terrified. A feeling of helplessness is key here. Afterwards, there is often no one for the parents to debrief with, and in the chaos following the birth of a baby, these emotionally overwhelming birth stories can become internalized and unprocessed. The rates of birth trauma for older mothers are high, as they are at an increased risk for pregnancy complications, premature birth, and stillbirth, and awareness of these risks is important.

Another high-risk factor for PND/A is a previous mental health issue, such as depression or anxiety. This was true for me. I had experienced several bouts of depression and anxiety across my lifetime as well as previous trauma. Still, it took me a long time to put together that I was really not coping well. Despite being a counsellor—or perhaps because of how I perceived my status as a counsellor—I did not seek help until things were truly desperate. Even then I did not exactly put my hand up; it was put up for me by my maternal child health nurse.

My thinking at the time resembled that of a fractured computer circuit, jumping from here to there and back again. Decision making was overwhelming, and I felt like I was drowning in the responsibility for caring for my child and maintaining some dignity in front of my

partner's children. I was suffering from severe sleep deprivation, which made it near impossible to make sense of much beyond the immediate moment. Answering the simplest of questions required me to stop and give my blank, foggy mind time to find words so that I could respond with some sort of coherence. This was frustrating for my partner, who did not understand why my ability to think and respond had become so slow. Unintentionally his frustration only increased my anxiety, which slowed my cognition further. No fault of his, he just did not understand what was going on—neither of us did.

I was the frog, and the pot was boiling; I had no idea how bad things were getting because I was so in it. I was sure I would figure things out, telling myself that I just needed to do some more reading about parenting. How many ways can you google "how to get a baby to sleep?" My resistance to reach out for therapeutic care was despite years of training in the field as well as years of my own therapy. I still cringe about this, yet I know I am not alone. Plenty of other professionals in the field do the same thing, perhaps believing that we should somehow have all the answers. This is part of a perfectionistic personality type—yet another risk factor.

And on top of all that, my attachment wounds came in to play as well. It seems I have ongoing issues with staying in tune with my own needs, which is part of my anxious, sometimes disorganized attachment style. Even though I had a basic understanding of attachment theory going into motherhood, it turns out having a child has been a fantastic training ground for gaining insight into my own attachment patterning and that of others. What I learned is that our attachment style will influence how we transition to parenthood, the potential development of mental health issues, and how we handle the increased relationship conflict that normally comes with having a baby. It will also influence how our babies develop their attachment styles, which in turn influence their relationships and friendships to come.

Generally, our attachment insecurities are triggered when we are threatened or stressed, and the transition to parenthood is ripe with these sorts of triggers. So, for me, when I get scared or stressed, I become fearful of abandonment, panicky that I am being left behind, that I cannot trust my partner to be there for me. I focus more on what others think and feel and use that as a way to affirm my self-worth and sense of self. I abandon my needs or get confused with thinking that

what I need is for someone else to behave in a certain way, which will then make things alright for me, but the reassurance of love and acceptance that I seek never seems sufficient. The anxiety comes because of my belief that even when someone does show up, they will leave again—a cycle of dissatisfaction and loneliness.

With compassionate hindsight, I can see that this transition to parenthood produced a whole new level of distress for me, with the baby demanding care, love, and attention; a partner doing his best to be there for me while experiencing his own mental health issues; and my partner's older children with all of their own needs. Where did me and my needs fit in to that picture? The storm surrounded me.

Although becoming a mother used to be the ultimate initiation into adulthood for women, it is no longer the case. Many women now claim their maturity and status by alternative means. Now we drink, have sex, move out, get a job, buy a house (if we are privileged), have an independent career, and generally take care of ourselves. These things have come to define our maturation. Although motherhood is no longer the pinnacle of adult status for most women, it still involves a significant movement from one sphere of life to another. For some of us, this new sphere lands us back into a not always comfortable state of dependence.

I noticed that for me and other women who decided not to earn a wage initially after having a baby, were unexpectedly disturbed by relying on a partner's income. Despite my partner's genuine declaration that the family's income was shared money, not contributing in the same way felt uncomfortable at best and even shame laden at worst. It felt like a harking back to the bad old days of dependency and the power imbalance between genders. It can complicate things between partners, or at least it did with us.

I hated asking for money, even though I knew it was fair. I was used to financially contributing, and without realizing it, my sense of worth was very much connected to that contribution. The significance of this in the context of older mothers is that we are more used to being in control of these things. When agency of any kind is taken away, it can be challenging. Navigating the waters of greater dependency can feel aggravating, scary, and disempowering, and reflecting on this with ourselves and our partners can help mitigate the problems it can cause.

It is not that my partner and I would necessarily fight about money directly, but there was tension in the air about our tight financial

situation. Our conflict was deeper than money. Neither of us was navigating our trauma well. We hung in there, trying to hold on to our connection, but we ended up hurting each other and suffering. My dialling-up behaviour and persistence and his opposing withdrawal behaviour became a negative cycle we now name "Out of Tune." We were out of tune with each other, our emotions discordant. We were angry, sad, hurt, as well as scared of losing each other. Our bodies clenched, bracing for the next tidal wave. The more in his face I got, the more he pulled back; the more I felt compelled to get his attention, the more he felt under attack and overwhelmed and turned away, hoping it would all get better on its own; and the more alone and sadder I got, then the angrier I got and the more alone we both felt.

Looking back over the whole transition period I see that I had to learn flexibility and how to let go of the idea that I was in control of much of what was happening. Babies are constantly changing; just as a pattern in their behaviour appears, it changes, through no fault of the parents—that is just the life course of babies. I needed to focus on what I could control and reduce my sense of achievement to small things that now became big—like having a shower, getting out for a walk, eating something other than toast, or drinking a cup of tea while it was still hot.

In addition to learning the importance of celebrating small wins, I also needed support to help me process the birth trauma and find ways to connect with my partner about what I (and he) were going through.

I was so self-conscious about fumbling and stumbling in front of others that I needed to find ways to be gentle with myself and not hide away from them. It took lots of big breaths to step through that shame and a strong conviction that connecting with people would help. Anything is better than being alone with depression and a baby to care for. I needed professional help, and not just from one source. It took help from my maternal child healthcare nurse, a sleep nanny, a counsellor, and a couple's therapist for me to repair—for us to repair.

Ultimately, my recovery included a huge amount self-reflection on my life so far, about who I thought I was, and who I now understood myself to be. Motherhood entailed a massive reviewing of identity— one I had not known would be so challenging and so transformative, both personally and professionally.

My expectations of myself were high and particularly influenced by

my educational and professional experiences. Those experiences had led me to believe that if I worked hard enough at something, I could master it. My sense of self-worth was tied up with this idea of mastery. What I learned was that professionalism, or being a professional, can be a great mask, one that distracts us and others from our frailties and our vulnerabilities. Without this mask and my old role, I found myself exposed—not only to the world but to myself. This exposure has made me humbler as a therapist and more authentic in my sense of self, which in turn has helped me cultivate more depth in my relationships and a greater awareness of those moments when I feel vulnerable.

There is absolutely no way that any of the romantic relationships from my youth could have endured what Scott and I have been through. For all the troughs our relationship went through, his maturity and mine have gotten us through dark days indeed. Our life experiences have given us the substance we needed to work though this set of issues. We were eventually able to support each other as we learned about moving through trauma and parenthood as a couple. In my younger incarnations as a partner, I had not yet learned how to stand back and mindfully view things from a distance in order to gain the grounding that a broader perspective can enable. As an older mother, I am more able to self-soothe in ways that I would not have been able to as a younger woman. That is not to say that other young women do not have this capacity, just that I did not, and that having the skills to gain greater perspective on my life and relationships has helped me a great deal.

Being an older mum has also meant less of the fun yet limiting booze and drugs of my youth. Finding more sustainable ways to be with my feelings and thoughts has been a big shift for me. My past has been dotted with drinking my feelings down to a place where I could breathe again. Now I just practice breathing instead. Mostly. Although the painful dissonance between wanting to hide myself and wanting to be seen still continues for me in times of stress, as I age, I feel so much gentler with these parts of myself that sometimes seem so flawed.

And despite initially feeling a lack of confidence when I returned to work, I am so thankful that I had a career behind me to return to. I have been able to adapt work to motherhood and to step into more financial stability than my younger years ever afforded me. I was able to land gently back in to work through volunteering, working small

hours, and receiving lots of supervision. I started back with two days paid per week plus a few hours volunteering and took seven years to start working full time. I work solely in private practice now, which gives me the flexibility to work around Scout's needs and the needs of my nervous system. This flexibility has been key for our balance as a family.

How I wish I had sought help earlier. I feel so much love in my heart for the younger me who went through all of this. I can imagine that if I were able to meet her now, feeling lost, overwhelmed, and ashamed, I would wrap my arms around her, make her a cup of tea, and invite her to sit down and relax while I jiggled the baby. I would remind her of all she had already achieved. I would tell her everything will be okay and that she is doing an amazing job in the middle of some really difficult circumstances. I would stay with her and rub her back, take her into the sunshine to enjoy the beauty of nature, and rally support to wash those goddamn floors and look after the meals.

I had so wanted to get it right. And because of the crisis that babies sometimes create, I could not see that there was actually no right way to mother—just the need for resilience to bounce back from all the miscues, the failed experiments, and the inevitable bumps in the road.

It has been tough. There is no doubt about that, but as I dive back into my memories of the past seven years, I am touched and full of respect for that fiery initiation into motherhood, with its sharp licks of confusion and fear, disorientation, and ultimate surrender.

And my hope is that by reading this, you are soothed of some of your own self-doubts and prepared for your own possible challenges. Go gently out there and reach out to your loved ones because we absolutely cannot get through this on our own. We need to be kind to ourselves and each other. We need to talk more with our partners about our individual and shared expectations. We need to remember that we will not be able to control our babies. And we need to expect some challenges to our identities and how we feel valued in the world without our familiar professional roles and status.

I want to make a difference for others out there who are becoming parents for the first time and create softer landings for those who are toughing it out. I want to be the person that I wish I had known at the time: someone who is otherwise pretty competent and established and who is honest about their struggles with their depression and

confidence as a mum and holding her head high despite all of that.

A large part of recovering from the trauma of Scout's birth has been a process of healing my own shame. I have shared my story many times in my role as a volunteer community educator on PND/A with the hopes of creating more safety and less stigma for others to share their stories. As I nurture others, I nurture that part of myself that felt as if it were drowning. I love my role as an educator and have spoken to many new parents and healthcare providers about what it feels like to go through it from the inside. In addition, I now specialize in working with individuals and couples who are transitioning to parenthood, hoping to reassure and nurture others who suffer from depression and anxiety as they usher and nurture their babies into this world.

I am a wounded healer, yes indeed. Always have been. With support and age, I have learned to compassionately turn towards my own wounds, nuzzle them, sit by the fire, and hold the suffering lovingly alongside the shame, acceptance alongside the disbelief, and awareness alongside the inexperience. My hope is to welcome any and all who need that warmth to come join me at the fire. There is plenty of room and the ground is well worn. It is better if we are together.

Being older as a mother is nothing to fear—well, no more than usual. It requires the same courage and flexibility that is needed at any other age, and we have the bonus of life experience and challenges already faced to remind us that we can overcome hard things. What we as older mothers perhaps need to remember is that reaching out is okay, mistakes are to be expected, trauma can be healed, and slowing down is very, very important. Drink in the smell of your baby's skin, watch and observe this remarkable creature, feel it all, and when possible, let the arms of the world come in to hold you as you wobble. Remember that this too shall pass; nothing lasts forever, and recovering from the storm is always possible.

The following lists are for you to reflect on your own perinatal mental health. This list may or may not be relevant for you, but knowledge is power, and it may be useful in relation to you, your partner, or loved ones in the perinatal period. Perhaps even to reflect on your own parents' experience.

## Key Risk Factors for Post-natal Depression and Posttraumatic Stress

- Previous history of mental health issues
- Previous trauma, particularly early childhood trauma or neglect
- Family history of mental health issues
- Physical health issues for mother or baby
- Death of a parent or loved one around the time of the birth
- Absence of one's own mother
- Birth trauma
- Premature birth
- Intense hormonal adjustment
- Trouble breastfeeding or settling
- Worry about financial or housing security
- Family violence
- Difficult sleeping patterns of baby or sleep deprivation
- Isolation
- Unrealistic expectations from self, partner, family, or community
- Loss and grief issues
- Previous reproductive loss (e.g., IVF, miscarriage, termination, stillbirth, and death of a baby)
- Difficult or complex pregnancy
- Relationship stress
- Perfectionistic tendencies

## Key Protective Factors

- Secure attachment and securely attached relationships
- Continuity of professional care
- Strong support networks (e.g., family, friends, communities, and other new parents)
- Healthy communication practices
- Positive sense of identity and cultural heritage
- Setting realistic expectations
- Developing an optimistic outlook
- Being physically healthy and engaging in regular self-care (e.g., exercising, eating well, reducing stress where possible, meditation or other contemplative practices)
- Access to a broad range of coping and problem-solving skills
- Openness to support seeking
- Access to support services
- Seeking help early
- Stable housing and finances

## Helpful Resources

PANDA: www.panda.org.au

Becoming Us: becomingusfamily.com

*Down Came the Rain* by Brooke Shields (Hachette, 2006)

## Works Cited

Maushart, Susan. *The Mask of Motherhood: How Becoming a Mother Changes Our Lives and How We Never Talk about It.* Penguin, 1999.

Chapter 11

# Making a Life

## Constance Morrill

My journey to motherhood was much longer than I intended it to be. I had always known I wanted a child, at least one, maybe more. When I thought about becoming a mother, my thoughts were that I would not raise a child in my hometown of St. Louis, Missouri; I would not choose a man like my father, in personality or in age; and there would be no violence or all-night fighting in my family. And unlike my own mother, I would work. In short, I envisioned the family I would make as utterly different from the family I was born into. I had raised myself in a civil war zone, where class, family values, and unconscious parenting were locked in constant battle, complete with broken glass and sometimes blood. What I did not fully realize, perhaps, was how the experience of trauma and the urge to heal it would become intertwined with my experience of parenthood.

I came from a family in which women were not raised with the expectation that they would hold powerful or responsible professional positions. This was especially true on my father's side, which was a whole generation older than my mother's. According to my father, his sister did not go to college because their father did not think higher education was necessary for women. Thankfully, my father did not share that belief. He also chose in my mother a woman who had started but did not complete her master's in fine arts, making her the most educated of all the women who married into the Morrill family.

My father, who had an exceptional math mind and immense self-control, followed his father into the insurance business, specializing in accident insurance and liability claims—a perfect match for a man who was also interpersonally risk-averse. A poster board created with

images and letters cut out of the newspaper by my father's friends at the time of his marriage to my mother in 1965 bore the words "so elusive, it took half a century to capture." My father was fifty-two. Marrying my mother, a thirty-year-old divorcée with a six-year-old son, was the greatest risk he ever took.

My mother was from Jackson, Mississippi, and had lost her father at age ten, six months after he returned from four years of army service in the South Pacific during World War II. A corporate attorney in civilian life, my grandfather trained spies for an elite reconnaissance unit during the war and assumed a larger-than-life place in the family, one beyond criticism or reproach. Losing her father—first to war and then, more concretely, to death—left my mother with overwhelming feelings of sadness and abandonment. She could not articulate these feelings as a child, but rage took root in her unprocessed grief. Yet it was unacceptable to be angry at a man who had been venerated as a hero and patriot in her family. While she idealized her father, she turned her rage against the two men she chose as husbands, men who were absent emotionally and a full generation older than her. She once told me that a psychiatrist had taught her "how to get angry," but I cannot help but wonder if he ever thought to suggest to her that she was angry at her father—for dying.

My mother did have a professional identity as a watercolourist. She had earned an undergraduate degree and then became one of a small cohort of women in the 1950s to go on to postgraduate study. Not long after starting her MFA at Washington University in St. Louis, she married her painting instructor—a well-known Irish-American artist of the era who was thirty-five years older than her, a start-in-the-morning alcoholic with a sixth grade education, and two adult children from a previous marriage. A letter I came across after her death revealed that she did not complete her spring 1958 semester of the MFA program. The timing suggested that she had become pregnant some months after her marriage, and in November 1958, at the age of twenty-three, she gave birth to my older half-brother. Five years later, she was a divorced, single mother giving painting lessons and counting pennies.

When she met my father, who was twenty-two years her senior with an Ivy League college education and no children, she needed financial stability and a sober partner. He offered both, and she married

him on December 11, 1965, six months after their first meeting. I was born in 1967, just seven months after my mother had a watercolour hang in the Metropolitan Museum in New York. Throughout the rest of her marriage, my mother maintained that my father had chosen her because she was "a proven broodmare"—a statement infused with resentment at what she saw as my father's failure to truly see, appreciate, or accept my mother's personhood. She was a woman of unique talent, courage, creativity, and thoughtfulness, yet her childhood losses had left her with deficits that she was never able to overcome. My mother was a physically abusive spouse, and often an emotionally (and occasionally physically) abusive parent to both me and my older half-brother. My friends would occasionally ask if she was an alcoholic, to which I would reply, "I wish she were, because that would explain a lot." As I grew up, her losses became mine, and in the chaos of her tormented marriage to my father, her violent outbursts at him, and his desperate but unenlightened attempts to temper the destruction, my needs often took a backseat to my mother's.

Growing up with parents who were a generation apart and who exhibited wildly different ways of being in the world—and quite aside from the domestic violence I witnessed—I received no guidance and had no expectations to live up to in terms of pursuing a career. I was also never pressured to adhere to other social conventions, like getting married. I was expected to go to college; beyond that, my future was a cipher. Some might consider this situation freeing, but for me, it was anxiety-producing. After finishing college, I was sure of only one thing: I needed to leave my parents' home and my hometown. I needed to find a way to support myself and not ask for too much help. I now know that I also needed time to process the various traumas of my own childhood and the ways I was parented in order to know who I was and what kind of life I wanted to make.

I struggled to find that life. In the process, which entailed a good bit of psychotherapy, I earned three different graduate degrees over the course of sixteen years, in French, international affairs, and social work. While I am keenly aware of how privileged I was to be able to pursue these degrees, only the last opened a clear professional path forward.

Yet none were wasted. The first two degrees, in particular, expanded my understanding of the world in immeasurable and vital ways, leading

me indirectly to my true calling. After five research trips to post-genocide Rwanda, where I interviewed prisoners accused (often falsely) of genocide as juveniles, having worked on over thirty cases as an interpreter for francophone Africans seeking political or gender-based asylum to escape torture and persecution in their home countries, and carrying the insights about myself that I had gained as a patient, I was ready for a profession that sought to heal trauma. I would become a wounded healer, working to heal myself as I accompanied others on their journeys.

Becoming a mother did not happen easily for me. I met my true life partner, Jesse, in 2000, and we were married in 2004. We hoped to have children but were soon confronted with fertility issues that, while they had nothing to do with age, required extra time to resolve. During this time of uncertainty, in the fall of 2007, I began my first semester of social work school at Columbia University, a consciously chosen antidote to the pain of our situation. Although time was not on our side, in November of 2007, at the age of forty, I became pregnant.

And so it happened that I began to develop a professional identity at the same time that I was embarking on motherhood. As a clinician, I was forced to think constantly about relationships: those in the lives of my patients and my own therapeutic relationship to them as well as my relationship to my parents, my husband, my child, and to my *self*. Determined to finish the program I had started, where I was already seeing patients in a clinical internship, I had to incorporate my changing physical appearance into my sessions. It was interesting to see which of my patients noticed a change and which did not. My pregnancy itself was largely uneventful but culminated in a long and painful induced labour, followed by a caesarean section that left me in a fog of morphine, not as fully present as I would have wished.

None of this reduced our great joy. On August 9, 2008, Jake was with us at last—a beautiful and peaceful boy with big brown eyes and, as Jesse said, a look of surprise to find himself in the world outside the womb. I later learned the old expression "Everything's Jake," which meant "everything's okay." He certainly seemed to embody this meaning.

I took a year off from social work school, appreciating the luxury I had to do so, while Jesse worked full-time and held down our health insurance. My first five months with Jake were filled with intimacy,

wonder, and luckily, only a trace of post-partum depression. I learned firsthand how exhausting being a full-time parent of an easy infant who woke up every four hours for the first months of his life could be. Jake was an awake child from the beginning, and I relished sleep. But we were truly lucky to not have more serious problems. I breastfed him for about ten months, occasionally supplementing with formula, such as when I had mastitis and had to take antibiotics. I ignored any shaming messages about not breastfeeding exclusively. My husband never complained and was a more than equal partner in making dinner, changing diapers, feeding Jake, and being a generally great father.

However, in the fall of my second year in social work school, when Jake was almost one, I was diagnosed with a chronic lung disease, bronchiectasis, in the aftermath of being treated for a partially collapsed lung. This seemed an especially unjust diagnosis for an asthmatic and non-smoker. For most of the next ten years, I coped relatively well with this illness, which sometimes entails severe bouts of coughing to clear my lungs of thick ropes of mucus. Daily coughing has also affected my voice, such that I now, in 2020, sometimes sound like a smoker.

After being hired as a staff psychotherapist in an outpatient mental health clinic in Queens in 2011 and concurrently embarking on an intense training program in family and couple therapy, I told Jesse that I was worried I had taken on more than I could manage. "We'll make it work," he assured me. After building up a caseload of approximately twenty patients per week, I soon began working late two nights a week and seeing four families in a row at the family therapy institute. Jesse was picking up the slack in other areas and was consequently spending more time with Jake. As a therapist, I was working with adult individuals, couples, and children—all of whom had experienced some form of trauma in their lives, whether physical abuse, sexual abuse, and/or witnessing or experiencing domestic or other violence. Working with trauma came naturally to me. Emotionally, I could manage these experiences well, and being older was a definite advantage as a clinician. But I did not have a model of a working mother, or a stable mother, to fall back on—only that of a depressed, unpredictable, and narcissistic mother, and a somewhat rigid and emotionally absent, if well-meaning, father.

The responsibilities I shouldered in my professional life—which sometimes included negotiating the delicate emotional terrain of a

patient who was teetering between life and death—were intense but motivating. I was working to help heal the shame-inducing residue of sexual abuse in the individual and in the family, as sexual abuse often translated into the unconscious turning of a blind eye toward symptomatic behaviour in a child whose mother had been a victim. I was gently coaxing those who were terrified of interactions outside the incubator of therapy to take risks to prove to themselves that they could begin to manage real life. I was facilitating the clarification of couple relationships, helping partners to identify and elucidate patterns of interaction that could pave the way for more conscious decision-making about communication, values, and their futures, and serving as an enlightened witness for mothers and fathers who were daughters and sons of narcissistic mothers and fathers, and who, like me, were trying to not fail their children.

This was rewarding work, and I was trying hard not to make mistakes. Such mistakes were usually about timing, technique, and form. Psychotherapy is more an art than a science, and there were times when detailed brushwork did not lead to more depth, and times when I was just using the wrong brush. I was dedicated and careful, and I felt the individuals who entrusted their stories to me deserved my complete mental and emotional presence. But after seeing my full caseload of patients, I could not complete all my required paperwork fast enough to get home before my son's bedtime on my work nights. And for this, I felt guilty. Jake had a present and stable freelancer father and an increasingly physically absent, working mother. Again, timing, technique, and form.

Inevitably my humanness was as present in my work as it was in my parenting. I made missteps at work and at home. In general, I was able to repair and rebuild if I made a mistake with my patients, and often these exchanges were enriching and deepened the therapeutic relationship. But with my son, the stakes were higher: He did not have the option to dump me. At least not yet.

There were moments when I had to take or make phone calls that interrupted my time with Jake, and occasionally, I made room to see patients on the weekend, especially in order to have a collateral session with another family member that could not happen without a change of schedule. I would always check with Jesse before making these adjustments, and he almost always accommodated me, but sometimes I

wished he would not. I had many late nights. Although this never got in the way of my dedication to my patients, it definitely caused problems in my family. I was often exhausted after a day of seeing eight to ten patients and then having to complete voluminous amounts of paperwork to ensure my sessions would be paid. I was regularly sleep-deprived, unless I had fewer sessions, or if my sleep was not disrupted by coughing or Jake calling out for something in the middle of the night. My guilt toward my son was palpable. My husband seemed to do everything without complaint, but he was unhappy in his own professional pursuits, and we could not reach each other on many fronts. He seemed depressed to me, although he would not admit it.

None of my professional experiences—or my forty-four years of living—had prepared me for how to react when my son, at age three, suddenly did not come to me for comfort and instead sought his father's arms. Here I was in training to become a family therapist, and my own child was letting me know I was not a "good enough mother."[1] How could I do this work if I could not get it right for my own family? I had to step back and survey the situation. By default, my husband had become the hero of our family. I was both grateful and jealous, and saddened by the recognition of those feelings. It seemed that my focus on my new career, for which I thought I had to play catch-up because of my late start, had compromised my relationship to my own child. And this left me feeling helpless, guilty, and stupid.

Sometime in January of 2012, the following scene played out. I was sitting on the floor of our bedroom with Jake, whereas Jesse stood. Jake was clearly upset about something but could not fully articulate it, as his few tears were infused with anger. I believe I had just come home from work. Jake was an early talker, but this was beyond his developmental capacity. I tried to hold him, but he pushed me away and moved towards his father, who had crouched down to receive him. Neither of us knew what to do about my apparent failure. I felt an overwhelming sense of inadequacy, sadness, and helplessness rising inside me. At the same time, I was irritated that my husband could not fix the situation. Jake had picked up on my sadness and sense of failure, but it was not his job to comfort or appease me, and he clearly wanted nothing to do with me. In my dejection and confusion, I wanted my husband to know how to make me feel better, yet of course this situation was not his fault. Still, he became the unfortunate target of my angry defenses as I was

unconsciously swept up in the object world of my childhood in which my father stood helpless against my mother's narcissistic rage, underneath which was a desire to connect and be seen. Jesse preferred to not talk about things because talking, he said, always made him feel worse. I yelled at him later, essentially demanding why he had not managed the situation better. He yelled back, telling me to stop accusing him of things he had not done wrong.

I was fortunate to have a psychoanalytically trained therapist to whom I described this scene through tears. I will never forget her words: "Don't let him [my son] think he can destroy you." This advice was straight out of Austrian-British psychoanalyst Melanie Klein's[2] playbook, and as a therapist myself—struggling to make sure I practiced what I preached—not only did I understand it immediately, but I also knew I had to use it to repair my relationship with my son. I had to show Jake that I could tolerate his anger and not make him feel responsible for my emotional wellbeing. Although I understood this principle theoretically, I had not previously experienced such overwhelming feelings of inadequacy or encountered such a scenario in my training. This, however, is where being an older mother was on my side. I had some hard-won maturity that I could tap into and chose to respond to my son's needs and put my own vulnerabilities in their proper perspective. When I got home that afternoon, I picked up a toy train and asked Jake, "Will you play with me?" I remember exactly where we both stood as he turned his head towards me with a twinkle in his eye. He came over to me, took the toy, and told me he wanted us to build a train track. So we did. Within a few days, things felt as if they were rebalancing. But this would not be the last time we had to adjust.

Jesse and I continued to fight and disconnect. Our fights had a distinct pattern, but we could rarely review and discuss them and come out with clarity. Jesse accused me of getting angry too easily, and I accused him of closing down any possibility of dialogue, especially about how to parent our son. In the language of couple therapy, I was pursuing, and he was withdrawing. Jake, at age seven, had also begun to express angry feelings. When his feelings overcame him, he would turn over chairs, slam his bedroom door, and throw his toys around the room. This only happened at home, never at school—evidence that he had the solid ability to manage his behaviour where the stakes were higher. On the plus side, I wanted to believe that he felt safe expressing

his anger at home. Watching him turn over chairs and slam doors summoned up images of my mother breaking mirrors, dishes, and furniture, but by then, I had learned that a child's anger was often symptomatic of a larger problem in the family. Indeed, it did cross my mind that my mother's adult tantrums were long overdue manifestations of sealed-off childhood grief and anger. Jake also began to yell at Jesse and me that he hated us when we told him "no" or when he was disappointed by circumstances that were beyond his—or our—control. So, did that mean Jake had a behavior problem, or did my husband and I have a relationship problem? I was not rattled by Jake's "I hate yous," but my husband was.

It helped that I could remember some good things my mother had done. She never fell apart—or allowed me to destroy her—when I told her I hated her. I had internalized my mother's ability to absorb my "I hate yous" to her without feeling that I had to protect her feelings, so I learned to bring forth her indestructibility as a positive incarnation of her within myself. My mother was not at all good at repairing emotional damage that she had inflicted, however, and I came to realize that making repairs with Jake was a way I could be the mother to him that I had never had.

And I knew Jake's rages were not like my mother's. He was letting us know that my husband and I needed to adjust our own behaviour and that we needed to be present in different ways and set limits more consistently. Jesse and I clashed about how to handle these episodes, which I felt were our responsibility. We had also argued in front of Jake but had not repaired these arguments, so Jake had not witnessed repair. This was a familiar pattern for both of us, with the one difference that my husband's parents had divorced when he was five, and mine had stayed together in abject misery for thirty years. Jesse would frequently express that he found Jake's anger disturbing, yet I found this comment frustrating because it was never accompanied by the recognition that it was our dynamic that was disturbing our child, and despite all my training, I could not convince him to consider his role in the disturbance.

One night I asked my husband, "Didn't you ever tell your parents that you hated them?" He said, astonished, "No, never." "No wonder you are freaked out by this!" I exclaimed, insight flooding in. I tried to convince him that it was normal for kids of all ages to feel anger at their

parents and to express this by saying "I hate you!" and that it was more problematic if a child felt he could not express any negative feelings towards a parent. In family therapy, this is called a "relational constraint." My husband was skeptical, and although he never said so, I imagined that he resented my appealing to any professional expertise I had, and I tried not to do it. Yet there were many times when I could not get him to discuss how to handle Jake's behaviour. I googled "when children say, 'I hate you'" and sent him links to numerous articles— evidence that this was a common and not necessarily problematic occurrence. He ignored them. I felt invalidated and angry. It turned out that he felt this way, too, but for different reasons. He had accommodated me so I could get my career off the ground, taking on the bulk of the childcare for the years I spent in training, and had also been frustrated in his own career, but he had kept a lot of his frustration from me, which was ultimately disorienting for me.

Eventually, we capitulated to each other and to our situation and attempted couple therapy—several times. I soon got over my shame at being a couple therapist in couple therapy. It was not until we found a psychoanalyst who did not let us get away with anything that we finally began to find our way out of the woods. Just because I was good at helping others see their way to clarity did not mean I could transform my marriage on my own. In addition, my husband finally agreed to go into individual therapy. Over the course of several months, Jake's anger slowly abated, and my husband was less disturbed by it when it flared.

Maintaining balance is still a daily struggle, as I try to manage my illness as well as find time (and usually fail) to exercise, sleep, and be present for my son and the various social and academic dilemmas he encounters. My husband and I both give each other time off as parents, which sometimes means we do not spend both days on the weekend together. Jake panics less about not understanding his homework, but I still get anxious when I am not able to help calm him down quickly. I worry that as time goes by, none of us will get enough sleep. But as Jake works his way through the sixth grade, we are finally getting better at helping him manage his anxiety by maintaining a more organized home environment, coordinating our schedules, and planning ahead, as well as building more fun into the week. We have also partnered with Jake's school to help him develop better organizational skills. I feel we are making progress.

Now at fifty-two, I am halfway through a psychoanalytic training program (the final frontier), which requires me to be in analysis three times per week but takes me away from Jake only one night a week during the school year. We have moved to be closer to his school, and he has been gaining independence by walking to and from school since the spring of his fifth grade year. I have a stable number of patients in my private practice, and Jesse and I are weaning ourselves from couple therapy, as our conflicts have subsided, and we have improved at making repairs. I have finally come to accept that my energy as an older mother with a chronic illness is limited, and getting to sleep before midnight gives me faith that I can handle the next day even if I am awakened by coughing or when Jake has a bad dream—but not both. The state of the world makes parenting and protecting our son from the onslaught of violent realities ever more complicated. But at home, everything's Jake, and we continue to make our lives.

## Endnotes

1. The concept of the "good enough mother" (now more broadly conceived as the "good enough parent") was first introduced by the British paediatrician and psychoanalyst Donald W. Winnicott (1896–1971). According to Winnicott, a "good enough parent" is one who is highly attuned to a child's needs from infancy and who, over time, naturally becomes more focused on other tasks, thus allowing the child to gradually experience feelings of frustration, such that the child may develop the ability to tolerate a parent's failure or loss of omnipotence without being overwhelmed.

2. Melanie Klein (1882–1960) influenced the development of child psychology through innovative play techniques and was an early developer of object relations theory. Her ideas were expanded upon and clarified by later psychoanalysts, particularly Donald Winnicott.

Chapter 12

# Late Motherhood: Working As If One Has Children, Mothering As If One Has a Job

Karen Christopher

I dreaded focusing on myself when writing this chapter on late motherhood among highly-educated women. As a sociologist, I am used to reporting data on other women. In past work, I have documented alarming levels of work-family conflict in North America and explored policies that could help mothers pull back at home and at work. Writing this chapter, however, made me own up to why I have been reluctant to explore how late motherhood has affected me. I have been afraid to admit that I gave up being on the academic fast track after having children.

I did not give up academia or research entirely; I still publish academic work, just not at the pace I did before having children. I still teach, work with graduate students on their research projects, and travel to academic conferences about once a year.

But once I had my son fourteen years ago—the same year I successfully went up for tenure—I told myself that I would no longer obsess and stress about publishing academic articles as I had before he was born. This decision relied on many kinds of privilege. First, now that I had tenure, I could afford to cut back on publishing without worrying about losing my job. I also had a partner, so if I quit publishing altogether and had to leave academia, we could at least

temporarily rely on his salary. I am a white, able-bodied, straight, cisgender woman and so have never faced unequal treatment or blocked opportunities on the basis of these identities. My children, so far, do not have special needs. In other words, the only things possibly holding me back in academia were my gender and having children in my mid-to-late thirties.

And the truth is that becoming a mother completely changed how I did my job. It now takes me far longer to begin, execute, and complete research projects. Although I think I have ultimately created better research these past fourteen years, given that I have slowed down and focused on projects one at a time, my research productivity—the main indicator of status at my Research I university—has suffered. I also now struggle to stay up-to-date on the burgeoning research in my areas of expertise. Whereas I used to spend weekends keeping up on dozens of journals in my field, I now devote maybe a week or two in the summer to this task, if I am lucky.

As a professional who waited until my mid-thirties to have children, I worry that my all-encompassing career impinges on my ability to be an involved mother. I know I am not alone in these worries. As Annabel Crabb put it so succinctly in *The Wife Drought*: "The obligation for working mothers is a very precise one: the feeling that one ought to work as if one did not have children, while raising one's children as if one did not have a job" (11). While working on this paper for an hour on the day before Thanksgiving, I was interrupted thirteen times by my eleven-year-old and fourteen-year-old, asking what food we had in the house, whether we could go to Target, when their dad would be home, how high one should turn on the burner to boil water, etc. (On the upside, they learned how to make a classic American dish: mac and cheese.) This example shows that I clearly cannot work as if I do not have children, and I am not raising children as if I do not have a job.

How do I—and millions of other highly-educated mothers who had children late in life—negotiate family and work demands, and why is it painful for me to admit my struggles?

## Raising One's Children As If One Did Not Have a Job

Later childbearing can be beneficial to families, especially when mothers have high levels of education: We typically earn higher salaries

as we age and so have more resources for our kids. This is particularly true for partnered mothers, who often partner with another highly-educated person, thus increasing family income. More resources are clearly beneficial for parents and children. However, high levels of resources, combined with cultural imperatives to be intensive mothers and ideal workers can also cause stress and exacerbate class and race inequalities among families.

Although I was ready to have a child in theory, before my first child was born, I had no idea how time-intensive raising an infant would be. The simple biological functions alone, such as nursing, take up hundreds of hours if one fulfills the twelve months of breastfeeding recommended by the American Academy of Pediatrics—double that if mothers reach the two years recommended by the World Health Organization.

To avoid returning to teaching when my son was five weeks old, I took an unpaid leave for a semester. This is another indication of my marital and economic privilege, which many mothers—even highly-educated mothers—cannot afford. But towards the end of that unpaid leave, I felt I had squandered the time off because I had done little writing. How would I ever get anything done again with this fragile and precious being in my life? (So much for not stressing and obsessing about publishing.) I was also terrified of not being a good mother; sometime during the second month of my son's life, I realized that when I was holding him, I should be hugging him, not making sure I would not drop him.

Going back to work gave me much needed time away from my son and the ability to interact with colleagues. My partner and I created complicated schedules so that we could spend near-equal time with him and have as much work time as possible. We put our son in daycare, and managing my career and parenting was feeling slightly more manageable. When we had our daughter three years later, I was lucky to be able to time her birth with a year-long sabbatical (at half salary). But once again my anxiety over not getting enough done that year and being a good enough mother to two kids under four was daunting.

In terms of work, my research slowed significantly after having our children; I publish about half as many articles as I did before they were born. (At my university, a steady stream of publications is necessary for final promotion to full professor.) That does not mean that my work

load diminished significantly, however. Post-tenure, I have also taken on far more service obligations in my job, such as working with many graduate students, chairing our faculty assembly of more than three hundred faculty members, chairing departmental and college committees, and providing formal and informal mentoring of students. Increased service and teaching obligations are the norm for female associate professors across the board. Joya Misra et al. found that among associate professors at their university, "Men spent seven and a half hours more a week on their research than did women" (23). Women, in contrast, "taught an hour more each week than men, mentored an additional two hours a week, and spent nearly five hours more a week on service [which] translates to women spending roughly 220 more hours on teaching, mentoring, and service over two semesters than men at that rank" (23). Given my lower research productivity and higher service commitments, I am not certain when I will have met the expectations to go up for promotion to full professor.

On the home front, I found myself facing a set of standards typical of highly-educated, higher-income parents of all races that Annette Lareau calls "concerted cultivation," which emphasizes cultivating a child's talents with a wide range of scheduled activities and reasoning and talking with children rather than giving commands. It also involves actively intervening with professionals (such as teachers or doctors) on behalf of one's children and socializing them to be comfortable doing this. Others have used terms like "helicopter parenting" (or "tiger mothering" when applied to Asian American mothers) to describe concerted cultivation practices. Some parents do challenge these practices: advocates of "free-range parenting" reject the presence of hovering parents and grant children more freedom to do things on their own. But it is clear that at this point in the twenty-first century, mothering among middle- and upper-middle-class families has typically become a time-intensive, expert-driven, and expensive endeavour (Hays; Arendell). Indeed, research shows that even though most mothers today work for pay far more hours than in the past, they have also significantly increased the amount of time they spend with their children (Bianchi). This kind of "intensive mothering" (Hays) has become the norm, particularly among highly-educated, professional mothers.

Robin Simon's review of research reveals the drawbacks of our

current parenting practices: American parents are more anxious, depressed, and angry than nonparents. Simon suggests that several structural factors exacerbate these negative outcomes: Media and cultural practices idealize parenthood while the state provides little social support in the form of subsidized child care and paid leaves. When mothers are expected to enjoy every moment of parenthood in a context that provides little social or practical support, their wellbeing suffers. Although parents do report getting more fulfillment out of life than nonparents, that fulfillment comes at a cost to their psychological wellbeing.

My own research also shows that employed women, particularly those with professional jobs, do not engage in intensive mothering as much as in extensive mothering. Whereas highly-educated mothers typically hire caregivers to care for their children while they work for pay, they still consider themselves in charge of their children's lives. This supports Susan Walzer's claim that women bear the overwhelming burden of the mental load of parenting. Every highly-educated mother I know well considers herself in charge of her kids' schedules. When fathers are present, they typically are active parents—they drive kids around, cook dinner, do laundry, help with homework—but mothers organize it all. And this constant sense of responsibility, as we know, is exhausting. My research has found that single mothers feel less pressure to be an intensive parent because our society expects them to also work for pay. But single mothers are quite often stressed when juggling job demands and parenting on their own.

Non-Caucasian highly-educated mothers face additional stresses. As Patricia Hill Collins has written, African American parents also have to teach their children about racism and how to navigate racist institutions and situations without also teaching them they are powerless. As a white mother, I do not have to teach my children to dress and act certain ways to avoid police surveillance, which Dawn Dow has found is a common fear among African American middle-class parents.

We also need to be conscious of how upper-middle-class parenting strategies can exacerbate larger societal inequalities. My partner and I have struggled with decisions about sending our children to competitive magnet schools in our local public school system. (Our district's magnet schools are public schools but require applications from students and

choose students based on their qualifications.) These schools disproportionately accept upper-middle class children (like ours) with highly-educated parents, who are the least likely to need magnet schools to succeed. Margaret Hagerman writes about the "conundrum of privilege" in which the constant aim of most white, upper-middle-class parents is to give their children the best opportunities, but she notes that this also typically takes opportunities away from less-privileged children:

> White parents, and parents in general, need to understand that all children are worthy of their consideration. This idea that your own child is the most important thing—that's something we could try to rethink. When affluent white parents are making these decisions about parenting, they could consider in some way at least how their decisions will affect not only their kid, but other kids. This might mean a parent votes for policies that would lead to the best possible outcome for as many kids as possible, but might be less advantageous for their own child. My overall point is that in this moment when being a good citizen conflicts with being a good parent, I think that most white parents choose to be good parents, when, sometimes at the very least, they should choose to be good citizens. (qtd. in Pinsker 4)

As Jessica McCrory Calarco shows, these processes begin in elementary schools, where more privileged parents and students push for advantages and special treatment in schools, whereas lower-income parents are much less likely to intervene. This kind of concerted cultivation begins even earlier than many scholars have recognized. Such parenting practices are also particularly likely among older mothers, who are more likely than younger mothers to have completed higher education themselves and have more cultural capital to help their children navigate educational institutions.

When cultural norms push mothers to be proactive in developing our children's talents, advocating for them, and insisting on the best for them, privileged children will gain further advantages over less privileged children. Thus, this kind of parenting is not only quite stressful for mothers but can exacerbate social inequalities by class. And as Collins reminds us, centuries of structural racism in educational, economic, and political institutions in the United States (US) means

that class inequalities are closely linked to racial/ethnic inequalities.

## Working as if One Did Not Have Children

One benefit to having children later in life is that mothers are more likely to have completed higher education and be established in our careers. Among highly-educated mothers, this means many of us may have achieved tenure, made partner, or moved up the corporate ladder. We are also more likely than women in lower-wage jobs to have some degree of flexibility in our schedules (Williams, *Reshaping*), even if that flexibility is often fleeting in the US.

As noted, I myself had received tenure the year my son was born, following six years of extremely long work hours prior to his birth. But while these kinds of accomplishments may give us more flexibility after having kids, they also tend to be self-perpetuating. Feminist scholars like Mary Blair-Loy and Joan Williams have found widespread support in US culture for the notion of an ideal worker who prioritizes work life over all else and is socialized into a culture of overwork in professional schools and workplaces, practices that can be difficult to challenge. Small wonder, then, that the sociology program in which I earned my PhD in the late 1990s had never had a female faculty member who was also a mother. (Thankfully, this has since changed.)

But after having my son, I no longer wanted to work fifty- to sixty-hour workweeks. At our university (where my partner is also a professor), we have some degree of flexibility in our work plans, such as being able to keep our full benefits when working at 80 per cent of our workload. But few faculty go to this reduced workload, as most of us cannot afford to lose 20 per cent of their salary. (Our university has given faculty raises only once in the past decade, which means our salaries have come to cover fewer expenses over time.) In addition, many of us feel that our workload would not really decrease by 20 per cent, so we would be paid 80 per cent of our salary while working closer to 100 per cent. As a nonunionized faculty, we are not protected by collective bargaining agreements that might better protect faculty from overwork.

Many professionals struggle with long work hours in the US, even though research has shown that many dual-earner professional couples would prefer shorter work hours and more flexibility (Jacobs and

Gerson). However, there are few established ways to cut back in professional jobs. Mothers attempting to go part-time sometimes find themselves penalized with poor work assignments or with workloads impossible to actually complete on a part-time schedule (Stone). Even where flexible work policies exist on the books, few employees take them because (as Arlie Hochschild points out) they reasonably believe they will be penalized for doing so. Indeed, Joan Williams and Rachel Dempsey have found a "maternal wall bias" among employers that negatively affects African American and white professional working women seeking more flexibility at work.

As a result, work-family conflict is commonplace in North America. Recent quantitative research found that over 70 per cent of employed mothers reported experiencing "work-nonwork interference"—a measure of work-family conflict (Schieman et al.). Professional mothers are well aware how easily and pervasively the demands of work can invade our home lives—our work emails are often within arm's reach while we are helping with homework, cooking, standing on sidelines, or even trying to sleep. Qualitative research has long documented the stressful lives of employed mothers, which include second and third shifts of housework and emotional labour with family members (Hochschild, *Second Shift*, *Time Bind*; Walzer).

## Changing Workplaces and Parenting Practices

So what is an educated, employed older mother to do? Sheryl Sandberg advised us to "lean in" at work—to be more assertive, confident, and committed in our jobs. Many women bristled at this advice coming from a white, highly-educated billionaire who has an easier time "leaning in" to work than more typical North American mothers. Furthermore, women have been leaning in for decades—attaining more education, working more, and taking off less time when having children—yet persistent gender inequalities in pay and promotion remain.

To change this, as feminist scholars have argued for decades, we must acknowledge the cultural and personal power of the ideal worker and intensive mother ideologies and resist them in any way possible. This, in my experience, is hard in practice. As noted earlier, many older, highly-educated women are socialized into the long work hours

and laser focus on one's work implicit in the ideal worker model, which is an important component of the superwoman trope for working mothers who effortlessly do it all. And as Gloria Steinem pointed out years ago, "Superwoman was always the enemy of the feminist movement" (qtd. in Scott 5). A more egalitarian model would require all workers to work more reasonable hours and have time for families or other endeavours outside of the workplace

Challenging the ideal worker model will require at least two strategies—first, acknowledging how the workplace and family can constrain our lives and, second, not individualizing our problems. Over and over again, I have had conversations with friends and colleagues about why we do not have more time—a framing of the question that automatically assumes this problem is our fault.

Instead of interrogating and blaming ourselves, however, we should interrogate our workplaces. How could they be structured to allow us more flexibility? How can we challenge gendered strategies that disadvantage mothers at work? In short, we need to reframe the questions to ask how our workplaces can give us more time and how our families, schools, and communities can reduce caregiving demands on mothers and others who perform mothering responsibilities without pay, such as single fathers and grandparents. For example, in the US, more than 2.5 million grandparents have stepped into parenting roles due to an opioid epidemic that has left parents addicted, incarcerated, or deceased (Lent).

Even if we are unable to reduce our work hours, one form of resistance could be to no longer take on those aspects of the ideal worker model that benefit us least. For example, female academics could resist the pattern of doing far more service work than male colleagues, which often does not lead to promotion or pay increases. Could we allow ourselves to walk away from some of this service, even if we feel guilty? We can remind ourselves, and each other, that our male colleagues usually do not feel guilty doing this. And when we are able to point out these kinds of inconsistencies in work tasks and expectations without damaging our chances for promotion, we need to speak up. Women with class or race privilege may also need to speak up about gender-race inequities in work tasks, given that women with fewer privileges often face greater repercussions for speaking out. For example, given persistent racial stereotypes such as the "angry Black

woman," non-Caucasian women are more likely to be punished for speaking up. White professional women need to be aware of this and work with other women to implement changes that will benefit all women in our workplaces, even where the reasons for discrimination may vary.

We older mothers who have gained more security and power in our jobs can also push for structural changes that will increase flexibility for parents. For example, those of us on our university's Family-Friendly Policy Committee worked to implement policy changes for all university workers, such as increasing the length of paid leaves for both women and men and making the university calendar more consistent with the local public school calendar. Even small changes can have big effects, such as questioning the timing of meetings: Why, for instance, must some of the most important meetings take place at the same time that schools let out? More than one of my colleagues has had to remind their department chair that calling last-minute meetings can be a nightmare for working parents.

An important caveat to this discussion is that these actions do not diminish the need for mothers in policy-making positions. Compared to men or nonmothers in powerful positions, mothers in these positions are more likely to understand the need for family-friendly policies. If our society resisted the ideal worker model with shorter work weeks and more flexible workplaces, more mothers could become executives and politicians. Most countries, however, are clearly not there yet. Our corporate, legal, and political jobs typically require long work hours, which leads many parents, particularly mothers, to avoid these jobs.

One partial solution for mothers who do want those jobs would be to walk away from being primary caregivers. For partnered mothers, this may mean their partners could do more child care. This is often challenging in heterosexual couples because men typically earn more, so these couples would sacrifice his higher salary—not an easy or possible strategy for some families. This strategy would also no doubt be harder for single mothers in demanding jobs, who would have to increase their reliance on paid caregivers, extended family, and communities to help raise their children. But as Anne-Marie Slaughter and others have argued, we also need to reevaluate what matters. Many members of the younger generation are resisting the extremely long work hours required in high-profile jobs (Gerson), and as the old guard

slowly retires, we may see more acceptance of shorter work weeks. In the US, younger women are also postponing motherhood, and older mothers with more education and work experience may be especially well positioned to make change in future workplaces.

At the same time, enacting policy changes promoting flexibility is also vital because institutionalizing such changes will affect more employees and persist over time. Policies such as paid leaves for men could help men work less and care more, challenging both the ideal worker and intensive mothering models. Older mothers, who may also be taking care of aging parents in addition to young children, would benefit from paid leaves for elder- and childcare.

A micro-level way to challenge the model of intensive mothering is to give ourselves the freedom to walk away from parenting tasks we do not enjoy. For example, every winter I tell my children, "Mom does not do winter sports" because I hate being outside in freezing weather. Walking away from unenjoyable parenting tasks is undoubtedly easier for partnered women, who can expect our partners to do more. Straight couples can perhaps learn from lesbian couples, who tend to share household labour more equitably than straight couples and divide tasks based on partners' actual abilities and preferences (Brewster). We can also learn from changing norms within heterosexual couples over the past few decades: Whereas in 1965, US women did 6.8 times as much housework as men, in 2012, that had fallen to 1.7 times as much housework (Sayer). Mothers also need to allow fathers to learn how to do some parenting tasks their own way. As Williams points out, the gatekeeping involved in insisting that our way is the only way works against genuine equality (*Unbending Gender*).

There are also other models for mothers who do not have partners. A single African American mother I interviewed in 2010 said that she had raised her kids to be "community kids," relying on extended family for childcare to earn two college degrees and a better job. We need to recognize and perhaps emulate what Collins has described as the "other-mothering" in African American communities as an important source of caregiving and valid way to approach parenting.

Intensive mothering can also be exacerbated by institutions like schools. In my experience, many schools and after-school programs have a policy of automatically contacting mothers if children get sick or need something during the school day. Being able to identify a partner

or another caregiver as the primary contact instead is an example of small changes that can help diminish the mental load of parenting that tends to disproportionately fall on mothers. Letting go of some parenting tasks will require that mothers have more supportive partners and/or family members, communities, schools, and workplaces. These are not easy or simple changes but not impossible ones either.

## Conclusion

In sum, if we are to be able to parent as if we have jobs and work as if we are also parents, we will need more support. I have struggled with my lower research productivity since having children largely because I bought into the notion that academics should be working all the time, which is not a healthy way to work or live. When we challenge the idea that we must be all-in all the time—as mothers and as workers—we open up spaces for more egalitarian ways of working and parenting.

To do that, we need to change our policies and our belief systems; greater flexibility at work will be limited at best if the ideal worker model remains ascendant. Such policies as shorter work weeks, better pay for part-time work, and comprehensive sick leaves could create more humane conditions not only for those of us in high-prestige professional jobs but also for all workers. In addition, challenging the intensive mothering model, particularly its assumptions that mothers are ideal caregivers and that mothers' paid work is secondary to that of men, also helps challenge the sexism that underlies it. Structural challenges to capitalism and patriarchy could benefit all workers and parents, including but certainly not limited to professional, older mothers.

## Works Cited

Arendell, Terry. "Conceiving and Investigating Motherhood: The Decade's Scholarship." *Journal of Marriage and the Family*, vol. 64, no. 4, 2000, pp. 1192-1207.

Bianchi, Suzanne. "Maternal Employment and Time with Children: Dramatic Change or Surprising Continuity?" *Demography*, vol. 37, no. 4, 2011, pp. 401-414.

Blair-loy, Mary. *Competing Devotions: Career and Family among Women Executives.* Harvard, 2003.

Brewster, Melanie E. "Lesbian Women and Household Labor Division: A Systematic Review of Scholarly Research from 2000 to 2015." *Journal of Lesbian Studies,* vol. 21, no. 1, 2017, pp. 47-69.

Calarco, Jessica McCrory. *Negotiating Opportunities: How the Middle Class Secures Advantages in School.* Oxford University Press, 2018.

Christopher, Karen. "Extensive Mothering: Employed Mothers' Constructions of the Good Mother." *Gender & Society,* vol. 26, no. 1, 2012, pp. 73-96.

Collins, Patricia Hill. *Black Feminist Thought: Knowledge, Consciousness, and the Politics of Empowerment.* Routledge, 2000.

Crabb, Annabel. *The Wife Drought.* Penguin, 2015.

Dow, Dawn. "The Deadly Challenges of Raising African American Boys: Navigating the Controlling Image of the 'Thug.'" *Gender & Society,* vol. 30, 2016, pp. 161-88.

Hagerman, Margaret. *White Kids: Growing Up with Privilege in a Racially Divided America.* New York University, 2018.

Gerson, Kathleen. *The Unfinished Gender Revolution.* Oxford, 2011.

Hays, Sharon. *The Cultural Contradictions of Motherhood.* Yale, 1996.

Hochschild, Arlie. *The Second Shift.* Viking, 1989.

Hochschild, Arlie. *The Time Bind.* Metropolitan Books, 1997.

Jacobs, Jerry A, and Kathleen Gerson. *The Time Divide: Work, Family and Gender Inequality.* Harvard, 2005.

Lareau, Annette. *Unequal Childhoods: Class, Race, and Family Life.* University of California, 2003.

Lent, Jaia Peterson. "Grandparents Are Raising the Children of the Opioid Crisis." *Aging Today Blog,* 2016, www.asaging.org/blog/grandparents-are-raising-children-opioid-crisis. Accessed 16 June 2022.

Misra, Joya, et al. "The Ivory Ceiling of Service Work." *Academe,* vol. 97, no. 1, 2011, pp. 22-26.

Pinsker, Joe. "How Well-Intentioned White Families Can Perpetuate Racism." *The Atlantic,* getpocket.com/explore/item/how-well-intentioned-white-families-can-perpetuate-racism?utm_source

=pocketnewtab&fbclid=IwAR0Skz3OlyOxc6JNmmcAzQOz5
_16LflkElZBnERugQqTnqXShLH50yHQG3s. Accessed 16 June 2022.

Sandberg, Sheryl. *Women, Work and the Will to Lead*. Knopf, 2013.

Sayer, Liana. "Trends in Women's and Men's Time Use, 1965–2012: Back to the Future?" In *Gender and Couple Relationships*, edited by Susan M. McHale, et al., Springer, 2015, pp. 43-77.

Schieman, Scott, Melissa Milkie, and Paul Glavin. "When Work Interferes with Life: Work-nonwork Interference and the Influence of Work-related Demands and Resources." *American Sociological Review*, vol. 74, no. 6, 2009, pp. 966-88.

Scott, Linda. "Imagining Feminism in the Marketplace: Linda Scott (University of Illinois) Interviews Gloria Steinem." *Advertising and Society Review*, vol. 4, no. 3, 2003, pp. 1-7.

Simon, Robin. "The Joys of Parenthood, Reconsidered." *Contexts*, vol. 7, 2008, pp. 40-45.

Slaughter, Anne-Marie. "Why Women Still Can't Have It All." *The Atlantic*, July/August, 2012.

Stone, Pamela. *Opting Out? Why Women Really Quit Careers and Head Home*. University of California, 2007.

Walzer, Susan. "Thinking About the Baby: Gender and Divisions of Infant Care." *Social Problems*, vol. 43, no. 2, 1996, pp. 219-35.

Williams, Joan C. *Reshaping the Work-family Debate: Why Men and Class Matter*. Harvard, 2012.

Williams, Joan C. *Unbending Gender: Why Family and Work Conflict and What To Do About It*. Oxford, 1999.

Williams, Joan C., and Rachel Dempsey. *What Works for Women at Work*. NYU, 2014.

Chapter 13

# The Perils and Pleasures of a Peerless Life: Identity Changes in Midlife Motherhood

Elizabeth Allison

The year we turned fifty, many of my childhood friends sent their children off to college. My social media feed crackled with their gleeful news of their offspring's acceptance at prestigious schools. My own daughter began an educational adventure as well: She started first grade at our neighbourhood public school.

I was clearly out of sync with my age peers. Becoming a first-time mother in the middle of my fifth decade was unusual enough that my story was featured as the lede in a newspaper article about the "risks and rewards" of later motherhood (Yadegaran). My daughter was born when I was forty-four—advanced maternal age, in medical terminology, that made mine a geriatric pregnancy. Such language felt stigmatizing and inaccurate. Newly married and launching a new career, I was a novice, enlivened by beginnings, not winding down as such labels suggested. Others reflected this self-perception back to me: observers, including my own doctors, often assumed my age to be a decade less than my driver's license showed.

Midlife motherhood is becoming more common as women pursue advanced degrees and demanding careers. My professional and intellectual ambitions had taken precedence over family and domestic goals as I earned three advanced degrees and traveled across the world for

research. I met my husband on the cusp of forty and began trying to get pregnant without medical intervention in my early forties. For years, I tracked my cycles to the hour to catch the few magic fertile days each month. As the months ticked by, I began to assume that I was too old to get pregnant and began investigating domestic adoption. At forty-three, after bringing the same focus to achieving pregnancy that I brought to my academic work, I finally became pregnant. Toni Weschler's *Taking Charge of Your Fertility* served as my primary text, and fertility workshops that included intensive yoga and diet modification to decrease inflammation in the body were my coursework.

As I prepared for motherhood, my most common feeling was that of invisibility. It was difficult to find role models who could show what this next phase of life might be like. Most sources on motherhood in midlife urged slowing down and embracing one's empty nest. Available advice assumed that late pregnancy was an unexpected surprise, followed the birth of several previous children, or both. Although my late pregnancy might be considered a surprise in that I had not wanted children until I met my partner, I had no previous experience with pregnancy or motherhood. In books and articles, midlife first-time mothers were presented either as sleek, wealthy, high-powered professionals tended by a coterie of assistants or as aging, grand-mother-like figures coping with a host of chronic health conditions. Neither of these narrow stereotypes fit. Furthermore, the books and articles I found mainly addressed superficial matters of appearance and lifestyle —greying, managing aches and pains, planning for retirement—while remaining conspicuously silent on the inner work of remaking one's identity after decades of independent adulthood.

Just as I did not see myself reflected in the various sources I consulted, I did not have much in common with the other moms-to-be in my prenatal yoga class: twenty-somethings who were eager to embrace stay-at-home and high-touch parenting, who were developing their adult identities along with their identities as parents. After four decades of identifying as *not* a mother, I found myself peerless in my mid-forties as I navigated the most profound identity change I had ever experienced. My initial thrill with the joy that my daughter brought to our family obscured the necessary losses that taking on a new identity in midlife involved. With increasing numbers of women coming to motherhood at midlife, models of pathways through this transition are

needed. Candid descriptions of the changes involved can help new mothers navigate this life stage. For me, the absence of role models was initially disorienting, but it eventually allowed me to engage in a self-construction process in which I remade midlife motherhood, as well as my professional identity, to meet my own political, ecological, and feminist ideals.

## Deconstructing an Identity

Looking back at the first tumultuous years of my daughter's life and my own reinvention of myself as a mother, my biggest misperception was expecting that my life would go on as it had for so many years. Assuming that the priorities of travel, professional achievement, and outdoor adventure that had guided my life for decades would remain unchanged, I failed to anticipate the profound reordering of values, priorities, and motivations that motherhood would bring. I imagined the addition of an adorable, cooperative mascot who would make me look even more accomplished as I balanced travel and professional work with caring for a child.

Travel had been a dominant theme in my personal and professional life. In my twenties, I had traveled around the US for work, and in my free time, I had visited national parks for hiking and rock-climbing. In my thirties, travel intensified as I embarked on international fieldwork for my graduate degrees, living in the Himalayas and traveling throughout Asia. I had loved the newness, discovery, and surprise of travel. With motherhood, I expected this to continue without slowing down: I would throw baby in the backpack, just as the biochemist and pioneering mountaineer Arlene Blum described doing with her daughter in her memoir of mountaineering. I imagined that my baby would soon accompany me around the Himalayas, wrapped in a traditional Bhutanese baby carrier and helping me bond with village women I was interviewing.

This fantasy of unfettered freedom was soon burst. Travelling to Europe with an infant shocked me into recognition of how much my life had changed. In hazy days of nursing and diapering, I missed out on the gustatory and artistic wonders of Italy. I was disappointed to discover that I was not the relaxed, easy-going mother that I had expected to be. Instead, my new priorities and anxieties reshaped my

approach to travel, leading me to skip a family reunion in Bangkok—
a favourite destination in my footloose, single days. Previously, I had
not given much thought to what outdoors enthusiasts call "objective
hazards"—contaminated drinking water, inclement weather, poison-
ous snakes, rabid dogs, buses tumbling from steep mountain roads—
which I had believed could be managed with sensible planning. Now, I
found myself envisioning everything that could go wrong and harm
my daughter. Even our annual trips to the Sierra Nevada mountains of
California became exercises in constant vigilance and imagined
catastrophe. Later, I came to realize that my catastrophic thinking was
overblown and a convenient focus for larger struggles related to the
transition to motherhood.

Identity changes at work were equally confusing and disorienting.
My professional life had been about competence and achievement.
Suddenly, though, it seemed that colleagues now saw me mainly as a
mother, not as a scholar, and in so doing ignored my professional con-
tributions. Not wanting to feed this narrative, I seldom mentioned my
daughter at work and tried never to have parenting responsibilities
interfere with work meetings, lest I seem less serious or committed.

Even before my daughter was born, I, as the sole female member of
my academic department, had been advised to be maternal towards my
students and to nurture them—an essentialist expectation related more
to gender norms than to any particular competence. Especially after
motherhood, I bristled at the idea that my motherly skills would be
more important than my intellectual contributions. In fact, woman
professors who fail to conform to the gendered norms of caring are
routinely penalized in student evaluations. At the same time, gender
and academic norms elevate the archetype of the remote male professor,
dwelling in the realm of pure reason, unencumbered by messy material
realities. Immersed in the urgent bodily needs of an infant, I could not
avoid mundane materiality. Although the repetitive tasks of caring for
a small child can be a form of spiritual practice producing new insight,
the hierarchy of academic knowledge has largely excluded such
concrete and particular knowledge from its purview. Even as more
women join the professoriate, the incorporation of knowledge derived
from lived experience and daily practice remains marginalized, as do
the practical concerns of mothers balancing work and parenting.

If my motherhood was invisible at work—partly through my own

doing—I also felt invisible as a professional woman in the maternal sphere. The children of most of my age peers were much older. Other professional women who were mothers of young children were far too busy and pressured to meet up. The irony of our packed lives was that we were unable to spend time with those most like us, as we all were juggling too many balls. Many other mothers of young children seemed not to have demanding jobs. Many younger moms had not yet invested a great deal of time and effort into their careers and were able to pause their careers to embrace full-time parenting. Some stay-at-home moms suggested that it would be better for my family if I did not work because it contributed to household stress and took me away from my daughter. Of course, no one made the same arguments about not working—or even reducing hours—to my partner, which made me feel even more invisible, as if I were engaged in a scam. Becoming a mother thus made me even more aware of how women's desires—whether for intellectual stimulation or professional achievement—are excluded from the debates about what is good for a family. In the dominant cultural messages of maternal self-sacrifice, a mother is expected to subsume her goals to the good of her family and child. Pushing back on this cultural narrative requires concentrated effort.

With the early 1980s Enjoli perfume ad echoing in my mind ("I can bring home the bacon, fry it up in a pan, and never ever let you forget that you're a man, cause I'm a woooo-maaaan"), I imagined I would be twice as accomplished, twice as cool, as I mothered, worked, and travelled with ease. It was only later that I realized this vision from the media was part of the patriarchy's toolkit to keep women compliant and docile. If I were so busy spinning all my plates and making it look effortless, I would have no time to complain about the structural challenges facing women (and especially mothers), such as sexism, the motherhood pay penalty, and the lack of high-quality prenatal care, attention to women's postpartum health, and affordable child care. The goal of succeeding at everything while appearing calm and unflappable is a distraction from these larger, structural issues. The relentless pressure to be the perfect, fit, stylish, attractive, well-read, and hip-to-current-events mother is the current incarnation of the earlier "angel in the house" paradigm that kept women confined to domestic realms.

## Reconstructing an Identity

After the first couple of sleepless, disorienting years of motherhood, I began consciously reconstructing my identity as a twenty-first-century professional woman and mother. None of the available cultural models seemed to fit; all felt too restrictive for the multiple roles I played. Lacking peers or role models with my particular set of circumstances, I had to construct for myself a version of motherhood aligned with my values, threading the needle between the relentless, hyperfocused helicopter-parent narrative and the laissez-faire model of child rearing of the 1970s and 1980s. I had waited too long for my daughter to be disengaged, but neither did I have the time or capacity to lead her in weekly Pinterest-worthy craft projects. I also resisted the professional hyperachievement model of outsourcing all child and household care to paid help, which felt exploitive and exclusionary. Who could I be as a mother, then?

With the help of a skilled therapist, I began constructing my own version of motherhood upon three pillars: yoga, exercise, and support (condensed into the acronym YES). Ironically, perhaps, accepting support was the biggest hurdle and provided the greatest insight on my motherhood journey. Learning to ask for and prioritize support required humility and vulnerability. My conditioning as an independent autonomous actor made it difficult for me to ask for and accept help rather than give it. With time, I began to understand how essential support was in raising our daughter. My husband and I joined a neighborhood childcare co-op where we shared tips about infant care, then toddler outings, and now grade school sleepovers. The other families in the co-op, as well as two former grad student sitters, have served as the essential "village" required to raise a child in a hectic urban area without family nearby. Internet groups of likeminded mothers, particularly academic mothers, have also offered essential support, providing advice and empathy for balancing the demands of motherhood and career in a patriarchal society.

My process of developing strategies of support meant figuring out ways to share child raising and household duties equally with my husband. Establishing this feminist model of shared parenting has required me to investigate my own implicit expectations about the roles of mothers and fathers. The common cultural script of the incompetent or disengaged father who has to be directed or coerced into contributing to

the household by a controlling mother can be hard to overturn. Yet for me to flourish in my career and as a person, we had to approach the sharing of duties intentionally and collaboratively. My husband, who had himself been raised by two professor parents, had more familiarity with juggling work and family than I had observed in the traditionally gendered division of labour in my childhood home. During our first eighteen months of parenthood, my husband joked that I was responsible for input to our daughter, whereas he was responsible for output, handling nearly all diaper changes. This fact, along with his university's more generous parental leave policy, allowed him to establish a strong relationship with our daughter from the start. Supremely organized and efficient and with a campus office closer to our home, he is often the primary parent on call for school and doctor's office visits as well as the arranger of summer camp, after-school activities, and playdates.

The other two pillars of my new identity, yoga and exercise, have been essential for keeping my mind and body healthy. As a form of moving meditation, yoga links body and breath, calming the mind to focus on the present moment. My practice of Forrest yoga, a modality created by Ana Forrest to heal physical and psychological trauma, has helped me move through stuck patterns and emotions to generate greater aliveness in my body. Bike commuting, hiking, and other vigorous exercise releases stress and builds strength for keeping up with my daughter. Skipping physical activity during deadline crunches that create time scarcity only creates additional problems with my focus or mood. Research on the effects of parents' careers on children's behaviour supports my experience that children's emotional health tends to be better when parents put family first and are psychologically present, regardless of the number of hours parents work. In studies of work-family issues, Stewart Friedman and Jeffrey Greenhaus, for instance, found that mothers' dedicating time to relaxation or self-care was associated with positive outcomes for children, whereas time spent on housework was not. Yet a commitment to embodied self-care pushes against the myth of the professor as disembodied head on a stick who spends every moment lost in thought. Although the dominant cultural narrative would have the self-sacrificing mother devote herself solely to her child or the diligent worker skip taking breaks, it is hard to be engaged or effective when one's body and spirit are neglected. One

benefit of being an older mother is having a deeper understanding what is required for optimum effectiveness and a willingness to pursue it.

In addition to relying on these three pillars, my process of consciously reconstructing motherhood has led to weaving the values that drive my academic work into motherhood. My husband and I both study and teach environmental issues. Understanding ecological interconnections and developing ways for humanity to live more lightly and sustainably on Earth has become even more important to me since the birth of my daughter. The Native American perspective that views all actions in their long-term context by considering their effect on the seven generations of descendants to follow feels all the more poignant as I consider the biologically impoverished world that my daughter will inherit. Our decisions to install solar panels on our roof, drive a plug-in electric car, frequent a farmer's market, depend on bicycles and walking for short trips, and promote hiking excursions all serve to model and teach our ecological values.

## Supporting Midlife Mothers

With women's average life expectancy in the United States now reaching eighty-one, giving birth after forty should no longer be seen as freakish or geriatric but simply as the convergence of a number of trends related to advances in women's physical, emotional, economic, and professional wellbeing. As greater access to education and professional opportunities has allowed women to pursue desires beyond the home and family, women and girls (and men and boys) need comprehensive information about fertility, pregnancy, and postpartum stages so they can balance professional and family goals and exercise full agency over reproductive decisions. This knowledge base must be built from an early age. Giving every teenager the knowledge of women's fertility that I gained from Weschler's book would help provide the knowledge they need to map out the timing of their childbearing and professional goals.

Addressing the specific concerns of older mothers must begin with recognizing midlife motherhood as a unique life stage with its own set of concerns and developmental goals. Understanding the particular challenges and gifts of this stage of life requires more research. Creating opportunities for midlife mothers to share their stories, such as this

volume, can reduce isolation and invisibility.

Social innovation is also necessary to support older mothers. Older mothers in demanding phases of their careers will especially benefit from comprehensive pre- and postnatal care to support the many demands of childbearing on their bodies and time. All mothers need more generous parental leave policies and better childcare options to balance professional and family needs with a minimum of guilt and stress. Workplaces must provide greater accommodation to the physical needs of pregnant and postpartum women. Without job security, it is difficult for women to push back against professional environments' ableist expectations about the physical capacities of pregnant and postpartum women, which can vary widely.

Although older mothers may require more time to recover from childbirth, maternal and parental leave policies continue to be criminally short and underfunded in the United States. My state of California has among the best policies in the nation; it offers paid family leave of up to six weeks of partial pay for new parents to take time off to bond with a child and short-term disability insurance covering six weeks or more to recover from the birth. But compared to the six to twelve *months* of paid maternity leave offered by many developed countries (Raub et al.), even this three-to-four-month leave is brutally short.

## New Narratives of Motherhood

New narratives about what it means to be a professional, a mother, and a life partner are necessary to escape narrow, idealized roles for mothers that no longer reflect the lived realities of women's experience. Language that marginalizes midlife mothers as "older," "geriatric," "late," or "advanced age" becomes increasingly inaccurate as more women populate this life stage. New narratives can recognize women's pregnancy and the early years of motherhood as a relatively brief part of a long career arc during which they may scale back their professional responsibilities rather than a time when women must overwork, often on little sleep, while recovering from a major physical event and reconstructing their identities. New narratives should not valorize the overperforming superwoman but rather validate women who take care of their own needs and work within their physical and emotional limits. New narratives should depict professional and family respon-

sibilities as an interwoven pattern, with multiple on ramps into professional fields rather than a single linear upwards trajectory. Each woman will have her own pathway towards a new identify in motherhood based on her particular circumstances; sharing stories can illuminate possibilities. Ultimately, new narratives will arise only from women's talking honestly and authentically about the realities of our lives, discussing the difficulties inherent in transitioning to motherhood without intergenerational support, decreasing the ableist language that requires workers to be indefatigable robots, and recognizing that women can continue to be productive, contributing professionals and dedicated mothers.

Reconstructing my own narrative of midlife motherhood has meant relying on yoga, exercise, and support as well as strengthening connections to those parts of my identity that were suppressed during the intensity of parenting a baby. Although professional achievement remained a non-negotiable part of my identity—I launched a new graduate program in my specialty the year after my daughter was born—the previous priorities of travel and adventure took a back seat for several years.

For my fiftieth birthday, I requested a family trip to Iceland, embracing a long fascination with the place. That trip marked a reinvigoration of my values of travel and adventure, now in a family context, with my five-year-old daughter riding horseback and hiking alongside steep waterfalls and boiling geothermal mudpots. My narrative of midlife motherhood also includes space for an independent identity forged out of the fires of resistance and reconstruction. As I conclude this chapter, I am in Iceland again, solo this time, reconnecting with the core of myself, separate from my identities as a professor, mother, and wife. Although the dominant narrative of motherhood had led me to believe that it was impossibly selfish to take significant time away from my family, my husband and daughter, with the help of our neighbourhood co-op and supportive friends, have offered the incalculable gift of time and space for nurturing my essential core. Relying on support and tapping into persistent fascination have allowed me to find myself a room of my own.

## Works Cited

Blum, Arlene. *Breaking Trail: A Climbing Life.* Harcourt, 2007.

Forrest, Ana T. *Fierce Medicine: Breakthrough Practices to Heal the Body and Ignite the Spirit.* HarperCollins, 2012.

Friedman, Stewart D., and Jeffrey H. Greenhaus. *Work and Family—Allies or Enemies? What Happens When Business Professionals Confront Life Choices.* Oxford University Press, 2000.

Raub, Amy, et al. *Paid Parental Leave: A Detailed Look at Approaches Across OECD Countries.* WORLD Policy Analysis Center, UCLA Fielding School of Public Health, 2018.

Weschler, Toni. *Taking Charge of Your Fertility: 10th Anniversary Edition.* William Morrow, 2006.

Yadegaran, Jessica. "First-Time Moms over 40: The Risks, the Rewards." *The Mercury News,* 17 Sept. 2013, www.mercurynews.com/2013/09/17/first-time-moms-over-40-the-risks-the-rewards/. Accessed 16 June 2022.

Chapter 14

# It Is Revealing Itself: An Examination of the Identity Challenges of Late Motherhood for the Professional Woman

Maura J. Mills

D riven. Focused. Relentlessly Type-A. This was who I had been since some of my earliest work- (and school-) related memories. To be certain, children had always been part of The Plan (indeed, I had them named by the time I was ten), but equally as central to The Plan was an inexorable career focus. It was the latter that drove me through eleven years of continuous higher education, which in turn led seamlessly into a tenure-track university professorship.

I married. Bought a house. Got a dog.

I was on track. I was becoming who I had always intended to be.

But one year flowed into the next, and before I knew it, my 'prime childbearing years' were behind me. I had followed the path widely considered optimal for the successful tenure-track academic, only to discover that it was inherently at odds with women's biological clocks—and therefore inherently gender biased.

So, with requisite respect for The Plan, I quickly sought to balance the professional aspect of my identity by adding a motherhood aspect.

My son was born in the summer of 2014.[1]

I felt reasonably well positioned—perhaps naively so—to "have it all." (For a controversial yet worthwhile perspective on "having it all", see Ann-Marie Slaughter's work in *The Atlantic*.) My late foray into motherhood had enabled me to spend critical years in my late twenties and early thirties devoted to my education and career goals, thereby setting me up well for success in that domain. I felt strongly as though my career and my established professional persona could withstand the introduction of a child. And I was right—mostly.

In the weeks following my son's birth, I felt new. Yet somehow, I felt both old and new at the same time. In many respects, I was learning from the ground up, and my comparatively late motherhood—compounded by the fact that I nonetheless was the first in my friend group and network of colleagues to have a baby—meant that I had no one to turn to for advice or knowledgeable support. In that respect, I felt alone. Not helping matters, professional-tenure-track-me kept breathing down my neck, constantly reminding me that this was a time when I was arguably supposed to be at the height of my career, at least in terms of productivity. To that end, I took no work leave after my son's birth, although fortunately I had been blessed with a 'summer baby'—the most sought-after variety among academics in the United States (Armenti), which notoriously offers no federally mandated paid leave to new mothers (International Labour Organization).

Undoubtedly, these threats to my identity were exacerbated by judgment from others, which challenged my already shaken sense of self even further. Early into my motherhood journey, for instance, an (otherwise affable – and female, childless) acquaintance remarked that mothers will never be as worthwhile to the workplace as non-mothers, as the former have a constant and necessary distraction that must always come before the work. (Notably, she has since gone on to have a child of her own—also as a late and well-educated professional herself—and I often wonder how she would sit with that statement now.)

Such comments reflect an inherent societal bias against working mothers in general, at least insofar as ideal motherhood is perceived to be incompatible with the image of the ideal worker (which, not coincidentally, is generally male; Williams). This bias is likely compounded by so-called "late" motherhood, which further challenges societal views about a woman's family planning as mapped onto the employee lifecycle. Perhaps it is that once women reach a certain age or career

stage, any subsequent pursuit of motherhood is viewed as a twofold deviation from normative expectations and is therefore doubly judged. In this respect, I felt fortunate to be entrenched in academia, where being an older mother often seems more the norm than not, due in large part to the aforementioned overlap between age, the timing of doctoral training programs, and the tenure-track trajectory of the profession.

## Identity as Shaping the Work Itself

As an academic, I am fortunate to have considerable control over the focus of my research and writing. In the decade or so preceding my first child's birth, I had begun developing a research program that increasingly focused on work-family issues. After my son's arrival, however, my inherent interest in that domain skyrocketed, and I doubled down on that emphasis. Further, the lens through which I envisaged and approached that work became more nuanced and benefited greatly from the vastly improved insight I was gaining into that area of study. Motherhood gave me that. Becoming a mother had shifted not only my personal identity but also my professional identity. I became more passionate, more knowledgeable, and more focused on this particular facet of my work, as it became increasingly salient to me how parenthood so differentially impacted my professional and personal identities as compared to those of my husband, whose shift was comparably minimal (and whose employer expected his shift to be minimal).

This more streamlined focus on a work-family and gender research program started to occur as early as my pregnancy, during which time I chaired a popular conference symposium on the intersection of work, family, and gender, later followed by an edited book reflecting the same theme (Mills). Coincidentally, I finished the book mere days before my son was born (I recall making the final edits while sitting on a stack of towels in case my water broke). Only two months after my son was born, he and my husband travelled with me to my field's annual conference so that I could host another symposium addressing the work-family interface. This melding of my work and professional identities, I believe, was made possible largely by the fact that I was a late mother: I had already established myself well enough in the field to make these opportunities possible, and I had the skills to make them a reality.

## The Tipping Point

When my second child was born four years later, I unexpectedly struggled more after her birth than I had after the birth of my first. Perhaps the increasingly heavy burden I felt was due not only to now having two children for whom to care—although that obviously intensified my caregiving responsibilities—but also to being even more deeply familiar with the literature surrounding career women and mothering and the struggles inherent in managing both domains simultaneously—and society's (and employers') views of attempts to do so. With my first, I had tried hard to separate the motherhood side of my life from the professional side. It was not until a colleague remarked to me one day that I appeared "to have it all together" that it dawned on me that I might be doing other women (particularly women rising through academia and themselves aspiring toward both careers and motherhood) a disservice by divorcing the two domains so drastically. Therefore, after the birth of my second child, I made a conscious effort to be more vocal about the realities of working motherhood. And as a professor, I now make it a point to mention my children in my classes (and have since heard from more students about their desire to balance their future career alongside their future family – as well as their anxiety regarding how to do so). It has been rewarding to model the coexistence of these dual roles for the next generation, as well as to play a part in shaping the policies in the institutions and organizations that they will one day grow into.

## The Body of Identity

The impact of late motherhood upon my identity has stretched beyond the intangible, however. It has also been physical. Of course, one's body endures massive changes both during and after pregnancy. While some of these changes are visible, the majority are invisible, which also means that they go unseen and unrecognized by others (particularly those who have not borne children), who often implicitly assume that a woman's body has largely returned to its pre-pregnancy state following birth (and thus presume she is recovered). On the contrary, it is precisely during that time that many women—myself included—struggle in silence.

I have had three pregnancies, each of which challenged my physical identity in different ways. The first was a traumatic birth followed by a similarly traumatic "fourth trimester," which did in fact include many visible physical manifestations (e.g., full-body hives), although they were not necessarily related to my 'advanced' age. My second pregnancy presented both physical and psychological challenges. As is typical, I had decided to wait until the second trimester to disclose the pregnancy to my employer—making it all the more difficult to maintain my typical professional persona when I lost the pregnancy, during which time I continued to work for a month while waiting to miscarry, and ultimately underwent a D&C[2] when my body (as I perceived it at the time) failed me. Because pregnancy loss is more common in older women than in younger women (Nybo Andersen et al.), some may blame the loss on my own delaying of parenthood, though I would emphatically reject such blame.

My third pregnancy, when I was obviously at my oldest, presented new challenges. Although the birth itself was generally uncomplicated, I felt my body cope differently with my last pregnancy (and postpartum phase) than with my first. Coincidence, perhaps. But I was also not as young as I used to be. Not only was the pregnancy physically (and mentally and emotionally) draining, but it also presented me with new medical complications, including some that lasted well into my postpartum year, and some that are still ongoing.

In some respects, then, late motherhood has forced me to come to grips with the aging of my body sooner than I otherwise would have. But, interestingly, motherhood may have also slowed my aging process as much as it accelerated it, in line with the old adage "children keep you young." And although late motherhood has consistently challenged my identity and my sense of self from various angles, in some ways it has also led me to fall in love with myself all over again—and for very different reasons.

## A Literary Caution

I contrast my experience with that of my own mother. We each had our first child at the same age, but experienced very different paths insofar as the extent to which we envisioned motherhood as shaping our identities, both professional and otherwise. A former nurse, she quit

her job even prior to her pregnancy, intent on devoting her entire being to moth-ering, letting it envelop her identity entirely. In contrast, I could not let go of my professional self, and felt no desire to do so. I was determined to "have it all"—and took particular umbrage at the notion that motherhood might overwhelm my established sense of personhood as a woman and a professional.

To that end, I periodically found myself reflecting on Kate Chopin's feminist novel *The Awakening*, and a telling quote to which I continually returned: "I would give up the unessential; I would give up my money, I would give up my life for my children; but I wouldn't give myself. I can't make it more clear; it's only something I am beginning to comprehend, which is revealing itself to me" (122). Although it is usually the beginning of this excerpt that strikes me most sharply, its latter half provides an important lens for the perspective of late motherhood in particular. As a professional already reasonably well-established in my field at the time of my first pregnancy, I felt confident that my new motherhood would not overwhelm my professional identity, which was already so central a part of who I was.

However, I also underestimated the power of the small human beings I would soon meet, as well as the unending extent of their demands and needs—and the inexplicable extent to which they would pull at my heart and my soul. Somehow, as each arrived, they became my greatest achievements, and the best parts of me. This was something that, to reflect Chopin's words, I came to increasingly comprehend day by day, and that continually reveals itself to me as my children age— and as I age further alongside them. That is, although my sense of self and my individual identity and personhood are undeniably important, I am also increasingly coming to accept that a) my identity is malleable, b) it is increasingly tied up in my motherhood, c) it does not preclude my identity as a professional,—and d) this complex identity formulation *is okay.*

My acceptance of these facts was, I believe, made harder by my late motherhood, such that my identity as a professional (workaholic, if I'm being frank) was already so well-established that I therefore experienced any deviation from it as more threatening than it otherwise would have been. Whereas at a younger age this shift may have seemed more natural within an identity that was still itself developing, at a later age it felt slightly more like an affront to who I was and who I had believed

myself to be.

Finally, I expect that my identity balance will continue to evolve as my children age. I try to remind myself that at present both are at high-needs ages (one and four). Although every age and stage has its own demands, there is little that they can do for themselves at this point. They require constant attending to—a fact which in and of itself ties my identity and being almost inextricably with theirs. Even though this can be daunting at times—and can force a shift in identity more toward the motherhood end of the motherhood-professional continuum[3]—I strive to remain cognizant of the fact that this stage is fleeting, and that the fluid focus of my identity can shift not only at different times of day but also at different ages and stages of life.

## Conclusion

My identity has shifted, but it has far from collapsed. Late motherhood brought to me new challenges, and new rewards. It also allowed me to reap unintended benefits from my educational and career experiences that spilled over into raising my children, such as increased patience and a more research-informed approach to parenting. Moreover, I have largely reconciled my motherhood identity with my professional identity, have intertwined them where possible, and, broadly, have reenvisioned who I am and who I want to be. Most notably, perhaps, I am cognizant of the fact that this complex intertwining of identity facets will further shift as I mother my children through the various stages of their lives and also as I move through the subsequent stages of my career. In this way, I find central to my identity the recognition that it is malleable, and must necessarily evolve alongside the context of my life. This amalgamation of various aspects of my identity—and how I can remain true to each of them—continues, as Chopin would say, to reveal itself to me.

## Endnotes

1. This presentation makes it all sound very cookie cutter and seamless. However, it is important, I believe, to note that The Plan was also repeatedly interrupted by the unexpected and unwelcome—as are most people's plans. Along the way there were familial deaths,

cancer diagnoses, and fertility concerns, to name a few. Such trials, I believe, are more the norm than not (especially as we age), and thus I mention them here only to normalize the fact that sometimes The Plan appears to deviate into a Wayward Path, and to emphasize the importance of continuing the hike in the face of it all.

2. Dilation and curettage; an obstetric surgical procedure commonly used in abortions and missed or incomplete miscarriages.

3. Presuming such a continuum exists; I like to think it may be better represented by a Venn diagram.

## Works Cited

Armenti, Carmen. "May Babies and Posttenure Babies: Maternal Decisions of Women Professors." *Review of Higher Education*, vol. 27, no. 2, 2004, pp. 211-31.

Chopin, Kate. *The Awakening*. Norton, 1976.

International Labour Organization. *Maternity and Paternity at Work: Law and Practice across the World*. International Labour Office, Geneva, Switzerland, 2014.

Mills, Maura. *Gender and the Work-Family Experience: An Inter-section of Two Domains*. Springer, 2015.

Nybo Andersen, Anne-Marie, et al. "Maternal Age and Fetal Loss: Population Based Register Linkage Study." *British Medical Journal*, vol. 320, no. 7251, 2000, pp. 1708-12.

Slaughter, Anne-Marie. "Why Women Still Can't Have It All." *The Atlantic*, July/August 2012, www.theatlantic.com/magazine/archive/2012/07/why-women-still-cant-have-it-all/309020/. Accessed 16 June 2022.

Williams, Joan. *Unbending Gender: Why Work and Family Conflict and What to Do About It*. Oxford University Press, 2000.

Chapter 15

# Shrugging Off the Mental Load: Resisting the Roles of the Good Wife and Mother

Caroline J. Smith

On May 9, 2017, French illustrator and blogger Emma published a feminist cartoon "Fallait Demander" ("You Should Have Asked") on her website *emmaclit.com*.[1] The cartoon portrays what she, and many others, see as the unequal distribution of labour among parents. In the case of the white, heterosexual couple she depicts, the woman takes on responsibilities that far outweigh the work of the husband. Towards the end of the cartoon, the husband, surveying a mess in the kitchen, shouts, "What a disaster! What did you do?" The wife responds: "What do you mean what did I do? I did EVERYTHING. That's what I did!" The final speech balloon of that scene is the husband saying, "But... you should have asked! I would've helped!"

Emma's cartoon went viral, sparking debates about the mental load, which Liz Dean, Brendan Churchill, and Leah Ruppanner define in their 2021 essay "The Mental Load: Building a Deeper Theoretical Understanding of How Cognitive and Emotional Labor Overload Women and Mothers" as "the *thinking, planning, scheduling,* and *organizing* of family members—and the *emotional* labor associated with this work" (13). In both France and the United States, publications such as *The Huffington Post* and *Glamour* and websites such as *Scary Mommy* devoted time to analyzing Emma's work and discussing the distribution of labour among married, heterosexual couples.

If my husband and I had read this comic prior to the birth of our

first and only child in 2011, we would not have argued about it; we would have scoffed at it. As a feminist cultural critic, I felt, at the time, acutely aware of the potential gender traps that faced me as a mother. My husband, also an academic, was equally enlightened; together, we felt confident that we could defy traditional, gendered parenting roles. Intellectually, we might have understood the concepts of the second shift and the mental load, but with the arrival of our son, we would find that putting our beliefs into practice was much more difficult.

In this chapter, I would like to explore, through my personal experience, the pervasiveness of these societal messages about being a so-called good wife and mother—whether that means working the second shift or taking on the mental load. In my case, these struggles to achieve equality in parenting were complicated by my late in life mothering, the nature of my career, and the postpartum depression and anxiety I experienced. In order to make up for the time earlier on where I felt I had failed as a mother, I jumped into the roles of super wife and mother. My struggle, while personal, reflects larger political issues about work, mothering, and heterosexual marriage.

My husband and I were well aware of what Arlie Hochschild labelled the "second shift" in her 1989 book of the same name. To Hochschild, the second shift occurred when a mother finished performing her nine to five duties and came home to begin her second shift of the day, caring for her children and completing household tasks. In 2012, when *Second Shift* was rereleased, Hochschild updated her findings in her afterword. She noted that although on some level attitudes about gender and labour had changed, women still did a disproportionate amount of labour in the home. In fact, in 2016, the US Bureau of Labor Statistics reported:

> "Men spend on average 1.46 hours per day engaged in childcare compared to women's 2.16 hours per day. Additionally, men and women both perform other household labor, such as housework, food preparation, and garden care; men perform 2.13 hours per day compared with women's 2.61 hours" ("American Time Use Survey").

My husband and I, in our early married lives, worked hard to divide the household labour equally. Having married when I was thirty-three-years-old, and he was twenty-nine-years-old, we had had plenty of time

to develop independent approaches to housework, making slight adjustments when married. Together, at home, we easily fell into a rhythm where we pulled our equal weight, either taking on the tasks we most enjoyed or tackling whatever task we felt like taking on that particular day. We lived in Glover Park, DC—an area with access to restaurants, nightlife, and not far from the downtown, which provides residents with cultural activities galore. We both had academic work we were invested in. My husband was pursuing his PhD in evolutionary biology, and I was employed as a writing professor. We both taught, and we both enjoyed the research and writing that we did. While we had talked about possibly having children one day, my husband was much more enthusiastic than I was. It was difficult for me to conceive of a life like ours being enriched by a child; instead, I imagined a child derailing both our academic and leisure pursuits.

My mindset changed in April 2010. Even though I was entering the advanced maternal age demographic (women giving birth after age thirty-five), my biological clock was not dictating our choices. Rather, for the first time in my life, I felt a sense of stability. It became easier to imagine adding a child into the mix. We decided to buy a house. The DC public school system seemed less frightening and more easy to navigate the more research we did and the more we discussed it with other residents. I was coming up on a sabbatical, which would mean if our child were born in spring 2011, I would receive a semester of parental leave followed by a semester of sabbatical. Consequently, the steep DC child-care costs would be alleviated if my husband and I split childcare responsibilities at home. I would apply for promotion to associate professor in 2012, which meant a slight pay rise. We began imagining a little family and planning accordingly.

Our son was born in May of 2011 shortly after my thirty-eighth birthday. Just prior to his birth, we came up with a concrete division of labour. My husband would continue with his research and summer teaching responsibilities. While my husband was at work, I would take on primary-care responsibilities for our son. When home, my husband would watch our son so that I could flex my intellectual muscles by finishing up an editing project and beginning a new and exciting solo writing project about women's food memoirs that I had promised to work on during my sabbatical. We were embracing what Marc and Amy Vachon called "equally shared parenting"—a concept discussed

in their 2010 book of the same name. We looked forward to the upcoming year.

But it wasn't long before our carefully established plan began rapidly deteriorating. My childbirth was not the easiest. I laboured for twenty-four hours before the doctor detected our son was tachycardic. She encouraged us to have a caesarean section. In a cloud of fear and pure mental and physical exhaustion, we agreed. I spent a few days in the hospital physically recovering from the birth and learning to breastfeed. When we returned home from the hospital, things became even more complicated. I noticed that my scar was not healing correctly; in fact, one night, I stood up from working on my computer to discover the bottom of my shirt was covered in fluid and blood. I had developed an infection from surgery, which was treated with antibiotics. The doctor had difficulty finding an appropriate antibiotic; some made me horribly sick to my stomach, whereas others made me break out in a rash. Finally, after about two weeks, the doctors got things right, and I was physically on the mend.

My mental state, however, had begun to deteriorate. According to the National Institute for Mental Health, there is no one single cause of postpartum depression. There are, however, factors that can increase one's chance of experiencing it, including "a stressful life event during pregnancy or shortly after giving birth, such as job loss, death of a loved one, domestic violence or personal illness" and "medical complications during childbirth, including premature delivery or having a baby with medical problems" ("Postpartum Depression Facts")—two factors that I experienced. Although the National Institute for Mental Health asserts that "postpartum depression can affect any woman regardless of age, race, ethnicity, or economic status" ("Postpartum Depression Facts"), it makes sense that women giving birth later in life would be at higher risks for postpartum depression largely because women of advanced maternal age are more likely to experience the risk factors associated with postpartum depression (e.g., complications after birth as well as multiple births, which can more dramatically affect hormonal levels) (Morris Psychological Group). Recent studies have corroborated this correlation. A 2014 study conducted by Giulia M. Muraca and K.S. Joseph revealed that "the prevalence of depression in women who had recently delivered was significantly higher in women aged 40 to 44 years than in women aged 30 to 35 years." A 2018 study

conducted by Brittany Strelow et al. focused exclusively on the experiences of postpartum depression in older mothers, and the authors note the following: "Compared with younger women, older women generally have higher educational levels and professional positions with increased responsibilities and can suffer from elevated stress, and additional burdens of contributing to the family finances."

My husband was a cheerful coparent. When I woke up in the night to feed our son, he was awake right beside me. When I needed a nap, he took the baby. It was not long before he was taking on the majority of the responsibilities at home, even though he had research to do and classes to teach. Because my husband had taken on a lot of the childcare responsibilities primarily because I was physically unable, I became convinced that he was better with the baby. He was good at swaddling and soothing. He took charge at the paediatrician's office. Having been a high-achieving person much of my life, I did not understand why I was not excelling at these tasks, especially since mothering was supposedly my biological destiny. I could not think of my husband as a really good father; I only thought of myself as a really bad mother.

As a feminist scholar, on an intellectual level, I was conscious of the damaging cultural messaging regarding motherhood that society telegraphs to women. In *Representations of Motherhood* Donna Bassin, Margaret Honey, and Meryle Mahrer Kaplan describe this unrealistic image:

> The predominant image of the mother in white Western society is of the ever-bountiful, ever-giving, self-sacrificing mother. This image resonates with a mother who lovingly anticipates and meets the child's every need. She is substantial and plentiful. She is not destroyed or overwhelmed by the demands of her child. Instead she finds fulfillment and satisfaction in caring for her offspring. (2-3)

Yet despite being aware intellectually, emotionally, I found it much harder to resist this messaging. As my husband and I moved on with our lives, I began to think more and more about those early months and all the ways in which I had failed so spectacularly as a mother. My guilt was increased by the fact that because I had given birth later in life I assumed my life experience and book smarts, if you will, would help me excel at this job. I looked around at other mothers— some who

were only teenagers, and some with three or four children—and I could not understand how they were able to do it.

It is no surprise that it was my husband who helped to pull me out of what had become the consistent state of anxiety and despair. He fought to figure things out for us, calling around to see if there were any resources for new parents in the area. He found a moms' group which met weekly at our local library. He found a support group for moms with postpartum depression and anxiety. He helped me find a therapist. He supported me when I decided to go on medication for anxiety and depression. Each of these steps directed me towards the path of healing.

I returned to work in the fall of 2012. My husband and I had agreed —both for personal reasons and financial reasons—to keep our son at home, which meant swapping days. The classroom provided me with a welcome break from parenting. I drank coffee uninterrupted and talked with bright, young people about television, movies, and writing. On the days I was home with our son, we went to the library, took walks, and met other mothers and their young children for playdates at the park. My book project, though, went largely ignored. Prior to the birth of my son, I reserved time on the days that I was not in the classroom for research and writing. Now, I viewed those days as my mothering days. My days teaching became my off days from being a mom—the job that I found more demanding. Work on the book project that I had been so excited about prior to my son's birth had completely stalled.

I began slowly adding more and more tasks to my plate in an effort to make up for lost time with my son and to repay my husband for performing all the household and childcare labour early on in my son's life. In order to cope with my feelings of guilt, I took on an intense workload—both at school and in my home. Subconsciously, by taking on the second shift and the mental load, I was paying penance for my inability to fulfill my role as mother in those early months.

My overachievement started first at work. I taught my classes with the same level of enthusiasm and commitment that I had prior to giving birth. I still graded papers quickly, sticking to my two-week turn around policy even though the dean had increased the number of students in the first-year level writing courses I taught. In terms of research, I finished up the editing project I was working on with colleagues. I placed my individual book project on the back burner. Even so, the year I returned from family leave and sabbatical, I

assembled my dossier in order to be considered for promotion to associate professor. I received news that I was granted promotion in spring 2013.

Not only did returning to and excelling in my academic life provide a welcome relief from the monotony of childcare, but it also dampened the feelings of failure that continued to plague me, despite actively taking steps to improve my mental health. Checking off tasks as completed had been a measure of my self-worth for so long; it felt good to be able to successfully do that again. The checklist for motherhood (making sure your child eats properly, sleeps enough, learns, and grows) seemed much more daunting and unachievable.

At home, I began to undermine my husband's participation in parenting. We did not have any outside help except the occasional visit from my mother-in-law or a few hours with a babysitter. When our son turned four, we enrolled him in a half-day preschool program at a cooperative nursery school, which required both parent participation in the classroom one afternoon a week and mandatory parent education meetings once a month. I eagerly agreed to both. In addition to taking on these parenting responsibilities, I slowly began to take on the mental load that Emma illustrates in her cartoon. I became the person who scheduled the appointments, meal planned, and food shopped. I was the one who noticed the worn-out sneakers and ordered a new pair. I tried to become a classic, American, 1950s mother. The only difference was that I was also an associate professor.

As my son got older and much easier to deal with—sleeping through the night, attending full-day public school, and becoming a bit more self-sufficient—my husband and I found ourselves, surprisingly, embroiled in more and more battles over household labour. I began to become resentful of taking on what seemed like all of the household and childcare responsibilities. From my perspective, I was working a second shift, carrying the mental load, and playing the role of the default parent, even though my husband was perfectly capable of doing household chores, managing the household schedule, and parenting. I also became concerned about the effect this dynamic was having on our son. As he got older, would he begin to see women as people who provided for you, who took care of your personal needs, and who, in short, made your life easier? What kind of a message, as a feminist, was I sending to my son? In the age of newly elected President Donald

Trump, with discussions of toxic masculinity and white, male privilege consistently making headlines, I was worried that I was not smashing the patriarchy. I was fortifying it.

And, then, while researching for this chapter I stumbled upon Orlee Hauser's article, "'I Love Being a Mom So I Don't Mind Doing It All': The Cost of Maternal Identity." In it, Hauser discusses the concept of maternal gatekeeping as it relates to motherhood and identity. Writing for CNN, Elissa Strauss defines maternal gatekeeping: "when moms control dads' household responsibilities and/or interactions with their children." Whereas this article places blame on mothers for the lack of progress in regard to the distribution of household labour by citing their tendency to gatekeeping, sociologists have explored deeply embedded ideas of gender that contribute to this tendency, going back to the nineteenth-century construct of separate spheres (Allen and Hawkins 201). Hauser specifically discusses how the early research on maternal identity very much defined it as an identity "achieved" (331). She reflects on the maternal gatekeeping study done by Sarah M. Allen and Alan J. Hawkins: "The authors posit that mothers who gatekeep strongly associate doing family work with affirming to themselves and to others that they are good wives and mothers. As such, handing over childcare tasks to fathers threatens the manner in which they affirm this identity" (331). She also notes how Ruth Gaunt (in her 2008 article "Maternal Gatekeeping" for the *Journal of Family Issues*) observes that "the more significant maternal identity is to a mother, the stronger the gatekeeping behavior will be" (331-32).

As I read Hauser's descriptions of this gatekeeping process, I began to see my situation in a different light. In her study, Hauser conducted forty semistructured interviews with couples of young children (333).[1] Admittedly, neither the studies that Hauser cites nor the couples that she interviews comment upon how maternal gatekeeping might result from the desire to claim maternal identity after having suffered from postpartum depression and anxiety. Nevertheless, she draws several conclusions that resonated with my situation. Hauser notes that maternal gatekeeping also signals to children that their mothers are the default parent. I thought back to those moments when my son would ask me to perform a task for him regardless of the fact that my husband was sitting next to me on the couch. She also comments that although mothers "value the control that maternal gatekeeping provides ... [they

find] the consequence of added work and responsibility burdensome" (339). She continues: "While [these mothers] wish their partners would do more, they don't feel it is their [partners'] primary responsibility; they feel that as mothers, it is their own" (339). Again, in reading this sentence, I began to see the way in which all of the recent fights over workload may be sparked from my tendency to gatekeep.

It seems reasonable to me that my gatekeeping resulted from my desire to, as Hauser puts it, "achieve" maternal identity after having failed—early on—to establish one. Having given birth later in life compounded this gatekeeping. I had established prior to my son's birth a firm identity as a scholar and teacher, and in the early months after his birth, I continued to cling to those identities, since they came with goals and expectations that I was already familiar with. Establishing a role as mother at any age would have been difficult for me, but figuring out what it meant to be a mother after I had already figured out what it meant to be an academic was particularly challenging for me. Like most women, I struggled to reconcile my life as a working mom with the role of mom. Maternal gatekeeping became a tangible way for me to erase the feelings of inadequacy that I felt so early on in my son's life.

Even though I returned to my role as teacher and became comfortable with my role as mother, I found myself still unable to return to my book project. Prior to my son's birth, I had tricked myself into thinking that I would have a full year to work on the project. Parental leave, I thought, especially with my husband actively coparenting, would be more like research leave. I reasoned I was getting a whole year to research and write at full pay. (At my institution, professors receive 60 per cent of their pay if they take a full academic year of sabbatical, whereas they receive full pay if you only take a semester.) But things did not work out that way. Instead, I spent time recovering physically and mentally from my childbirth experience. After I physically recovered, I would diligently leave the house for a coffee shop where I could sit and write uninterrupted, but I never used that time productively. Instead, it became a mental break from motherhood.

My son will turned nine on May 31, 2020. It was only when my next sabbatical came up during the 2018–2019 academic year that I finally felt as though I was ready to return to my book project. I had attempted to make progress on it through the years, but I was unable to do so. It was almost as if that project were so enmeshed with my

traumatic birth and postpartum experience that I could not read what I had written without returning to that same mental state. I dutifully returned to it the summer after my second sabbatical started, but in order to do so, I had to restructure the book completely. I had to make the project almost unrecognizable to me so that the associations it held would not continue to haunt me every time I went to open a file on my computer.

The scholarship that I was able to produce during that time period was an essay that focused on the character of Betty Draper from the television series *Mad Men*, a period drama focusing on 1950s America. In retrospect, my connection to the series—and to this particular female lead— developed because I was puzzling out what it meant to be a mother. For me, Betty, who plays the role of wife to the leading man in the series, moves beyond the one-dimensional representations of mothers that we often see on American television. Betty is complex. Admittedly, she makes some poor parenting decisions, but she can also be surprisingly tender and protective with her children.

At the end of the episode "Shoot," we see these contradictions so clearly. The scene sequence depicts Betty frying sausage as the kids run in to eat. She excitedly tells her husband that she will be taking the kids to "the community center to watch them fill the pool." She plays with her daughter's hair. She takes laundry out of the dryer and calls to her children upstairs. The camera then focuses on the wall clock which reads 1:00 p.m. Betty sits alone at the kitchen table, still in her nightgown.

This domestic scene is undermined in the final shot of the episode. At the episode's start, a neighbour who keeps homing pigeons threatens to kill the Drapers' dog if it bothers his birds, much to the shock and concern of Betty's two children. Still in her nightgown, Betty grabs her son's BB gun. As Bobby Helms's 1957 song "My Special Angel" swells in the background, a high-angled shot shows Betty, cigarette hanging out of the side of her mouth, BB gun poised as she squints one eye, taking aim and shooting.

To me, this image captures the many contradictions of motherhood that I was experiencing as a new older mother—the strong pull to fulfill the archetypal role that Bassin, Honey, and Mahrer describe juxtaposed with the equally powerful feelings of doubt and anxiety that I was experiencing. Crafting this chapter—that is, making a narrative from the jumble of thoughts and feelings that accompanied me after my

son was born and that continue to arise each day I live as a parent to him—helped me to better articulate my own experiences and to make sense of how they have affected me as a wife, an older mother and a scholar. This final image of Betty serves me well. Although Betty's actions reveal the fierce love she has for her children, the image of her with cigarette hanging out of her mouth, gun cocked, is not the packaged product that is sold to us as mothers. As an older academic, I have always been adept at identifying a goal and achieving that goal. As an older mother, I found it nearly impossible to live up to the standards expected of mothers. In a world that values perfect mothers only— those who embrace their roles and perform them dutifully—the image of Betty and her BB gun might just better capture the complexities and incongruences that often come with such a role.

## Endnotes

1. For the purpose of this chapter, I am using the English translation of Emma's work.

2. The specifics of Hauser's methodology are such:

   The bulk of my data was obtained from a series of 40 semi-structured interviews with respondents who have young children living in the household. In all cases, the mother and father lived together and all but three couples were married. In most cases, the mother and the father were interviewed separately, so that they would feel more comfortable speaking freely about their parenting relationship. Each interview was based on a series of prepared questions pertaining to the respondent's parenting experience. Thus, I explored the same group of central themes with respondents while allowing for flexibility in terms of probing any comments that seem especially interesting. Interviews lasted from between 45 minutes to over 2 hours and were transcribed verbatim. (333)

## Works Cited

Allen, Sarah M., and Alan J. Hawkins. "Maternal Gatekeeping: Mothers' Beliefs and Behaviors that Inhibit Greater Father Involvement in Family Work." *Journal of Marriage and the Family*, vol. 61, no. 1, 1999, pp. 199-212.

"American Time Use Survey—2016 Results." *Bureau of Labor Statistics.* 27 June 2017, www.bls.gov/news.release/pdf/atus.pdf. Accessed 16 June 2022.

Bassin, Donna, Margaret Honey, and Meryle Mahrer. *Representations of Motherhood.* Yale, 1996.

Dean, Liz, Brendan Churchill, and Leah Ruppanner. "The Mental Load: Building a Deeper Theoretical Understanding of How Cognitive and Emotional Labor Overload Women and Mothers." Community, Work, and Family, vol. 25, no. 1, 2021, pp. 13-29.

Hauser, Orlee. "'I Love Being a Mom So I Don't Mind Doing It All': The Cost of Maternal Identity." *Sociological Focus*, vol. 48, no. 4, 2015, pp. 329-53.

Hochschild, Arlie. *The Second Shift: Working Families and the Revolution at Home.* 1989. Penguin, 2012.

Muraca, Giulia M., and K.S. Joseph. "The Association Between Maternal Age and Depression." *National Library of Medicine*, pubmed.ncbi.nlm.nih.gov/25222359/. Accessed 23 June 2022.

"Postpartum Depression Facts." *National Institute for Mental Health.* www.nimh.nih.gov/health/publications/postpartum-depression-facts/index.shtml. Accessed 16 June 2022.

"Shoot." *Mad Men: Season 1,* written by Matthew Weiner and Chris Provenzano, directed by Paul Feig, AMC, 2007.

Strauss, Elissa. "Maternal Gatekeeping: Why Moms Don't Let Dads Help." *CNN*, 6 Dec. 2017, www.cnn.com/2017/12/06/health/maternal-gatekeeping-strauss/index.html. Accessed 16 June 2022.

Strelow, Brittan, et al. "Postpartum Depression in Older Women." *National Library of Medicine*, pubmed.ncbi.nlm.nih.gov/29401116/. Accessed 23 June 2022.

Vachon, Marc and Amy. *Equally Shared Parenting; Rewriting the Rules for a New Generation of Parents.* Perigee, 2010.

"You Should Have Asked." *Emma: Politics, Things That Make You Think, and Recreational Breaks,* 20 May 2017, english.emmaclit.com/2017/05/20/you-shouldve-asked/. Accessed 16 June 2022.

Chapter 16

# Confronting Taboos at the Intersection of Motherhood, Age, and Gender: Confessions of a Near-Geriatric Tiger Mom

Lisa K. Hanasono

Throughout my childhood, I embraced fiercely and unapologetically the sometimes seemingly contradictory life goals of becoming a supermom and career-oriented family breadwinner. Reinforced by the repeated mantras of teachers, role models, and politicians who stated optimistically that members of my generation could "be whatever we wanted to be when we grew up," I remained blissfully unaware of the structural barriers and social biases that would govern my professorship path as an Asian American cisgender woman who wanted it all. Ironically, a tenure-track faculty position initially became my dream job because I believed it would allow me to simultaneously satisfy my passion for teaching and research and naturally maintain a healthy, robust work-life balance. From flexible teaching schedules and summer breaks to spend with my children to the promise of tenured job security, becoming an academic mother appeared, at first blush, a utopic destination for well-educated women who embraced both their families and careers. Although academic motherhood, especially for those along the tenure track, certainly affords many privileges, there are numerous untold, taken-for-granted challenges that must be named, interrogated, and addressed—such as conflicting biological and tenure clocks, systemic gender biases, persistent pay

gaps, inadequate parental leave policies, securing affordable childcare while attending academic conferences, and managing multiple roles as researchers, teachers, partners, and mothers (Hallstein and O'Reilly; Ward and Wolf-Wendel, *Academic Motherhood*; Ward and Wolf-Wendel, "Academic Motherhood"). Collectively, these factors can have negative immediate and cumulative effects on women's careers, from pregnancy to retirement (Mason et al.). These issues are further complicated when examined through an intersectional lens of race, culture, age, gender, and class.

Making issues regarding aging and motherhood particularly challenging for academic women is that speaking about them remains largely taboo, meaning that people are reticent to identify, interrogate, and discuss them. But shrouding these issues in silence renders them invisible and taken for granted. Moreover, failing to talk about these challenges keeps us from better understanding how they may manifest differently depending on key factors, such as culture, race, class, education level, gender identity, health status, and religious affiliation. And silencing the lived experiences of women with myriad intersecting identities conceals the increasingly urgent need for structural and societal change to support career-oriented mothers more effectively across their lifespans.

Drawing from my expertise as a researcher on gender equity, faculty career advancement, and communication studies and my own experiences as a fourth-generation Japanese American associate professor with tenure and (nearly) geriatric mother of a multiracial toddler, I identify and critique three taboos of academic motherhood. First, I address the taboo topic of pregnancy loss, which disproportionately affects women over the age of thirty-five. Second, I examine taboos surrounding the "fourth trimester." Third, I tackle mathematical taboos that often target older mothers as they calculate increasing medical expenses, their biological clocks, and their age relative to their offspring.

## Three Taboos

### Shattering the silence about pregnancy loss and maternal age

Like many career-driven women, I had opted to delay childbirth until I was in my thirties, following three decades of focusing largely on my educational and professional goals. In 2011, I married my graduate

school sweetheart John (who is six years older than me) and became the stepmother of a vivacious stepdaughter named Lexi. Although we considered and John welcomed the prospect of adding another child to our family, Lexi was the fiercest advocate for this move and often inquired when she would be getting a younger sibling. Still, we waited for a few years until John had secured a tenure-track faculty position, and I had submitted my dossier for tenure and promotion to associate professor. Our family plan was thus linear, logical, and straightforward: We would establish our careers and then expand our family. If only it had been that simple and easy.

In 2015, we were elated when pregnancy tests confirmed I was expecting. The intensely euphoric feelings we experienced when we got to witness our baby wiggle and dance on the sonogram screen and hear her steady heartbeat at seven-weeks' gestation was matched only by the intensity of our despair and grief when, at the following doctor's appointment several weeks later, I learned I had miscarried. Although miscarriages are surprisingly common, occurring in approximately 10 to 25 percent of all pregnancies, the etiology is often inexplicable and frequently attributed to unverified chromosomal abnormalities (American Pregnancy Association). Despite never receiving a formal or medically based reason for my miscarriage, I experienced a barrage of self-inflicted guilt and shame. Did I wait too long to try to have kids? Was my miscarriage a punishment for initially prioritizing my career over procreation? Had work-related stress and overexertion rendered my uterus a toxic gestational environment? How should I break the news to John and Lexi?

Shaken, John, Lexi, and I grieved together, revised our family planning timeline, and reaffirmed our commitment to having a baby. Despite the high prevalence of miscarriages in the United States (US), our mainstream culture seems to lack shared rituals and communication scripts for coping with early pregnancy loss. There was no body to bury, and the greeting card aisle seemed ill equipped to address this profound and specific type of loss. While exploring potential ways of coping with our loss, I learned about an Americanized version of the Japanese Buddhist practice *mizuko kuyo*, which serves as a meaningful ceremony to honour the life of an unborn child (Klass and Heath; Prichep) and seemed to speak spiritually to my Japanese American roots. Although the *mizuko kuyo* is not the only way to grieve, it

affirmed that I was not alone—and that many families, including those of Japanese and American heritage, have found ways to mourn miscarriage and cope together.

During this sad time, the ticking sound of my biological clock became increasingly louder. The urgency was palpable even though I felt young and fit. After reviewing my chart, one of my health providers cheerfully noted that I was "only thirty-four years old," which meant that I had not yet entered the "danger zone" defined medically as a "geriatric pregnancy," the medical term for pregnancies of all expectant women thirty-five years or older. This age-related threshold baffled me, as it seemed unlikely that one's thirty-fifth birthday would suddenly signal the beginning of more risky pregnancies, but it forced me to acknowledge the many direct correlations between maternal age and health complications. The following year, I cautiously and quietly navigated my second pregnancy while maintaining my full-time work responsibilities. And in 2017, we enthusiastically welcomed baby Sean into the world. His birth has been my most exhilarating and exhausting accomplishment to date.

Although my experience with miscarriage felt unique, pregnancy loss, including miscarriages and stillbirths, is a pervasive problem that affects women across the lifespan. But because many career-oriented women delay childbirth until their thirties or forties, they are disproportionately likely to experience pregnancy loss and fertility issues. Statistically, the risks of pregnancy complications are elevated among women who are thirty-five years and older, including an increased likelihood of pre-eclampsia, gestational diabetes, and placenta praevia (Kenny et al.; Lampinen et al.). As the Centers for Disease Control and Prevention noted, "Women aged 35 to 39 are almost twice as likely to die of pregnancy complications as women aged 20 to 24. The risk becomes even higher for women aged 40 or older" ("Maternal Health," para. 6). Older women are also more likely to utilize assisted reproductive technologies, such as vitro fertilization (Centers for Disease Control and Prevention, "Assisted Reproductive Technology").

Due to the increased risks of pregnancy loss and complications, many women tightly guard their gestational status as a secret until their second or third trimester, which can protect women and their partners from needing to grieve publicly or announce the loss of an unborn baby. However, not talking about pregnancy loss also renders the physical

and emotional challenges that many pregnant women experience invisible to their friends, family, and colleagues. As a result, many well-educated mothers with burgeoning careers expend valuable energy and emotional labour masking the many demands of early pregnancy, including exhaustion, morning sickness, and hormonal shifts. This can lead to feelings of isolation, a lack of social support, and work conditions that are unsympathetic to an expecting woman's changing body and life circumstances. These issues can be particularly burdensome for women of colour, women with health issues, and those with marginalized identities who are already navigating and negotiating broader structural inequities related to racism, ageism, and ableism. In higher education, for example, many faculty women of colour must cope with myriad microaggressions, being tokenized at the workplace, and being expected to perform inequitably large amounts of service and invisible labour (e.g., Hanasono et al.; Muhs et al.). These preexisting demands, coupled with the coping stressors affiliated with pregnancy symptoms or loss, can be overwhelming. To better prepare and support women across the lifespan, we need to shatter the silence surrounding maternal age and pregnancy loss.

## Fourth Trimester Taboos

The road to becoming a parent can be arduous, nonlinear, and unpredictable, and taboos related to motherhood and aging are not limited to the gestational period. Indeed, a second taboo topic related to older motherhood is the challenges that negatively impact career-oriented women who have children later in life that emerge during the fourth trimester—the notoriously difficult yet generally underdiscussed postpartum period, which continues for at least three months after delivery. Advanced maternal age has been linked to higher levels of postpartum depression, lower birth weight, and postdelivery health complications (e.g., Lisonkova et al.; Muraca and Joseph; Marozio et al.), which can exacerbate fourth-trimester stressors, such as sleepless nights, hormonal shifts, difficulties with breastfeeding, and limited time for self-care. This period can be particularly isolating for career-oriented women, some of whom are, for the first time, taking an extended leave of absence from work to recover and adjust to the new role of being a mother. Although legislative advances in the US protect many women from losing their jobs due to pregnancy and childbirth,

the vast majority of workplaces in the US offer minimal or no paid parental leave, which can foster extensive and long-lasting financial strain for families who face mounting medical bills.

In addition, many career-oriented mothers must navigate numerous social biases among their colleagues and clients who question whether it is possible to maintain success in both the professional and parenting domains. Academic mothers often feel the need to stave off and prove wrong other people's doubts about their scholarly commitment and productivity. For example, Sandra Faulkner describes a troubling conversation she had with a colleague who estimated that having a child costs an academic mother at least one peer-reviewed publication per year. Ranging from well-intentioned yet unsolicited advice to paternalistic protection, older mothers both inside and outside of academia tend to experience myriad microaggressions at the intersection of gender, age, ability, and class. Having children at a later age does not necessarily make the transition to motherhood easy. Instead of ignoring the set of fourth trimester taboos that many women experience, it is time to call them out and enact systemic and equitable solutions.

Another and perhaps self-imposed challenge I experienced during the postpartum period was the need to quell my tiger mom instincts. Long before Amy Chua popularized this concept through her controversial memoir, *Battle Hymn of the Tiger Mother*, the notion of tiger parenting was generally associated with overly controlling and demanding Asian and Asian American mothers who wanted nothing short of absolute success for their children (Juang et al.). Although tiger parenting is clearly only one and certainly not the most prominent form of parenting in Asian and Asian American cultures (e.g., Kim et al.), I nonetheless felt compelled to be the perfect mom who needed to raise an extremely successful child. This pressure initially manifested in the need to control everything—from feeding times and sleep schedules to not overexposing Sean to stimulating technologies and media. I yearned to do everything in my power to set my son up for academic, personal, and professional success. This well-intentioned yet unrealistic and unsustainable commitment was partially driven by some underlying anxieties about my maternal age and finite biological clock. My prior pregnancy loss, coupled with my and my partner's ages, forced us to acknowledge that baby Sean might be our last child,

and I wanted everything to be perfect. After months of sleep deprivation, exhaustion, and deep reflection, however, I came to the conclusion that I would have to relinquish some control and enjoy the chaos and unpredictability of parenthood.

## Calculating Risk

Admittedly, I have never been good at math. When confronted with a mathematical query—whether it requires multinomial regression analyses for a research project or simple arithmetic to double an everyday recipe—I rely heavily on calculators and statistical software. Since turning thirty-five, however, my medical, financial, and personal information have been (re)defined by a series of numerical computations and predictive algorithms. Although some numbers, such as my cholesterol levels and daily digital screen time, appear to be unremarkable and benign, I am keenly aware of how other numbers may impact my physical, mental, occupational, and relational wellbeing. In a cathartic attempt of confession, along with a well-intentioned urge to tackle the taboo numbers game, I would like to directly address a collection of statistics that reveals complex connections among age, gender, and parenting.

My second pregnancy was largely uneventful until the thirty-six-hour crescendo that preceded the birth of my son. At thirty-four-weeks pregnant, I continued my teaching, service, and research commitments. On the eve of my son's arrival, I was busy administering a midterm exam on campus while my cell phone's voicemail account silently fielded a series of urgent calls from my gynecologist about the sudden detection of preeclampsia, one of the leading causes of maternal deaths in the US. My healthcare provider noted abnormally high levels of protein in my urine and urged me to go to the emergency room for treatment. Fortunately, Sean was born the next day despite a series of maternal medical complications that required us to stay at the hospital beyond the typical recovery period for most new mothers and babies. Before the hospital discharged me, the on-call doctor sternly discussed my health status. After reviewing the numbers on my medical chart, she calculated my risk and advised me to wait at least two to three years before trying to conceive again. My body had been traumatized by the delivery, she said, and rushing into another pregnancy might jeopardize the health of my next baby and me. Although waiting two to three

years may seem like an insignificant amount of time for many people, these numbers had devastating implications on my dreams of having more children. With the assistance of my smartphone's calculator app, I determined that the next safe window for a subsequent pregnancy would not be until I was at least thirty-eight or thirty-nine years old— and that was assuming that my partner and I could conceive quickly. When considering the possibility of having another miscarriage or difficulties getting pregnant, our family planning timeline could easily exceed a maternal age of forty. This would mean that I would be fifty-eight years old upon this child's high school graduation, and I would be close to retirement age by the time they earned their college degree (assuming this child would pursue a postsecondary education, avoid gap years, and complete the graduation requirements within a typical four- to five-year time frame). Although having a child after the age of forty is fine with me—and I fully support parents who have children and expand their families after they are forty years old—the most immovable factor in the family-planning equation was my partner who expressed zero interest in starting another fatherhood chapter in his forties. Mathematically speaking, if I were to give birth at the age of forty, he would be forty-six years old, which would make him nearly sixty-five years old by the time our child would graduate from high school. For some people, including me, this would be fine. For him, however, the numbers game was over. Simply put, he had no interest in having more children.

Another taboo calculation involves baby budgets; people are often reticent to talk about finances, including those related to childrearing. Although parenting a child is priceless in many regards, how much money does it cost to raise a baby? Tracking childrearing costs since the 1960s, the US Department of Agriculture estimated that a middle-income couple will spend approximately $233,610 to raise a child from birth until they turn eighteen years old (not taking into consideration college expenditures and variations in geographical location and culture). Nonetheless, it is important to talk about the rising costs of parenthood, even among well-educated mothers with full-time jobs. The sheer cost of childcare, especially during the formative years before kindergarten, can be formidable. However, the grand total also includes expenditures, such as doctor appointments, food, clothing, extra-curricular activities, toys, and transportation. It might be taboo to say

it, but raising a family is expensive. To confront this important economic reality, we as a society need to engage in meaningful conversations and find sustainable solutions that better support working mothers and their families. What cultural shifts and policy changes might make workplaces more family friendly? How can we make childcare more accessible and affordable to parents across the lifespan? Although older parents may have more time to establish their careers and increase their earning potential, they may face additional financial challenges, such as simultaneously supporting the care of both their aging parents and young children (e.g., Bogan's research on the "sandwich generation"), delaying retirement to help their children cover the cost of college tuition, and affording increased costs for their own healthcare and insurance.

## Making Change

Recognizing the dangers of remaining silent, in this chapter, I identified and discussed a collection of taboos that are especially salient for career-oriented mothers who have children after the age of thirty. Although motherhood has its rewards and challenges for women of all ages, these issues can manifest differently across the lifespan. To complement extant literature on academic motherhood and research that focuses on women who have children in their teens and twenties, there is a need to name, interrogate, and address taboos and barriers that target mothers in their thirties, forties, and fifties who aim to have it all. Moreover, members of society need to work together to explore and enact viable, sustainable solutions to better support older parents who are expanding their families through such methods as childbirth and adoption. Whether they identify as near-geriatric tiger moms like me or simply want to lead fulfilling lives as mothers with successful careers, we need to tackle taboos and shatter stigma situated at the intersection of motherhood, age, and gender.

## Works Cited

American Pregnancy Association. "Miscarriage." American Pregnancy, americanpregnancy.org/pregnancy-complications/mis carriage. Accessed 17 June 2022.

Bogan, Vicki L. "Household Asset Allocation, Offspring Education, and the Sandwich Generation." *American Economic Review,* vol. 105, 2015, pp. 611-15.

Faulkner, Sandra L. "That Baby Will Cost You: An Intended Ambivalent Pregnancy." *Qualitative Inquiry,* vol. 18, no. 4, 2012, pp. 333-40.

Centers for Disease Control and Prevention. "Assisted Reproductive Technology: National Summary Report." *CDC,* www.cdc.gov/art/pdf/2015-report/ART-2015-National-Summary-Report.pdf Accessed 17 June 2022.

Centers for Disease Control and Prevention. "Maternal Health." *CDC,* www.cdc.gov/chronicdisease/resources/publications/aag/maternal.htm Accessed 17 June 2022.

Chua, Amy. *Battle Hymn of the Tiger Mom.* Penguin, 2011.

Hallstein, Lynn O., and Andrea O'Reilly. *Academic Motherhood in a Post-second Wave Context.* Demeter Press, 2012.

Hanasono, Lisa K., et al. "Secret Service: Revealing Gender Biases in the Visibility and Value of Faculty Service. *Journal of Diversity in Higher Education,* vol. 12, no. 1, 2019, pp. 85-98.

Juang, Linda P., et al. "Deconstructing the Myth of the "'Tiger Mother': An Introduction to the Special Issue on Tiger Parenting, Asian-heritage Families, and Child/adolescent Well-being." *Asian American Journal of Psychology,* vol. 4, no. 1, 2013, pp. 1-6.

Kenny, Louise C., et al. "Advanced Maternal Age and Adverse Pregnancy Outcome: Evidence from a Large Contemporary Cohort." *PLOS One,* vol. 8, no. 2, 2013, p. e56583.

Klass, Dennis, and Amy Olwen Heath. "Grief and Abortion: *Mizuoko kuyo,* the Japanese Ritual Resolution." *OMEGA Journal of Death and Dying,* vol. 34, no. 1, 1996, pp. 1-14.

Kim, Su Yeong, et al. "Does 'Tiger Parenting' Exist? Parenting Profiles of Chinese American and Adolescent Developmental Outcomes." *Asian American Journal of Psychology,* vol. 4, 2103, pp. 7-18.

Lampinen, Reeta, et al. "A Review of Pregnancy in Women over 35 Years of Age." *Open Nursing Journal,* vol. 3, 2009, pp. 33-38.

Lisonkova, Sarka, et al. "Maternal Age and Severe Maternal Morbidity: A Population-based Retrospective Cohort Study." *PLOS Medicine,*

vol. 14, no.5, 2017, p. e1002307.

Marozio, Luca, et al. "Maternal Age over 40 Years and Pregnancy Outcome: A Hospital-Based Survey." *Journal of Maternal-Fetal and Neonatal Medicine*, vol. 32, no. 10, 2019, pp. 1602-08.

Mason, Mary Ann, et al. *Do Babies Matter? Gender and Family in the Ivory Tower.* Rutgers, 2013.

Muhs, Gabriella Gutiérrez, et al. *Presumed Incompetent: The Intersections of Race and Class for Women in Academia.* Utah University Press, 2012.

Muraca, Giulia, and K. S. Joseph. "The Association between Maternal Age and Depression." *Journal of Obstetrics Gynecology Canada*, vol. 4, no. 36, 2014, pp. 803-10.

National Center for Health Statistics. "Mean Age of Mothers is on the Rise: United States, 2000–2014." *CDC*, www.cdc.gov/nchs/data/databriefs/db232.htm. Accessed 17 June 2022.

Prichep, Deena. "Adopting a Buddhist Ritual to Mourn Miscarriage, Abortion." *All Things Considered*, www.npr.org/2015/08/15/429761386/adopting-a-buddhist-ritual-to-mourn-miscarriage-abortion. Accessed 17 June 2022.

US Department of Agriculture. "The Cost of Raising a Child." *USDA*, www.usda.gov/media/blog/2017/01/13/cost-raising-child. Accessed 17 June 2022.

Ward, Kelly, and Lisa Wolf-Wendel. *Academic Motherhood: How Faculty Manage Work and Family.* Rutgers, 2012.

Ward, Kelly, and Lisa Wolf-Wendel. "Academic Motherhood: Mid-career Perspectives and the Ideal Worker Norm." *New Directions for Higher Education*, vol. 176, 2016, pp. 11-23.

# Notes on Contributors

**Elizabeth Allison**, PhD, is an American scholar of the transdisciplinary field of religion and ecology. Her research explores the intersection of religion, ethics, and environmental politics. Her devotion to bringing forth a more socially just and ecologically sustainable world intensified after she became a mother at forty-four. She is associate professor of ecology and religion at the California Institute of Integral Studies in San Francisco, California, USA, where she founded and chairs the graduate program in ecology, spirituality, and religion and created the Religion & Ecology Summit series of conferences. She is the author of numerous articles and chapters on climate change, environmental ethics, mountain socioecology, and Bhutan and is coeditor of *After the Death of Nature: Carolyn Merchant and the Future of Human-Nature Relations.* After a receiving a Fulbright fellowship in Nepal, she received her PhD in environmental science, policy and management from the University of California, Berkeley. She also holds a Master of Arts in religion from Yale Divinity School, a Master of Environmental Management from the Yale School of Forestry & Environmental Studies, and a BA in religion, cum laude, with a concentration in Environmental Studies, from Williams College.

**Laura Beckwith** holds a PhD from the School of International Development and Global Studies at the University of Ottawa. She previously completed a MSc in environment and sustainable development from University College London and a BA in international relations from the University of British Columbia. Originally from Canada, Laura now lives in Phnom Penh, Cambodia, with her family where she works as

an independent consultant and lecturer in international relations. Laura was thirty-six when her son was born.

**Karen Christopher** is originally from Birmingham, Alabama, USA. She earned her PhD in sociology at University of Arizona, USA, and had her son at age thirty-three and her daughter at age thirty-six. She is a professor of sociology at University of Louisville, where she recently received the College of Arts and Sciences Distinguished Teaching Award. Her current research explores work-family conflict among diverse groups of women and men. She has published articles in *Gender & Society, Advances in Gender Research, and Feminist Economics*, among other journals. When not teaching or writing, she enjoys play-ing sports with her partner and children. Two of her main goals as a parent are to see and support her children for who they are and to ensure they are aware of and know how to resist the many injustices in our society.

**Jean D'Cunha** is UN Women's senior global advisor on international migration, based in its Regional Office for Arab States, Cairo, Egypt. She holds a doctorate in sociology and has thirty-five years of lead-ership, academic and practitioner experience on gender equality and women's rights. She has served for nineteen years in senior technical and management positions within UNIFEM/UN Women, including heading UNIFEM's East/Southeast Asia Regional Office, Bangkok, establishing and heading UN Women's Office, Myanmar and UNIFEM's Global Migration section, New York. She developed the first UNIFEM Asia Pacific and Arab States Regional Migration Program in 2001, managing successive phases and building the base for the organization's continuing work on migration in Asia. The program received the AGFUND Award for pioneering development projects in 2003. Her internationally recognized expertise includes labour migration, trafficking, gender, climate change and disasters, sexual and gender-based violence. She has written chapters in books, UN papers and publications, as well as articles for Indian and inter-national journals and for the mainstream Indian press on these themes. She received the Eve's Weekly National Woman Journalist Award for "Outstanding Writing on Women's Issues" in 1986. An Indian, she is married, resides in Cairo, and has two sons, who were born when she was twenty-nine and thirty-five.

**Katharine Gelber** is originally from Tasmania, Australia, and now lives in Brisbane. She was two weeks short of her forty-first birthday when she had her child. She is a professor of political science and public policy and head of the School of Political Science and International Studies at the University of Queensland. She is also a Fellow of the Academy of Social Sciences in Australia. She was awarded her PhD from the University of Sydney (2000), her BA (Hons I) from the University of Sydney (1996), and her BA from the University of Tasmania (1991). Her expertise is in freedom of speech and speech regulation. She recently jointly edited, with Prof Susan Brison, *Free Speech in the Digital Age (Oxford Uni Press, 2019), and published Free Speech After 9/11 (Oxford University Press, 2016). In 2014, she and Luke McNamara were awarded* the Mayer Journal Article Prize by the Australian Political Studies Association for the best article in the *Australian Journal of Political Science.* In 2011, her book *Speech Matters: How to Get Free Speech Right (University of Queensland Press, 2011) was a finalist in the Australian Human Rights Awards (literature nonfiction category).*

**Anita Gibbs** is associate professor in social work and criminology, at the University of Otago, Dunedin, New Zealand. She became a birth parent at age thirty-five and later an adoptive parent of two children from Russia. These two children have neurodisabilities. Her current research interests include fetal alcohol spectrum disorder, mental health, and interventions and supports for families and caregivers with children who have complex needs. Anita's two sons actively participate in and collaborate with her to show that it is important and possible to live well and flourish with a neurodisability. Anita has published widely in the areas of criminal justice, social work, mental health, and more recently fetal alcohol spectrum disorder. She is regularly invited to speak at conferences and is a strong activist in the neurodisabilities field.

**Gretchen Good** is a senior lecturer in the School of Health Sciences at Massey University, Palmerston North, New Zealand. She has a PhD (Massey University) and an MA (Boston College) in rehabilitation for those who are blind and vision impaired and a BA in Journalism (Michigan State University). She is originally from the US and has lived, worked, and raised a family in New Zealand. She first became a mother, through adoption, at age forty-seven and again at age fifty.

Both of her children live with Down syndrome as well as some other complex health impairments. Gretchen identifies as a disabled academic and activist. Her research includes disability across the lifespan, disability advocacy, disability and disaster, disability and adoption, mothering and disability, and activity, independence, and life satisfaction. She is married to Dan Nash and is proud mother to Leo, Tiffany, and to the family's service dog, Caz.

**Lisa K. Hanasono** (PhD, Purdue University) is an associate professor in the School of Media and Communication at Bowling Green State University (BGSU) and a fourth-generation Japanese American (*yonsei*) cisgender woman who was born and raised in Indiana. As a scholar, she examines how people communicate prejudice, shatter stigma, and respond to discrimination. Through her research, academic, public presentations, and outreach, she aims to break the silence that surrounds pregnancy loss and tackle taboos about motherhood. Her work is informed by interdisciplinary and communication research as well as her personal experiences of becoming a stepmom at age twenty-eight, experiencing a miscarriage in her thirties, and giving birth to her son a few months before her thirty-fifth birthday. Dr. Hanasono lives in Bowling Green, Ohio, with her partner, John, her stepdaughter, Lexi, and her son, Sean. While writing her chapter for this book, Dr. Hanasono was awarded a research fellowship from BGSU's Institute for the Study of Culture and Society (ICS) to conduct research on miscarriage and motherhood. She would like to thank the ICS, its director, Dr. Jolie Sheffer, and this book's editors, Drs. Suzette Mitchell and Olga Sanmiguel-Valderrama for their support.

**Awhina Hollis-English**, from Hawkes Bay, New Zealand, has lectured at Massey University since 2010 in the School of Social Work and is now an Honorary Research Associate. Awhina has a PhD, an MA, a PgDip, and a BA. Awhina's areas of interest are social work practice, whānau hauā, and social policy. She specializes in teaching Māori social work development and became a mother at the age of thirty-one. She has three children.

**Renée E. Mazinegiizhigoo-kwe Bédard** is of Anishinaabeg ancestry and a member of Dokis First Nation in Canada. She holds a PhD from Trent University. Currently, she is an assistant professor in the Faculty of Education at Western University, located in London, Ontario, Canada. She began her journey in mothering at the age of thirty-six and now has two daughters named Willow and Juniper. Her area of research and publications includes work related to Anishinaabeg mothering, maternal philosophies, and the traditional cultural knowledge of those who identify on the female gender spectrum.

**Maura J. Mills**, PhD, is an assistant professor in the Department of Management at the Culverhouse College of Business, University of Alabama. She earned her BA degrees in Psychology and English (corporate communications) with minors in business administration and women's studies from Massachusetts College of Liberal Arts. Thereafter, she earned her MS and PhD degrees in industrial and organizational psychology from Kansas State University. Dr. Mill's research falls under the umbrella of positive organizational behaviour, with a specific focus on the work-family/work-life interface; gender, employee attitudes and engagement; and the psychometrically appropriate assessment of each. She has published over forty peer-refereed articles, several book chapters, and various industry publications. Her recent edited book (*Gender and the Work-Family Experience: An Intersection of Two Domains,* 2015, Springer) was met with wide praise and is being used as a textbook in relevant courses as well as to guide future research at the intersection of work-family and gender. Dr. Mills is originally from Australia, but has lived in a number of countries and US states, and currently resides in Alabama, US.

**Suzette Mitchell, PhD,** is an Associate with Gender At Work. Originally from Australia, she was forty-two when she had her daughter Veronika in Hanoi, Vietnam. She was running a United Nations agency during the birth and first four years of her daughter's life. She returned to Melbourne, Australia, when her daughter was eight, continuing to consult for the UN and the Asian Development Bank in international development for women. Her PhD was on the impact of the United Nations Fourth World Conference on Women and was conducted in the Department of Women's Studies and Political Science at the Australian National University.

**Constance Morrill**, MIA, LCSW, is American, originally from St. Louis, Missouri, and had her son, Jake, at age forty-one. She is a psychotherapist in private practice in New York City, where she works with individuals, couples, and families of multiple national, racial, and personal identities. She holds master's degrees in French, international affairs, and social work, and is certified in couple and family therapy, and psychoanalysis. She has provided psychological assessments for asylum seekers from Central America, South Asia, and West Africa and has served as an interpreter for over thirty asylum seekers from Haiti and francophone African nations, translating stories of trauma and well-founded fear for attorneys, medical professionals and asylum officers at the United States Citizenship and Immigration Services. From 2001 to 2005, over the course of five trips to Rwanda, she conducted social research and a series of interviews with imprisoned Rwandans accused of—but not necessarily guilty of—participating in the 1994 genocide as adolescents. She has given numerous talks on the Gacaca court system in Rwanda and served as a country expert on behalf of Rwandan asylum seekers.

**Simal Ozen Irmak**, PhD, MPH, is originally from Turkey. She was thirty-five when she had her daughter Lara Erin in 2016. She has a BA in business administration from Bogazici University and a PHD degree in integrative neuroscience from Rutgers University. After graduation, she worked first as a postdoctoral researcher and then as a life science research associate at Stanford University. During her academic research, she studied neural correlates of sleep, learning, and memory. In 2016, she left academia to provide full-time care for her daughter. She was a proud stay-at-home mom for about 1.5 years, which she considers as the most challenging and the most rewarding job she ever took. After experiencing postpartum depression, Dr. Ozen Irmak became passionate about finding scalable and effective solutions to support fellow parents. First, she conducted an independent research study to improve postpartum care. Insights gained from this study, which was a finalist at Stanford-Medicine X Digital Health Challenge, propelled her to change her career to healthcare. She recently received her MPH degree from UC Berkeley and cofounded Tibi Health, an early stage health technology company aiming to redesign how mental health is assessed.

**Olga Sanmiguel-Valderrama**, originally from Colombia, was forty-six when she had her first and only child, Ana Patricia. She earned her graduate degrees in Canada and currently is an associate professor in women's, gender, and sexuality studies at the University of Cincinnati in the US. Dr. Olga Sanmiguel-Valderrama is also the founder and director of the newly established The Americas, Indigenous, and Latinx Research Center at the University of Cincinnati. She has published extensively on women workers' rights in agribusinesses in Latin America and on the rights of Latinx immigrants in the US. Her latest coedited volume, *Global Women's Work Perspectives on Gender and Work in the Global Economy,* which was coedited with Beth English and Mary E. Frederickson, was published in late 2018. Until recently, Dr. Sanmiguel-Valderrama directed UC's Latin American Studies Program. Currently, she is working on a monograph on Latinx rights in the US. Her scholarly interest is the contributions of the diverse Latinx communities to the US's development.

**Caroline J. Smith** is an associate professor in the George Washington University's writing program where she serves as deputy director of First-Year Writing. She teaches a variety of first-year writing seminars themed around topics, such as visual culture, women's writing, and popular culture. After completing her undergraduate degree in her hometown of Bethlehem, Pennsylvania, she moved to Newark, Delaware, where she received both her MA and PhD from the University of Delaware. Her research interests include women's fiction and popular culture productions; she is the author of *Cosmopolitan Culture and Consumerism in Chick Lit* (2007). She currently resides in Washington, DC. She had her first child, Henry, at age thirty-eight.

**Caro White** is a counsellor and couple's therapist living in the beautiful Australian bush on the southwest coast of Victoria. She shares her home with her husband, Scott, and her daughter, Scout, and she relishes the occasional drop-in of her two grownup step children. They have a friendly yet obsessive dog, two guinea pigs (actually only one now), some chickens who are past their prime, and a multitude of birds, snakes, and kangaroos. She holds diplomas in art therapy and community development as well as a MA in counselling from La Trobe University in Melbourne. Her counselling practice focuses on trauma, attachment issues, and relationship struggles. She feels deeply

privileged to work with couples experiencing distress, which is commonly triggered by misattunements following the entry of children in to their lives. You would be likely to find her drinking a cup of tea, gardening, laughing with friends, having solemn time reflecting on her inner world, playing on the beach, or practicing her beloved meditation. Caro became a mother in her thirty-seventh year.